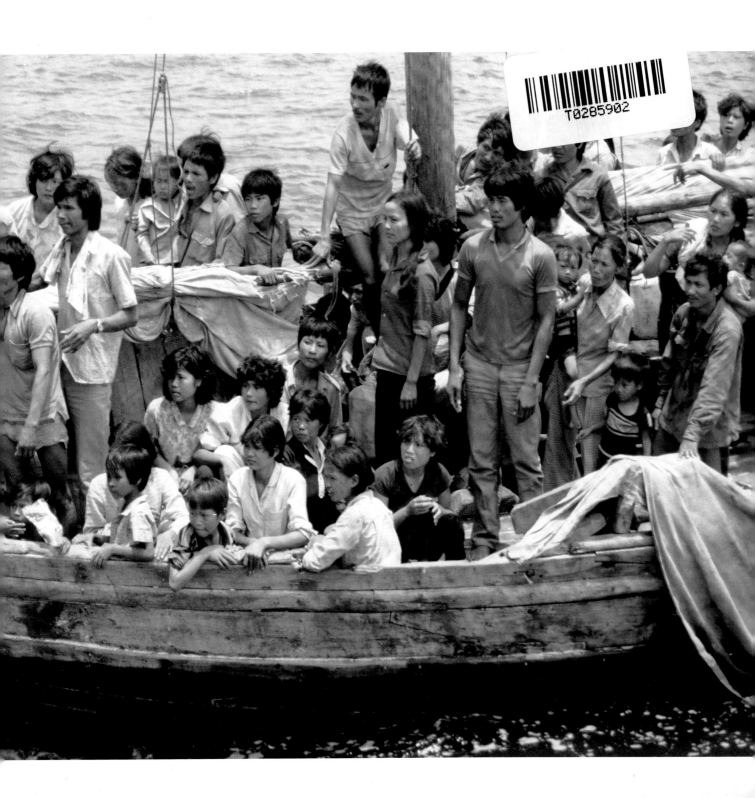
T0285902

# Along the Southern Boundary

A Marine Police Officer's Frontline Account
of the Vietnamese Boatpeople and their
Arrival in Hong Kong

## Les Bird

BLACKSMITH BOOKS

*Along the Southern Boundary*
ISBN 978-988-75547-3-8

Text copyright © 2021 Les Bird
Photographs copyright © 2021 Les Bird and the individual photographers as listed on pages 8-9

Published by Blacksmith Books
Unit 26, 19/F, Block B, Wah Lok Industrial Centre,
37-41 Shan Mei Street, Fo Tan, Hong Kong
Tel: (+852) 2877 7899
*www.blacksmithbooks.com*

Maps by Ryan Warden
First printing 2021

All rights reserved. No part of this book may be reproduced in any form or by any electronic means, including information storage and retrieval systems, without permission in writing from the publisher, except by a reviewer who may quote brief passages in a review. The right of Les Bird to be identified as the Author of the Work has been asserted as have his moral rights with respect to the Work.

# Contents

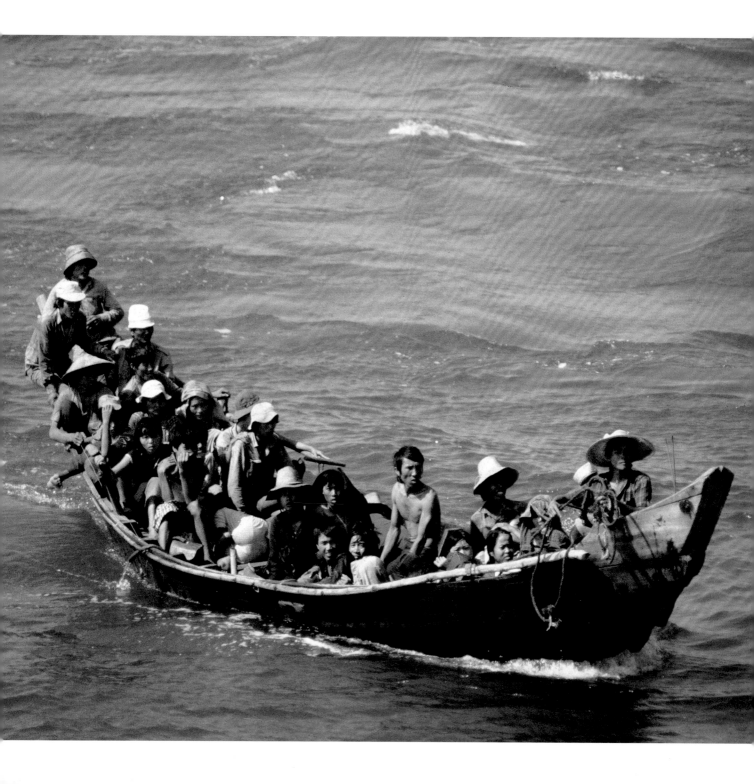

# Foreword

How Hong Kong's Marine Police dealt with the arrival of tens of thousands of Vietnamese boat people in the late 1970s right up to 1997 is a story well worth re-telling: a story of determination, skulduggery, courage and recklessness. The *Huey Fong* and *Skyluck*, with their thousands of people of all ages who had in fact paid unscrupulous organisers and corrupt officials in Vietnam for their passages. Or a single man in a tiny oval-shaped coracle who turned out to be a Filipino fisherman who had lost his way in the midst of the South China Sea. Hong Kong's Marine Police had to deal with them all. They did so with efficiency, compassion and a remarkable ability to improvise.

One picture is said to be worth a thousand words. The contemporary photographs, which make up a large part of this fascinating account, certainly bring alive, in a way that no words can match, the realities of what it meant to deal with such a massive arrival of people, whether genuine political refugees or those who were reckoned to be economic migrants. Or whether they were ethnic Chinese from South Vietnam, as most of the earlier arrivals were, or ethnic Vietnamese from North Vietnam, as was the case with most of the later arrivals. All were people who had come hundreds of miles, across an often treacherous sea in a vast array of different vessels, to get to Hong Kong in the hope of starting a new life.

From some of the follow-up stories, it is not surprising to learn that many have gone on to build successful lives elsewhere, in the United States, Britain, Canada or Australia. One day, let us hope that accounts of their later lives will be put together to complete the picture of this remarkable story – and the crucial role played in it by the Hong Kong Marine Police.

David Wilson
(Lord Wilson of Tillyorn)
Governor of Hong Kong, 1987-1992

# The Photographers

Author **Les Bird** was born in Staffordshire, England, in 1951. He joined the Royal Hong Kong Police (RHKP) in 1976 and served in the Marine Police until June 1997. A good part of that career he spent on the "southern boundary"  of Hong Kong, intercepting Vietnamese boatpeople vessels as they came into Hong Kong from the mid-1970s onwards. After leaving the Force, Bird moved into the private security business world. He is a founding member and chairman of Asia's Rhinos Rugby Football Club. He is married with two daughters. He still lives in Hong Kong.

**The rest of the team**

Born in Singapore, the son of a British Army officer, **Alasdair Watson** was educated in Ireland and read Economics at Warwick University before joining the Royal Hong Kong Police in 1981, transferring to the Marine  District. After holding many senior positions in Marine, Alasdair retired in 2014 after 33 years' service. He now lives in Salisbury, England, with his wife and daughter.

**John Turner** was born in Plymouth. As a child at the start of World War II, the city was bombed and John was evacuated to Shropshire. After completing his national service in the Royal Air Force he joined the Hong  Kong Police in 1955. He served the latter years of his police service in Marine District and was the Marine deputy commander in 1979 who oversaw the operational handling of the *Huey Fong* and the *Skyluck*. He started the Police Force Choir in 1976 and was a member of the the Really Big Chorus that sang *Messiah* in Beijing in 1994.

**Stephen Tooke** is from York. He joined the RHKP in 1985 and spent his entire service in Marine District. In 1989, when Tai Ah Chau was selected as a temporary centre for Vietnamese boatpeople, Stephen was tasked with heading  operations on the island. He also served in Marine's Small Boat Unit, Anti-Smuggling Task Force and the Special Duties Unit. In 1997, he became harbour master in Salcombe, Devon. He now runs the innovation technology company Tookie Limited. Stephen is married and has five children.

Son of a schoolmaster, brought up in both Yorkshire and on the Isles of Scilly, **Hugh Osborne** joined the RHKP in 1977 aged 22. He spent most of his career in the Police Tactical Unit where he was an instructor. Hugh was also

a police negotiator for 13 years of his service. He retired in 1997 and still lives in Hong Kong with his family. Hugh is an accomplished opera singer.

Born in Scotland, the son of a Royal Air Force officer, **Peter Conolly** lived and was educated in various locations around the world, following his father's military postings. Peter joined the RHKP in 1976, spending the

majority of his service in the Marine Police, five of which were as a staff officer based at Marine Police Headquarters in Tsim Sha Tsui. He retired from the Force in 1997 and returned to the Scottish Borders where he now lives with his wife and family.

**Crispian Barlow** is a Newfoundlander who has been involved in law enforcement for more than 45 years. After serving in the Royal Canadian Navy, he joined the RHKP and for the next 13 years served in both the Marine Police and the Explosive Ordnance Disposal Bureau.

He left Hong Kong in the late 1980s, spending the next 17 years as a game warden in South Africa. He spent two years in Vietnam as a training officer for the Forest Protection Department to set up training for their rangers. Presently he works for WWF Greater Mekong as their regional wildlife crime technical advisor.

Originally from North Wales, **Ian Clark** arrived in Hong Kong in 1985 to join the RHKP. During his 33-year career he managed the Stonecutters Island Vietnamese Boatpeople Detention Centre in 1989 and was involved in the preparations for events in Victoria Harbour in connection with the change of sovereignty ceremony at midnight on June 30th 1997 and

the subsequent departure of HMY *Britannia* through Lei Yue Mun Gap to the United Kingdom. Ian retired from the Force in February 2019 and now lives on Lantau Island in Hong Kong.

**Rod Colson** hails from a Royal Navy family. His father, Commander David Colson RN, also served in Hong Kong in the 1990s. Rod joined the RHKP in 1976 and other than a few years in the Police Tactical Unit, served

his entire 33 years' service in the Marine Police. A keen ocean sailor, he retired from the Force in 2009 and now lives with his wife and family in Thailand.

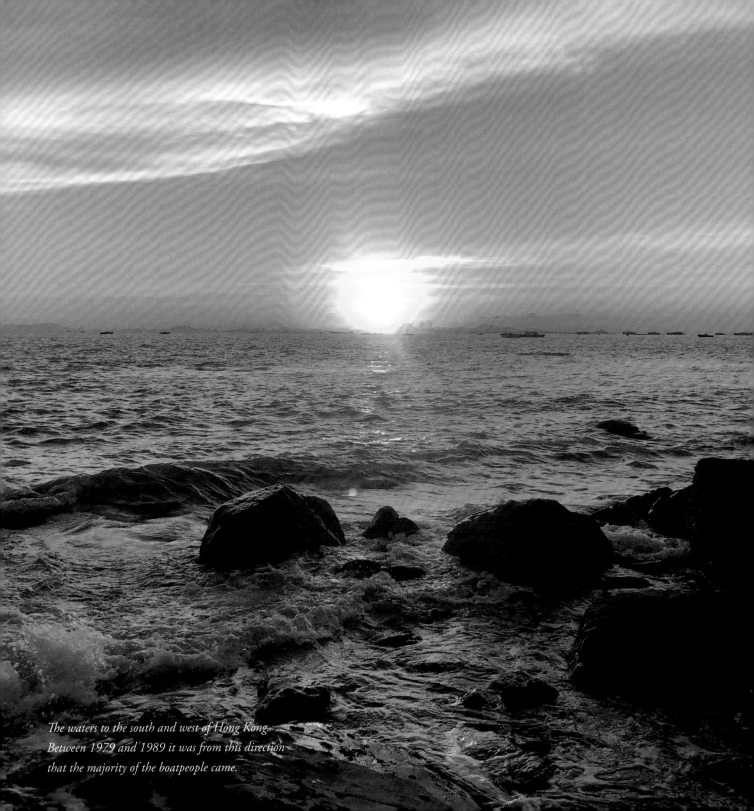

*The waters to the south and west of Hong Kong.*
*Between 1979 and 1989 it was from this direction*
*that the majority of the boatpeople came.*

# Introduction

A couple of years ago, when I was writing my memoir, *A Small Band Of Men: An Englishman's Adventures in Hong Kong's Marine Police,* I was able to recall much of that time by looking at the photographs I had taken. Each picture had a story attached to it, and by looking at the photos my memories came flooding back.

During my Marine Police career I always carried a camera and would take a few shots when circumstances permitted. But this collection of photos sat in a box for more than 30 years and some of them had not seen the light of day since the late 1970s. Among them: freedom swimmers attempting to cross the cold waters of Mirs Bay from China to Hong Kong; rescues during typhoons; and the face of a mother with babe in arms after she had sailed 1,000 miles across the South China Sea from Vietnam in a boat more suited to a river.

Although I used many of these photographs to jog my memory, I only used two in that memoir – on the front and back covers. So I contemplated putting a second book together with some of those photographs from my time in the Marine Police on the frontline of Hong Kong's southern sea boundary, when tens of thousands of refugees arrived here after fleeing the aftermath of the Vietnam War.

The "Vietnamese era" was an extraordinary time for Hong Kong. From the mid-1970s, when the first refugee vessels from Vietnam began arriving, right up until the late 1980s, I was often out at sea meeting these vessels as they arrived. These photographs portray our work as Marine Police, the ramshackle vessels coming in, the sheer resilience of people literally putting their lives on the line and facing not only starvation and the dangers of bad weather conditions, but exploitation by people-smuggling rackets, and the pirates who preyed on them.

In 1979 alone, almost 70,000 Vietnamese arrived in Hong Kong by boat. This represented one third of all those that were to arrive in the territory between 1975 and the late 1990s. No one knows for sure how many tried and never made it. I recall that in July of 1979, refugees were arriving in Hong Kong at a rate of about 500 each day. That is until the territory was hit by Typhoon Hope on August 2. After its direct hit on Hong Kong, Hope went on to sweep across the South China Sea. For two weeks there were no arrivals of refugees in Hong Kong.

It was also in 1979 that Hong Kong declared itself a "Port

of First Asylum" for all refugees from Vietnam. It was a brave move, and while there were controversies to follow, I and everyone else that was involved at the time was proud to be a part of this decision. With other countries in Southeast Asia closing their doors to the boatpeople, with some resorting to escorting overcrowded, dilapidated boats back out to sea, the tiny territory of Hong Kong did the opposite. It opened its doors and offered help. Of course, it was a tough decision for a territory that was at the same time returning illegal immigrants back over the border to China.

In the late 1970s, our vessels and equipment were nothing like the ones that can be seen today. They were small and slow and not suitable for handling hundreds of people day after day far out at sea. But the Marine Police are a resilient lot and are a tight-knit group: a group who have each other's backs. We were determined not to fail those in need. When I told them about my photo project, some of my former colleagues – the young men who'd been on the police launches helping with rescues and escorting the boats in – started searching out their own photos. They produced photos and stories of daring rescues at sea, and dealing with thousands of desperate people who arrived in Hong Kong during those years. Just like my own, their photographs and their memories of this time have been waiting for a chance to see the light of day.

Photographs have also helped forge new friendships in the most unexpected circumstances. A former soldier in the South Vietnamese Army, who escaped and travelled to Hong Kong on the people-smuggling freighter the *Sen On*, contacted me after seeing the Polaroid photo I took of the ship aground on Lo Kei Wan beach. He figured that he and I had stood together at that same moment in time and now he wanted to reconnect. There was the family in London, the father of which had passed through Hong Kong in 1984 aged 20. The family were looking for photographs of their early life, of which they had none. I was fortunately able to help them find photographs of their boat and of them in the camps in Hong Kong. These photographs, the only photographic record of their youth, are now framed and hang in one of their shops in east London.

The two little girls you see on the front cover are grinning through a porthole of the freighter, the *Huey Fong*, a people-smuggling ship that arrived here in 1978. They can't have been more than four years old, enjoying a moment of levity. I wonder if they now speak English with American accents and what their memory of this experience is, if any. They'd be nearing 50 now.

In this book, I'm joined by former refugees who tell me about how they got across the sea, leaving their families behind, and arriving in Hong Kong, plus former officials who talk about some of the decisions made including choosing the island of Tai Ah Chau as an ad hoc camp. Through my photographs and those of my Marine Police colleagues, this is the Vietnamese era told from out at sea.

Les Bird
Hong Kong
August 2021

**Map 1:** *The general routes taken by vessels sailing from Vietnam to Hong Kong*

CHINA

Macau

Hong Kong

Hanoi

Hai Phong

HAINAN ISLAND

Sanya

VIETNAM

Da Nang

SOUTH CHINA SEA

Ho Chi Minh City

Vung Tau

THE PHILIPPINES

100KM
54 Nautical Miles

*All in a hot and copper sky,*
*The bloody Sun, at noon,*
*Right up above the mast did stand,*
*No bigger than the Moon.*

*Day after day, day after day,*
*We stuck, nor breath nor motion;*
*As idle as a painted ship*
*Upon a painted ocean.*

From *The Rime of the Ancient Mariner* by Samuel Taylor Coleridge

## Pirates ruled the seas

On May 5, 1842, Sir Henry Pottinger, the Governor of Hong Kong, recognising the importance of law and order in and around the harbour, gazetted a new warrant for Lieutenant William Pedder of the Royal Navy, confirming his authority as "Harbour Master and Marine Magistrate of the Island of Hong Kong and its dependents". A year earlier, Captain Charles Elliot had proclaimed Hong Kong a free port and appointed Pedder to oversee the formation of a Harbour Police Force, but the gazetting of the warrant in 1842 served as the accepted date that Hong Kong's Water Police was established.

The urgency to create a waterborne law and enforcement agency (the land-based police force was formed two years later in 1844) highlighted the new colony's primary criminal concern at that time, that of piracy. The fact that "pirates ruled the seas" around Hong Kong in the 19th century was nothing new. They had done so for centuries. Unlike the criminals ashore, attracted by the pickings to be found in the new British colony, pirate fleets had been swarming around the Pearl River Estuary for more than 800 years.

Today, the Marine Police in Hong Kong have the same statutory powers as their colleagues on dry land, but the fact that their work is predominantly at sea makes the day-to-day life of a Marine Police officer very different from his or her land-based counterpart. I served in the Royal Hong Kong Police Marine division from 1976 until June 1997. During that time I found that our duties mirrored those of a coastguard rather than a conventional police force. Almost all of the duties I performed in those 21 years can be divided into three separate categories – search and rescue; immigration control; and anti-smuggling.

But it was between the years 1979 and 1989 that the Marine Police's search and rescue and immigration control capabilities were put to the test with the arrival at Hong Kong's southern sea boundary of almost 200,000 boat people from Vietnam.

*"The Old Lady of Tsim Sha Tsui". Located overlooking Victoria Harbour, Marine
Police Headquarters was one of the first structures built by the British on the
Kowloon peninsula in 1884. It was home to Hong Kong's Water Police until 1996.*

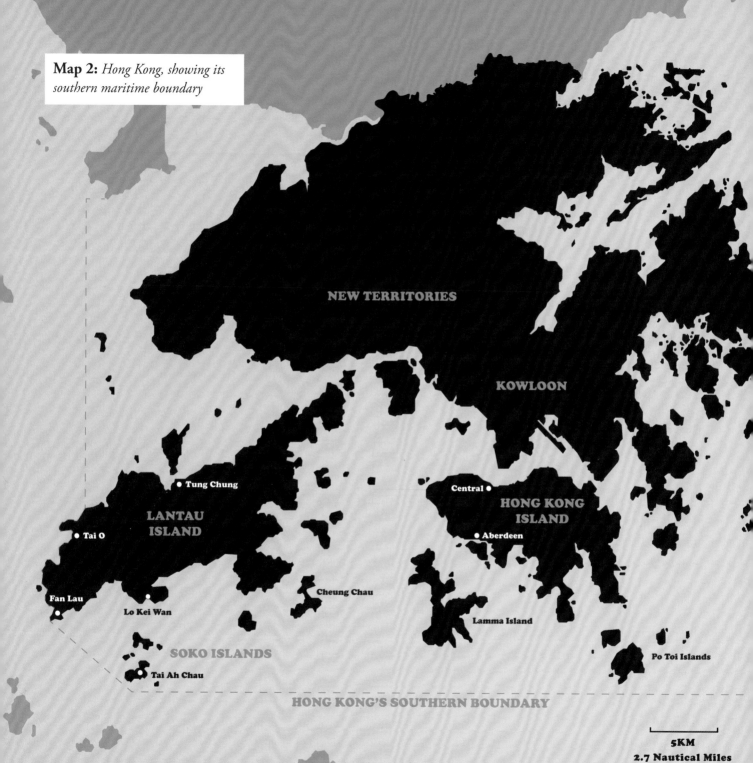

**Map 2:** *Hong Kong, showing its southern maritime boundary*

NEW TERRITORIES

KOWLOON

● Tung Chung

LANTAU
ISLAND

● Tai O

● Central

HONG KONG
ISLAND

● Aberdeen

Fan Lau
○

Lo Kei Wan
○

Cheung Chau

Lamma Island

SOKO ISLANDS

Po Toi Islands

○ Tai Ah Chau

HONG KONG'S SOUTHERN BOUNDARY

5KM
2.7 Nautical Miles

# Chapter One

# The Beginning

When it eventually came, the Communist victory in South Vietnam was no surprise to anyone. Indeed, many had seen it as inevitable from the moment the United States withdrew most of its physical support from the tottering regime in power. Since the early 1970s, there had been a steady flow into Hong Kong of Vietnamese-Chinese who had fled their country fearing the worst. But despite the incredible scenes of panic at the final collapse, no-one envisaged the sheer scale of the problems ahead. The first of these arrived in Hong Kong on May 4, 1975, in the form of 3,743 Vietnamese refugees who had been taken aboard the Danish ship *Clara Maersk* from a tiny steamer *Truong Xuam* in which they had escaped from Saigon.

This was the sort of emergency that Hong Kong has always been good at, and this first group was swiftly and efficiently landed, medically examined, clothed, fed and documented. They were then housed in four temporary camps while homes around the world could be found for them. Everyone heaved a sigh of relief: it could have been much worse.

### A box of plasters and a packet of aspirin

As a young Marine Police officer, my introduction to the "Vietnamese problem", as it was being referred to in 1977, was a steady one. 1977 and the first half of 1978 saw just 1,200 refugees arrive from Vietnam, all in small wooden boats. My own recollections of that time are of patrolling Hong Kong's southern sea boundary on the lookout for incoming Vietnamese vessels, rescuing people off the ones that were sinking, or pumping water out of the ones we thought we could save. We would offer First Aid to the refugees from my police launch's tiny First Aid box – which, in those days, contained no more than a box of plasters, a bottle of iodine and a packet of aspirin. This trickle of small vessels into Hong Kong was not seen as much of a problem for the Marine Police. These few refugee boats were not more than a minor distraction.

Towards the end of 1978, I was transferred from launch-going duties to Tai O Police Station, where I became the inspector responsible for the western half of Lantau Island. Tai O is situated on the westernmost tip of Lantau. The police station, built as an anti-piracy station in 1902, sits high on a hill overlooking the Pearl River Estuary. From my quarters on the upper floor of the station I had an uninterrupted view of both the Pearl River and the Portuguese colony of

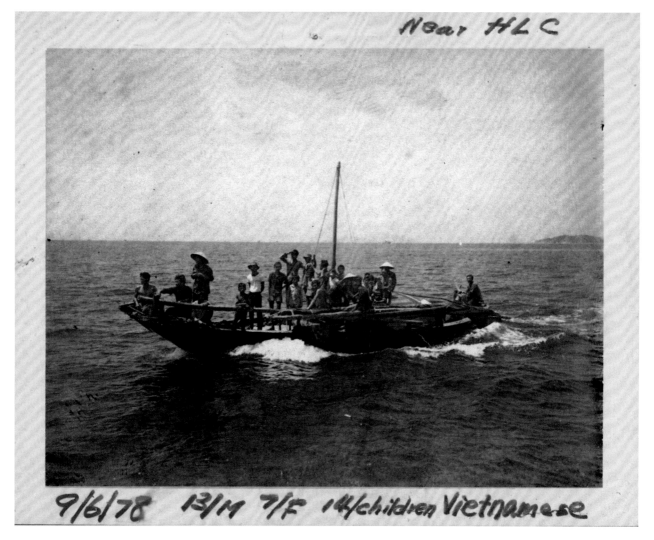

*Near HLC*

*9/6/78 13/M 7/F 14/children Vietnamese*

*This would have been one of the first Vietnamese refugee vessels I witnessed, as it was intercepted off the island of Hei Ling Chau, east of Lantau Island on 9 June 1978. Later on I used my own camera to provide a record of what would eventually be any number of boats, both large and small, that I would see over the next years. But here, I used the police launch Polaroid camera. Those readers over 45 or so will remember the Polaroid as a chunky affair; you pressed a large button to take a photo and then there was a whirring sound as the ready-made print came out of a slot on the side of this plastic machine. Then there would be that mysterious "darkroom" moment as the final picture developed in front of your eyes. Each police launch had one on board for evidence-recording purposes. This usually would be used to photograph things such as smuggled goods, but I used the one on my launch to take photos of Vietnamese vessels. I recall that this one had already travelled 12 miles inside Hong Kong waters before we stopped it, an indication that arrivals in the first half of 1978 were few and far between and we were not as alert to Vietnamese vessels entering Hong Kong waters as in the following year. There were 34 people on board.*

Macau in the west, and the South China Sea to the south.

My immediate predecessor as inspector was Ross Mitchell who recalls an incident a year earlier in 1977:

Nothing much happened in Tai O in 1977. We did catch the occasional illegal immigrant from China, but even that was a rarity. Recently I'd been reading in the newspapers about Vietnamese refugees that were beginning to arrive in Hong Kong in small boats. I read that these arrivals were few and far between, and not considered a problem for Hong Kong. They certainly were not a problem for our sleepy outpost.

One evening, I was walking back to the police station through Tai O village when I was met by one of my constables hurrying towards me. "We have some illegal immigrants back at the station," said the excited PC. This was a big deal for our remote location. I was quite pleased that my guys had actually caught someone. That is until the PC added, "and they don't speak any Chinese."

"Don't speak Chinese?" I mused. "What on earth is he talking about? That doesn't sound right." I hurried my pace.

Back at the police station compound I was confronted by a middle-aged man dressed in well-worn clothes. The man smiled and introduced himself, speaking in English. At first I had difficulty catching the heavily accented words.

"We have come from Vietnam," explained the man, now pointing towards the small wooden boat tied up alongside Tai O pier. "There are 20 of us."

*What was the Tai O Police Station is now a boutique hotel. I had the whole top floor as an inspector there in the late 1970s for my accommodation, with the report room and the cells on the ground floor, and a resident black dog called Ratbag. It was built as an anti-piracy station in 1902 and a predecessor of mine was shot and murdered there by one of his subordinates in 1918. It sits on a hill on the westernmost point of Lantau Island overlooking the Pearl River Estuary.*

Seeing this man standing in front of me now, and looking at the boatload of people at the pier, I was taken by surprise. I had never seen a Vietnamese vessel before, let alone one full of refugees. "What made you come here?" I asked. "What made you come to Tai O?"

"That," said the man, pointing up at the British flag flying above the police station. "When we saw that flag, we knew we were safe."

So that was Ross Mitchell's first experience. In 1977, Marine Police Inspector Bill Bailey and myself were studying for our

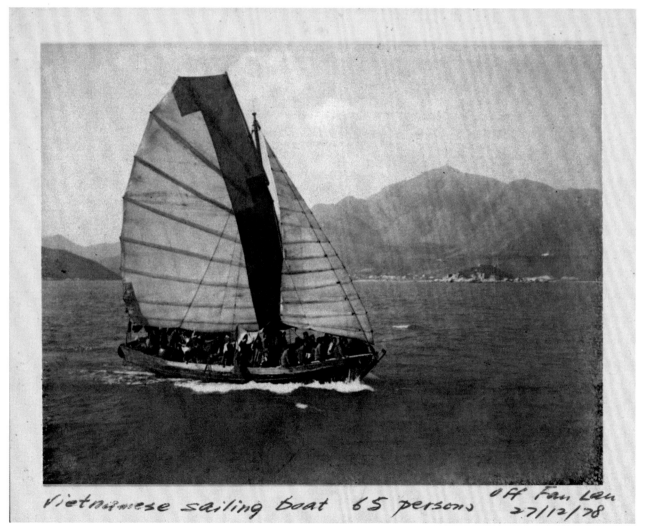

*Vietnamese sailing boat 65 persons*    *Off Fan Lau 27/12/78*

*I photographed this small sailing vessel on a blustery day in December 1978. The vessel makes good speed as it enters Hong Kong waters off Fan Lau. There were 65 people crammed aboard.*

Marine Department navigation examinations, but we still had to perform our seagoing duties to get our hours in. Bailey was on board Police Launch 1 one morning in September of that year.

At around 05:30, we were notified by radio from the Marine Control Centre that a group of some dishevelled-looking people had been seen in Stanley Village. The report stated there had also been a boat spotted on the beach nearby. Our first thoughts were that they must be illegal immigrants from China so I assembled a shore party, lowered a small boat and headed for Stanley. Almost at once we started finding Vietnamese people wandering around the town looking for food. In the early morning light, as we walked along Stanley Main Street and up Market Street, we came across Vietnamese coming in the opposite direction. They were not trying to escape, they were just hungry and exhausted. Over the next hour we gathered them all up, about 20 in all. We also located their small wooden boat, beached at one end of Stanley Bay.

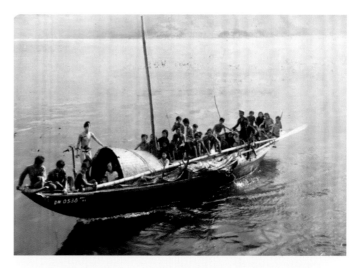

*From time to time my launch would be directed by my sector commander to escort several recently intercepted vessels from the southern boundary to the Government Dockyard for further processing. As this escort duty took a police launch off picket patrol for several hours it made sense to wait until we had quite a few newly arrived vessels and then escort the whole lot in one go. So this is sometime in 1978, when you can see here one of five vessels that we're escorting in. During these escort duties I always put one of my officers on board each Vietnamese vessel to ensure nothing untoward happened during the trip. "Follow me" is a pretty simple order to follow. However, once the refugees got their first sight of the Hong Kong skyline it became a difficult job to keep them all going in the same direction.*

So, in those early years of my Marine Police career here, the arrival of Vietnamese vessels into Hong Kong was something of a rarity. The big-ship, people-smuggling rackets were still to come, and the deluge of small vessels that was to hit the colony in 1979 could not yet be imagined. We all knew about the end of the war in Vietnam, and we all knew that some people had left their country by boat, and that some of them had made it as far as Hong Kong, but most of us in the Marine Police were yet to see a vessel originating from Vietnam. However, a rescue I was involved in the year before I went to Tai O brought home to me the enormous risks that were being taken to get here.

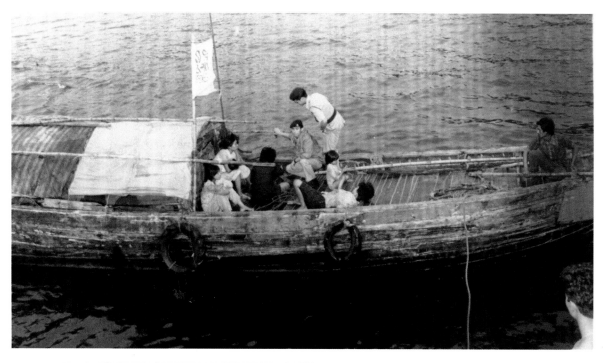

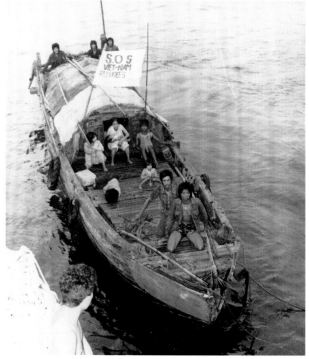

*This group had rigged up an SOS sign on a piece of sailcloth as their motorised wooden vessel chugged its way across 1,000 miles of South China Sea. Police Launch 56 intercepted it off the Soko Islands in 1979. Looking at the clapped-out old engine some minutes after I took these photographs, I was surprised that the vessel actually made it to Hong Kong. Parts of the engine had fallen off during the journey and been resecured with bits of wire and rope. They had also tried to repair part of the damaged bow en route. On board this vessel were 12 people: seven men, two women and three children, including a babe in arms. One of the children, a young boy, was quite sick. Two Marine Police officers transferred on to the vessel to check the medical condition of the group and one can be seen talking to the mother of the sick boy.*

## Would you like a cup of tea, by any chance?

In September, 1977, I was serving on Police Launch 1 (PL 1) and operating out of the Marine Police base inside Aberdeen typhoon shelter. I was one of two junior inspectors working on the 'A Crew'. Those working on PL 1 at that time were divided into two crews, A Crew and B Crew. Each of these two crews worked three days on, three days off, rotating with the other crew. The A Crew, my crew, were commanded by Chief Inspector Alan Cheung. Alan was in his late 40s and had more than 20 years' experience in the Marine Police, joining as a constable in 1956. He had risen through the ranks and was now one of the most highly respected mariners in the Force. Together with us on the A Crew was another junior inspector, Laurence Knox. Laurence had joined Marine the year before me, so he was the "senior junior". Working for us on the A Crew were 24 Marine sergeants and constables, all of whom had far more years' experience at sea than myself or Laurence.

It was the morning of 22 September as we returned to our base in Aberdeen after completing three days at sea. It had been a rough trip. The seas to the south and east were being affected by an approaching tropical storm that had, the day before, crossed the Philippine island of Luzon and was now heading northwest in the direction of Hong Kong. The last thing we had done that morning on board PL 1, before returning to our base, was to do a final run along the southern boundary to see if there were any vessels in distress. We found the seas that morning quite rough and completely devoid of craft. This did not come as a surprise as local fishermen watched the weather very carefully and would head for a secluded mooring as soon as news of an approaching storm was received. After handing over PL 1 to the B Crew officers, I packed up my gear and headed off home to get some rest.

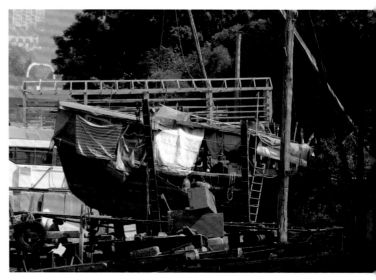

*A sampan undergoes a bit of repair at a dry dock in Aberdeen Harbour. The Marine South base is still stationed there as I would be when I later became the Marine commander overseeing the southern boundary. And it was from here that Laurence Knox and I aboard PL 1 headed out to Sung Kong.*

For the next three days, Hong Kong was hit by Severe Tropical Storm Freda, with wind speeds in excess of 100kph. On the morning of 25 September, I reported back for duty in Aberdeen. I found PL 1 alongside the pier already refuelled and ready for our next three-day patrol. Before that could happen it was the duty of the officers of the B Crew to hand over the launch to Alan, Laurence and myself in PL 1's officers' mess.

"It's been very quiet out there," began Tony Sirett, the chief inspector who commanded PL 1's B Crew, "but we

have had one problem that we haven't been able to resolve, but you guys might, now that the seas are beginning to subside."

"What's this about?" asked Alan, leaning forward across the chart table. Sirett turned the Admiralty chart around and jabbed a finger at the island of Sung Kong.

"Here," he began, pointing at the small island just east of the Po Toi group. "Two days ago the master of a fishing vessel making its way back into Aberdeen reported seeing a small boat in difficulty to the south of here. He told us that he changed course towards the boat but lost sight of it in the heavy seas. We went out and circumnavigated these islands, but we couldn't see anything. If there was a boat it had either sunk or the fisherman was mistaken." He looked up at Alan. "But once the seas calm down a bit, it might be a good idea if you go back out there and take another look."

Once PL 1 was ready to sail we set off for Sung Kong. Up in the wheelhouse Laurence and I pored over a chart of the waters to the south of Hong Kong, paying close attention to Sung Kong. "Rocky coastline, all the way around, no landing points," said Laurence. "Seas coming in from the south too," I said. "We are going to be lucky to find a small wooden boat out there after the recent storm."

The 15 miles from Aberdeen out to the east of Po Toi would usually take about one hour in calmer waters, but with huge rolling waves coming straight at us from the southeast the trip took far longer. As PL 1 was hit directly on the bows by a wave almost as tall as the launch herself, PL 1 responded by pitching forward, bows down, into the surf. Anything not tied down in the wheelhouse took flight. A metal waste bin in the radio cubicle at the rear of the wheelhouse came shooting out like a bullet and clattered into the rear of the chart table.

PL 1 was a big vessel, 111 feet long. Being tossed around the ocean in a launch of that size reminded us all just how powerful Mother Nature can be when she feels like it.

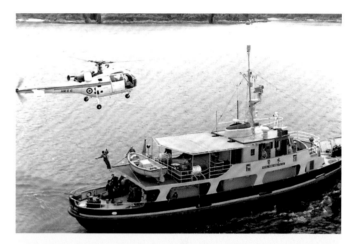

*Search and rescue (SAR) of people and vessels at sea was the main duty of the Marine Police during the Vietnamese years. On Police Launch 1, being the command platform for co-ordinating these operations, we practised every facet of SAR – working with other agencies such as the Royal Navy, British Army, Royal Air Force and the Royal Hong Kong Auxiliary Air Force (RHKAAF). Here, the crewman from a RHKAAF helicopter winches down on to the stern deck of PL 1, a frequent requirement when collecting a critically injured rescued person in urgent need of hospital treatment. Unfortunately, on that day in September 1977, the use of a helicopter was not an option due to winds from the severe tropical storm. Our dory, the small light blue boat on the upper stern deck of PL 1, is in her usual position, ready for action.*

An hour or so later, as we rounded the northern point of Beaufort Island, I picked up a set of binoculars and trained them on Sung Kong Island. It looked desolate. Sung Kong

is a small 0.25-square-mile rocky island, situated midpoint between Po Toi and Waglan Islands. The island's rugged coastline rises out of the sea almost vertically on all sides for 50 feet before levelling off on the foliage-covered top.

Alan Cheung took PL 1 around the north of the island, going in as close as a few hundred feet. With the sea still throwing PL 1 around, surging, pitching and rolling, he didn't want to risk going in any closer in case we suddenly got into difficulty ourselves.

"Look for debris, look for people, bodies. Look for any evidence of a boat or of life," shouted Alan as he and the coxswain remained focused on navigating PL 1 around Sung Kong. Knox and I responded by scanning the base of the island through our binoculars. As PL 1 rounded the southernmost point, Laurence shouted: "There, there they are, up there, two, three of them, I saw them in the bushes."

I trained my binoculars on where he was pointing. Trees and bushes, thick undergrowth on the highest peak on the island, all being blown in every direction by fearfully strong winds. "They were there, at least three, they ducked back down, in those bushes on the top," said Laurence.

"You sure?" asked Alan, who was still paying attention to PL 1's position in relation to the rocky coastline.

"Yes, sir. A man, red shirt, another person, grey shirt. Possibly one more. They moved too quickly for me to see more."

"Look for a boat," ordered Alan. "If there is anything it will probably be wreckage. Not much of a chance now though. If they lost their boat, it would have been washed away. I'll circumnavigate the island once more, so keep your eyes on the coast as we go."

I began to imagine who these people could be. "Two days ago," Tony Sirett had said. What condition would they be in now after being exposed to the storm? "Illegal immigrants?" I asked. Laurence shrugged. "This far south? Unlikely."

We continued to scan the sea for any wreckage, but there was nothing.

"OK, gather around." It was Alan. He had handed over the navigation of PL 1 to Station Sergeant Chan and was now paying close attention to the open chart. He pointed at Sung Kong. "If a small boat was coming in from the south, as Tony had said this morning," began Alan, "it could be Vietnamese. I can think of no other scenario. No Hong Kong fisherman would have been this far out knowing a storm was imminent." He looked up at us. "If I am correct, and they are Vietnamese, they will have been in poor condition before the storm. If their boat got tossed against those rocks and smashed, they might well be injured. Probably they are." Alan looked back out at the ocean. "And if they have been on that island for two days, they will be suffering from hypothermia for sure."

Alan went into the radio cubicle and picked up the microphone. It was time to summon assistance. A couple of minutes later he was back. "No helicopter movements today, I'm afraid. Still too dangerous to fly. Earliest we can get a chopper up is tomorrow. We need a plan."

To get nearer to Sung Kong in calm seas was impossible. A major patrol launch the size of PL 1 can't get within a couple of hundred yards of a rocky coast. In rough weather, like today, it would be madness to try.

"What about the dory?" I asked.

PL 1's tender, a small boat that sat on the upper stern

deck, was known as "the dory". It was a fibreglass craft, about 15 feet long. Painted light blue, it was powered by a small inboard engine that gave it a speed of 10 knots. It also came with two fairly long oars for use as and when the engine failed to work, which it sometimes did. The greatest number of people I ever saw in the dory was ten, but I'm sure it wasn't designed to carry that many. To me it always felt a bit unstable, and it rolled violently when anyone stood up.

Alan looked at me. "Going in towards the island in the dory on this swell might be okay. But stopping the dory getting smashed against those rocks would be a challenge. Then, how does anyone get out of the dory and on to the rocks? Look at those waves!"

Laurence had an opinion too. "Then we would need to climb 50 feet up that cliff face. The people up there might be injured or weak, or both. How do we get them back down? How do we get them into the dory, which might well be smashed up on the rocks itself or capsized?"

"Well," said Alan, "we need to give it a go." He walked off towards the stern and the dory.

"You willing to have a go?" Laurence asked, looking at me.

"If we use rope, set up a line, secure PL 1 to the dory. Two men in life jackets in the dory. We could get close in and see what our options are once there. If we get into trouble a hauling party could pull the dory back to PL 1," I replied, making things up as I spoke.

"You and me?" said Laurence.

I nodded. "I'm up for it if you are. Let's put it to Alan."

After Alan had thought things through it was decided

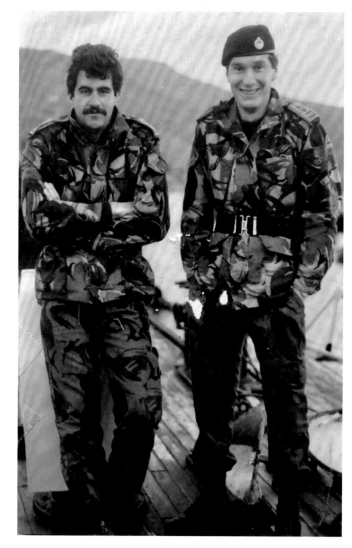

*My former Marine Police colleague Laurence Knox, right, and I. This shot was taken in 1980, a few years after the rescue at Sung Kong. Laurence and I served together in Marine for many years afterwards, although he was aide-de-camp to Governor David Wilson for a number of years in the late 1980s before we both left the Force in 1997 to explore other opportunities.*

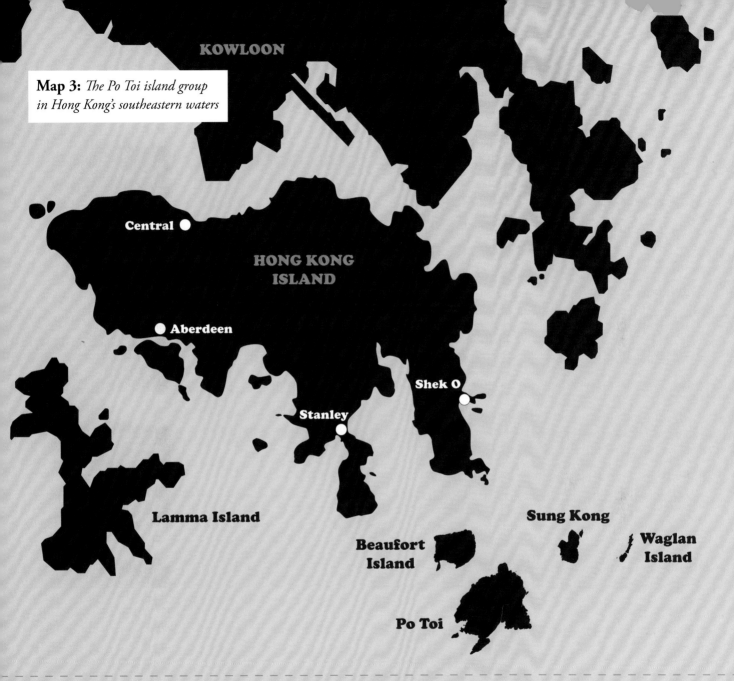

**Map 3:** *The Po Toi island group in Hong Kong's southeastern waters*

KOWLOON

Central

HONG KONG ISLAND

Aberdeen

Shek O

Stanley

Lamma Island

Sung Kong

Beaufort Island

Waglan Island

Po Toi

HONG KONG'S SOUTHERN BOUNDARY

2KM

1.08 Nautical Miles

that as it was my idea, I would be one of the two-man dory crew. But, as Alan had pointed out, we also needed an engineer in the dory in case there was an issue with the engine. "I'll put the oars in too," I said, walking off to get ready.

After the dory was lowered, I climbed down the ladder that had been lowered over the side. As I looked down, the dory rose and lowered on the swell beneath me. I looked up at the grinning Laurence. "Watch yer step and don't get wet," he smiled. I tried to get a foothold in the moving dory beneath me while battling to keep upright and avoiding taking a header overboard. A young engineer constable named Kong followed me down the ladder and I helped him climb into the dory. I knew this young guy was a good swimmer, which gave me some confidence.

Kong and I were both wearing the old-style life jackets. They were orange vests with two large pockets at the front and two at the back. In each pocket was stuffed a large block of polystyrene. The jackets were very clumsy and made movement quite difficult. Under them we were dressed in white Marine Police T-shirts and blue "engineer's" shorts. On our feet we wore the Marine-issue white Plimsolls. It was important not to be weighed down with heavy clothes. Trying to swim or stay afloat when wearing uniform is not much fun.

Kong started the dory and we chugged away from the side of PL 1. As we did so a sergeant on the stern deck of PL 1 let out the rope that had been secured to a fixed point inside our little boat. If the engine failed and we couldn't row back, they would just pull us back. Well, that was my idea.

As we got closer to the rocks the enormity of our task became more apparent. The sharp rock edges covered in slippery weed appeared and disappeared as the heavy swell washed over them. I began to have doubts. "Let's try further round this way," I shouted over to Kong. He moved the tiller, and we chugged a bit further along the coast. Our dory seemed helpless in this sea, our small engine having little effect against the movement of the ocean.

There was a split in the rocks. A crevice where the rock fractured, leaving a gap big enough for the dory to get in. The sea rushed into this gap, and then came pouring out again. It looked dangerous but I could see no other option. It was either this or turn back. I looked at Kong and pointed to the crevice. He didn't seem so sure. The gap was big enough to get the dory in, but with the sea throwing us around as it was, we could end up being smashed against the rocks. I turned and looked out to sea. There seemed to be phases of calm when the sea went flat, each lasting about 30 seconds. This was immediately followed by several very large waves. I figured if we waited for a flat phase, we could get in and maybe get some protection from one side of the crevice to keep us from getting smashed to bits or turned upside down by the following rolling surf.

We grabbed our chance, went in, took cover, and then got soaked by the following sea, which hit the backs of our heads like the punch of a heavyweight boxer. Shaking that off, I jumped out of the dory, taking one end of the rope with me. As I did, I slipped on the wet rocks and immediately fell back into the dory. I got up and tried again, this time managing to scramble a few feet up the rocks.

After tying up the dory as best I could, I helped Kong out, and we began to make our way around the edge of the

*PL 1 had tens of metres of rope for different purposes.*
*The one required on our rescue day at Sung Kong was*
*a good 150 yards long.*

crevice and up the side of the rock face. I was aware that the guys back on PL 1 would be watching the events through binoculars and I just hoped that that rope connection from the dory to PL 1 was still in place. I didn't fancy trying to row the dory back in that sea.

Over the next 15 minutes the two of us scrambled up the side of Sung Kong island until we were well into the thick foliage on the top. The wind was ferocious and even though we could now stand upright we both remained crouched in a ditch full of brambles. "We need to find them, have a look around," I shouted above the noise of the wind.

Doing more of a crawl than a walk we began to search through heavy foliage. The top of Sung Kong is uneven and it's not possible to see the whole island from any one specific place. So, it was a matter of walking around in the bushes until we found whoever it was Laurence had seen earlier. It took some time but eventually, out of the corner of my eye, I caught a glimpse of red. "They're over there," I called out and we both made for the clump of bushes to our right.

They were just sitting there, in a hole, two young men and a young woman, all in their twenties. All three looked exhausted. One of the men was barely conscious. He lay on his back and the young woman was cradling his head in her lap.

"What are you doing here?" asked Kong in Cantonese. The man sitting up shook his head, a blank stare. "You speak Cantonese?" I asked. Again, nothing. The man pointed out to sea. "Vietnam," he mumbled in English.

For the next hour we made our way down the side of Sung Kong towards where we had left the dory. Kong and I took it in turns to help the man who was obviously the weakest of the three. The man kept losing his footing, and it was all we could do not to fall down on to the rocks below. The other man and the woman helped each other, slowly descending behind us.

By the time we got back down to sea level I was surprised to find the dory in the same place we had left it and still in one piece. I could see it had taken a battering, but it was still there, and the rope was still attached. Now, the next problem was to get everyone back on to PL 1 safely.

Kong slid down the rocks above the boat on his backside.

He then made a grab for the rope and dragged the dory in towards himself as best he could. He turned to me and nodded. I began lowering the man who we had helped down. The man began to resist. He was afraid to go down close to sea level. It made me wonder what these three people had been through in order to get this far. The man was obviously terrified. Kong, realising the man was frozen in fear, climbed back up a few feet, grabbed the man by his shirt front and hauled him down that last bit. I began to help the other two to slide and scramble down.

With everyone now down at the bottom of the crevice we began to get these three people into the dory. Again, we waited for a lull in the sea conditions before doing this. I remained on the rocks holding the dory steady, while Kong manhandled the three Vietnamese into the dory.

Once all three were seated in the dory it was time to get out of there. "Start the engine," I shouted out to Kong, who began fiddling with the boat's starter motor. He made three attempts at turning the starter handle before the engine putt-putted into life. I took a look out to sea and at the state of the dory. The freeboard was dangerously low. The freeboard is the height of the top edge of a boat that can be seen above the surface of the water. The dory's freeboard was less than one foot. Once out of this crevice, and in the open sea, I began to imagine what could happen. If the dory capsized on our way back to PL 1, I felt sure that these three Vietnamese wouldn't make it.

"You go," I shouted to Kong. "Go, I'll stay here, there's too many of us. If I get in, we will be too heavy, we might capsize. As you are now, you should make it. Go now." I pointed back at PL 1, which was standing off about 200

yards. Kong didn't hesitate. There was some calm water, and he needed to get as close to PL 1 as he could before the following heavy swell hit the dory. I sat on the rock and watched them go, fingers crossed. I could see lots of activity on the stern deck of PL 1. They had obviously figured out that the dory was making a run for it, and that it had passengers who were not wearing lifesaving gear.

A grappling net was lowered over the side of PL 1 and members of the crew carrying orange life rings began to appear. PL 1 moved forward a little too, reducing the dory's task. I figured that Alan Cheung was at the helm.

The dory made it to PL 1, but as the small boat tried to go alongside it was buffeted by a large wave. There was an enormous crash, which I heard from where I was sitting. There was frantic activity down the side of PL 1 as crew members scrambled down to help those in the dory. Another large wave slammed the little boat into the side of PL 1 once more. Gradually everyone either climbed or was carried up on to PL 1's stern deck.

I remained where I was, waiting for an indication from PL 1 as to what was going to happen as far as getting me back on board. To my surprise the crew on the stern began winching the dory up out of the water and on to the launch's stern deck. "It's damaged," I thought to myself. That buffeting against the side of PL 1 I'd just witnessed had, no doubt, seriously damaged the dory. Now, we had no small boat capability.

I began looking around the rock formation I was sitting inside. The rope out to PL 1 was still secured to a rock just below me. Since PL 1 had moved position slightly nearer to where I was, the rope currently lay slack in the water. I could

see no alternative. I'd have to swim for it.

I stood up and began waving my arms above my head. The officers on the stern deck of PL 1 stopped what they were doing, stood up and looked back at me. I couldn't see Alan, but I could see Laurence. PL 1 was about 150 yards away, I had the line connecting to the police launch, and I had the life vest. The sea was still very rough but there were short periods of slack water. I also figured that Laurence would get the picture pretty quickly, and form a hauling party at his end of the rope that would, hopefully, not get too excited and pull me under.

I grabbed my end of the rope, waited for the next lull in the sea state and jumped in. I'd forgotten how useless the life vests were. The one I was wearing provided almost no buoyancy whatsoever, while at the same time seriously restricting my movements. Holding on to the rope with one hand I undid the ties to my life vest and pulled it off.

I then began pulling myself as quickly as I could along the rope toward PL 1. I could feel myself being dragged as I went. The crew on the stern deck had got the idea and were reducing the distance between them and me by hauling me in, just as I was pulling myself towards them, too.

I hit the side of PL 1 quite hard, mostly due to my colleagues' enthusiastic attempts to drag me to safety. A ladder had been lowered and I was up it faster than I'd ever climbed up a ladder before.

The three Vietnamese were by this time receiving treatment below decks. "How are they?" I asked Laurence.

"They're all suffering from hypothermia," he said. "They're dehydrated and haven't eaten in days. The one man keeps falling in and out of consciousness. Now you are back on board we are off back to base. An ambulance has been arranged."

"Where's Alan?"

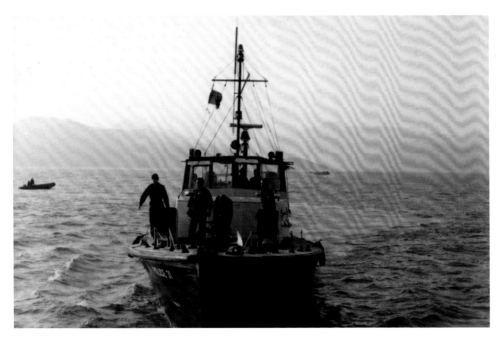

*Taken a year or so after the rescue, my colleague Laurence Knox can be seen here on the left on board PL 31, which was a smaller launch than PL 1. On that day at Sung Kong, Alan called up two similar launches as support, but they arrived after we had completed the rescue.*

"He's up top, driving. He's already reported the rescue to Marine Control. Would you like a cup of tea, by any chance?"

I later discovered that the three Vietnamese people we had found on Sung Kong were originally a group of six. They had taken three weeks to sail across the South China Sea from a port in southern Vietnam in a small sailing vessel. They made good progress until Severe Tropical Storm Freda began affecting the seas to the south of Hong Kong. They made it to a point to the south of Sung Kong, which is where the Hong Kong fishing vessel had seen them. Their vessel capsized in the heavy seas and these three were washed up on the rocks somewhere close to where we had moored the dory. They had then climbed to the top of the island and basically passed out with fatigue. They had been on the island for two days sheltering from the storm. They had no idea where they were.

I also later found out that the man who Kong and I carried down from the top of the island didn't survive. He died in hospital the following day. The other two recovered and were granted refugee status.

So that was the situation in 1977-78: an occasional group of Vietnamese coming in, but things were generally fairly quiet. Then, towards the end of 1978, life for those on the frontline changed forever.

# Chapter Two

# The Big Ship Era

Disturbing stories were beginning to come out of Vietnam to the effect that the government there was deliberately driving all ethnic Chinese out of the country as a matter of policy. Vietnamese Chinese were already suffering the kind of harassment that is traditional in racially inspired government policies: dismissal from jobs, confiscation of businesses and property and the like. Now they were being threatened with forced employment as labourers in new "economic zones"… unless they had gold or hard cash to buy "permission to leave". Even achieving this was but the beginning of their tribulations; for having bought the necessary permission they still had to actually get somewhere.

The *Clara Maersk*, by rescuing the people from the sinking *Truong Xuam*, was obeying the traditional custom of the sea. But there were other ships whose actions had nothing to do with humanitarian aid. For these ships were part of the cynical – and very lucrative – scheme of people smuggling, as we discovered on 20 December 1978, when, with one radio message, everything in Hong Kong changed.

```
HARBARMASTER
HONGKONG

AAA ON ABOUT 16PM OF THE 17TH DECEMBER M/V HUEYFONG ON VIETNAM OUTER
SEA FOUND SOME FISHING BOATS FULL OF THE VIETNAMESE REFUGEES THESE
BOATS WERE GETTING WRACK AND BEING SUNK UNDER HIGH SEA CONDITION THE
SITUATION WAS SO DANGEROUS THAT WE HAD TO RESCUE THEM

BBB THERE WERE ABOUT MORE THAN 2000 VIETNAMESE REFUGEES INCLUDING YOUNG
AND OLD ONES

CCC OUR SHIP IS SCARCE OF WATER FOOD AND MEDECINE ASKING THE PERMISSION
OF HONGKONG GOVERNMENT LET US SAIL TO HONGKONG REPLY URGENTLY PLEASE

MASTER
```

*The original radio message, sent from the master of the* Huey Fong *to the Harbour Master, Marine Department, Hong Kong as the ship crossed the South China Sea. Within a matter of hours Hong Kong authorities discovered the truth and refused the ship permission to enter Hong Kong territorial waters.*

## The *Huey Fong*

The call, to Hong Kong's Marine Department control room, was from the Taiwanese master of a 4,187-tonne Panamanian-registered freighter, the *Huey Fong*. The master, Shu Wen-shin, claimed that, just like the *Clara Maersk*, his ship had rescued more than 3,000 Vietnamese refugees from sinking boats in the South China Sea and he requested permission to dock in Hong Kong. But a swift investigation into the movements of the ship concluded the captain's story was phoney. And, as the *Huey Fong*'s next scheduled port of call was Kaohsiung in Taiwan, the Marine Department's response was to point out the international maritime agreement stating that shipwrecked survivors rescued by ocean-going vessels should land at the ship's next scheduled port of call, and that he should continue on to Kaohsiung and not enter Hong Kong territorial waters.

Shu didn't reply to that message, whilst a second message was also met with radio silence. The Marine Police, together with the Royal Navy, were alerted and four days later the *Huey Fong* was intercepted by a flotilla of patrol craft just outside Hong Kong waters, south of Po Toi Island, where she was forced to stop and drop anchor.

*John Turner, the Marine Police deputy commander, was one of the first officers to arrive at the* Huey Fong *in December 1978 on Hong Kong's southern sea boundary*

In that flotilla was then-Chief Superintendent John Turner, who was my boss at the time and the deputy commander of the Marine Police.

It was the Saturday before Christmas. After being told that the ship's estimated time of arrival at the colony sea boundary was a matter of hours away, I commandeered one of our patrol launches and headed off towards Po Toi. As we went I received a direct order from the operations room at Police Headquarters to stop the ship and not allow it to enter Hong Kong waters. This we did just south of Po Toi, on the colony boundary.

Having boarded the vessel we first secured the bridge. I briefly questioned the master through an interpreter – a refugee passenger who turned out to be an ex-military man who spoke excellent English. The Taiwanese captain claimed to have been at sea for more than two weeks and had rescued over 3,000 refugees from sinking boats in the South China Sea. While this seemed highly unlikely, my main concern was the plight of these refugees. The conditions on board this ship were awful. Upon opening the hatches the stench was terrible. Women and children, obviously very sick. And there was a complete lack of medical facilities.

We spent several hours organising the evacuation of the sick from the ship. But then came the directive that no one was to leave the ship and it must proceed to its next designated port of call, Kaohsiung. It was a difficult situation. As we stood on the deck of this

rusting hulk it was obvious to us that the sick required urgent medical attention, which was not possible here on the ship. Some needed hospitalisation. Yet my orders were to turn them away.

Finally, I believe word of the condition of these people reached the higher echelons of government and a message was received that the sick would be evacuated for medical treatment ashore. There then followed a procession of helicopters, Police launches, Royal Navy and Marine Department vessels. Doctors and nurses arrived to treat those who could be treated on board.

Via our self-appointed interpreter I spoke to some of the Vietnamese. Their stories about their journey were confused, they didn't ring true, and didn't make much sense. Someone had obviously contrived to get everyone to tell the same tale of a rescue on the high seas by a brave Taiwanese skipper, but the stories were different. They were making a mess of their performance. I felt sure it was all made up and I didn't think it would take much further questioning to find out the truth. One story I did believe, however, was told by an old man who came forward to tell us that several people on the ship had died during the journey and that the bodies had been thrown over the side.

As we stood on the crowded deck of the battered freighter the *Huey Fong*, listening to this tragic story, little did we realise at the time – this was just the beginning.

This left Hong Kong facing an international backlash for not allowing the refugees to land. Hong Kong was accused of causing prolonged suffering, even though the colony had shown leniency towards Vietnamese refugees since 1975, while certain other Southeast Asian countries had flatly refused passage, with some simply guiding ramshackle refugee vessels back out to sea.

## Stalemate

While the Government deliberated over what to do with the *Huey Fong*'s crew of traffickers and her 3,318 refugee passengers, the Marine Police were tasked with keeping watch on the ship and with ensuring those on board were provided with medical aid and food supplies. Police Launch 1, which was stationed alongside the *Huey Fong*, acted as a floating command post. Understandably, the medical team that were on board the police launch were kept busy around the clock.

A few days after the interception in Po Toi, on Christmas Day, 1978, Marine Police Inspector Mark Ogden was at home with his wife preparing lunch when the phone rang…

I was ordered to return for duty immediately, as there was a situation developing with the recently arrived refugee ship anchored south of Po Toi Island. I headed for our base in Aberdeen, where I found PL 1 about to cast off. I grabbed my gear from a locker and just made it as the launch left the dock.

PL 1, together with one of the Royal Navy patrol ships, HMS *Yarnton*, had been keeping station on the *Huey Fong* since the ship arrived. As we arrived

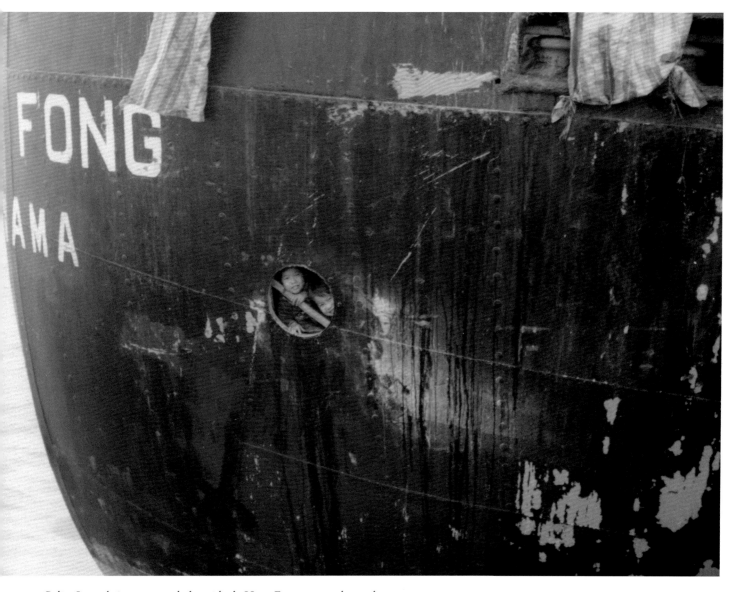

*Police Launch 1 was moored alongside the* Huey Fong *out on the southern boundary for 29 days while the Government deliberated on what to do with the refugees on board. During that time, as the two vessels sat side by side out at sea, some of the refugees and the crew of PL 1 became quite friendly. This was not surprising as many of those on board the* Huey Fong *were ethnic Chinese from the south of Vietnam, whose first language was Cantonese. The children in particular were always keen to see what was going on aboard the police launch.*

off Po Toi Island there was a bit of a commotion on board the *Huey Fong*. Hundreds of Vietnamese men were hanging over the side of the ship shouting and screaming at a Zodiac inflatable boat that was about to go alongside a ladder that had been lowered from the main deck. I later discovered that the Vietnamese had just, at that moment, been informed that they would not be allowed to land in Hong Kong and that an investigation was underway into the captain's dubious story. I assumed that the Vietnamese were shouting at the Zodiac as it was carrying a number of senior Hong Kong Government people, plus the captain of HMS *Yarnton*.

Without any warning, dozens of the Vietnamese men began climbing down the ladder towards the Zodiac. So the Royal Navy coxswain of the Zodiac began to turn the boat around. As he did so one of the Vietnamese men made a jump for it, trying to land in the Zodiac. He missed, went straight into the sea and disappeared. For a few seconds everyone looked on in silence at where the man had gone under. Then he popped back up, about 100 metres further away from the ship. A very strong current had taken hold of him and he was being swept further out to sea. The man was thrashing his arms at the water in an attempt to keep his head above the surface. He kept going under and then appearing again. At the sight of this, the shouting and screaming from the *Huey Fong* reached fever pitch. The coxswain of the Zodiac was trying to turn around, but the inflatable was full of people and slow to respond.

By an incredible piece of luck, as the man was being swept further out to sea, he passed very close to where we were positioned on PL 1. He must have been caught up in a strong rip current and went shooting along the side of PL 1, more under the water than above it. As he went hurtling by, an orange life ring attached to a line came flying out from below where I was standing. One of the PL 1 officers on a lower deck had flung it out in hope more than anything else. Remarkably the ring actually hit the man, who then managed to thrust an arm through the ring. I ran down to the lower deck and joined the hauling party that was pulling the man in. It took four of us to drag him in, the current was that strong. As we pulled the man out of the sea and on to the deck of PL 1, the hundreds of Vietnamese on the *Huey Fong* stopped shouting and began to clap and cheer, waving their arms above their heads and jumping up and down with joy. The incident was all over in a matter of seconds. It was one of the most remarkable things I've ever seen.

The *Huey Fong* had a crew of nine Taiwanese nationals. Shu continued to claim that he had rescued the Vietnamese from a flotilla of small boats somewhere in the South China Sea, but an investigation had revealed that the ship had in fact left Bangkok in early December with only one registered passenger. The ship had then sailed to a location south of Vung Tau on the east coast of Vietnam. Sources reported that the ship had then been met by a Vietnamese government vessel and escorted to an anchorage in the Mekong Delta.

After paying for their passage in gold, the refugees were then allowed to board the ship. Most of the gold went to the Vietnamese officials, while the remainder was divided between the crew. As no proper search of the ship had yet been possible, it was not known if the crew's gold was still on board.

*A Vietnamese woman from the* Huey Fong *is assisted down the gangway steps by a Marine Police officer and another refugee, on her way to receive medical treatment at a hospital ashore. There were two qualified doctors among the Vietnamese passengers on board the* Huey Fong *and if a person was sick, they would assist them initially before recommending any further treatment.*

After the *Huey Fong* had been at anchor on Hong Kong's colony boundary for three weeks, I was ordered to join a team of senior Marine Police officers that was to visit the ship. Although I was now living and working out at the Marine Police station at Tai O on Lantau Island, the powers-that-be at Marine Police Headquarters were keen for as many senior officers as possible to get a look and a feel for this people-smuggling vessel. It was their belief that the *Huey Fong* was not going to be the last of these racketeering big ships trying to enter Hong Kong, and it was important that senior Marine officers familiarise themselves with this ship's appearance and the conditions in which it came.

It was a blustery morning when we arrived at the scene, on the colony boundary just south of Po Toi Island. It was early January, and the seas out east were, as usual for that time of year, unpredictable. The *Huey Fong* rolled on its anchor in the heavy swell as we approached. I watched from some distance as the ship's "minder", Police Launch 1, rolled alongside in unison. A Royal Navy patrol craft, one of the Hong Kong Squadron, stood just off, keeping a watchful eye. There was a bitterly cold wind that January morning and everyone on board our launch was wrapped up in Marine winter-rig, which included a heavy woollen sweater and a dark blue reefer jacket. I had the collar of my jacket turned up in a vain attempt to keep out the biting wind. We approached the two vessels and came alongside Police Launch 1.

The *Huey Fong* was a coastal freighter, built in the 1950s. She had seen better days. The black hull of the ship was pockmarked with large patches of rust. I knew that if the outside of a ship looked like this, then the deck, cargo-hold and general "below-deck" areas would be in a very poor condition indeed. At the centre of the ship was a single large red funnel, and forward of the funnel was the bridge tower. The whole ship looked filthy and ready for the scrapheap.

### The stench of the stale urine was unbearable

Once on board Police Launch 1, I went out on to the bridge wing and looked up at the *Huey Fong*. Hundreds of faces peered back down at me. Most were young, children and teenagers. The kids were curious; some smiled and waved, others shouted out in Vietnamese.

*The district superintendent, Geoff Cox, takes a look at what is going on aboard the* Huey Fong *from the upper deck of Police Launch 1. Behind him is the Vietnamese interpreter relaying a message over the police launch's P.A. system. This interpreter was one of the refugees from the* Huey Fong. *He made himself known very early on as a 'Mr Fixit' who was fluent in Vietnamese, Cantonese and English. In return for his interpreting services he was allowed to use the showers on PL 1 rather than the prefabricated bathrooms that had been erected on the pontoon.*

As I walked around the upper deck of the police launch a Royal Hong Kong Auxiliary Air Force helicopter arrived carrying a large cargo of goods secured in a net that dangled immediately below the main body of the helicopter, which now hovered noisily above the stern deck of the *Huey Fong*. Anything not fixed down on the deck got blown around the ship. Bits of cardboard, papers, even a hat went flying up and around, all caught up in the downdraught. As the crew of the helicopter began to winch down a pallet of goods on to the ship's deck, a couple of uniformed Marine Police officers came forward, running in a crouch, and unhooked the pallet from the winch. Once the straps were undone, one of them looked up and gave the pilot a wave. The helicopter turned and flew off in the direction of Hong Kong Island. I watched as a group of Vietnamese men came forward and helped carry the goods from the pallet and piled it up on the deck of the ship.

While all this was going on, a ladder was lowered over the side of the *Huey Fong* by a couple of Marine Police officers who were up on the ship's main deck. I, and the others from our group, began to climb up the side of the ship and over the balustrade. As I climbed up I could see that the main

deck was full of people. Some were standing, others sitting. All were watching our every move. Once on the ship, a group of about 30 men crowded around us. One or two said hello, most just stared at us, no doubt hoping something was about to happen. We found that while the Vietnamese were free to roam around the ship, the master and the crew were being kept below decks under guard in the ship's galley. Not surprisingly, most of the refugees were up here, on the main deck, where they could get some fresh air and a view of what was going on.

After discussions with the Marine Police officers on the *Huey Fong* our party was led to a stairwell that descended below decks. The steps down were dark and dingy, and I did my best to keep my hands free from touching the grimy looking walls. In every corridor, cabin and alcove we found people, young and old, sitting or lying down. Hundreds more were packed into the ship's filthy hold. Conditions were awful; the stench of stale urine was unbearable. Officers working on board wrapped handkerchiefs around their faces. Some of those working on the ship had requested gas masks, but had been refused. It really was that bad and I was concerned about the health of everyone on the ship. I was glad when our visit came to an end.

Then-Chief Inspector Paul Lai was involved with both the *Huey Fong* and later the *Skyluck* as Police Launch 1 stayed alongside both ships – in the case of the *Huey Fong*, for one month, and the *Skyluck*, five.

The *Huey Fong* would swing on its own anchor when the sea got rough, which it did quite frequently as it was wintertime. The refugees on board were always seasick. Many would vomit on the deck, unable to handle the irregular motion of the ship. The smell was overpowering. Even on board Police Launch 1, standing off, we could smell the vomit. The refugees were given Bak Fa Yau by the medical staff assisting them. They all would use this ointment, so much so that the whole ship smelled of a mixture of vomit and this ointment. To this day I still feel sick when I smell Bak Fa Yau.

Deliberation on what to do with the *Huey Fong* and its passengers and crew continued for a further week. The Government was concerned that allowing this ship to dock and refugees to disembark would set a precedent. With other Southeast Asian countries refusing entry, the colony would be seen as a soft touch, the go-to destination for people smugglers to off-load their cargos. It was developing into a tough situation for everyone.

Some suggested that the Government should just refuel the *Huey Fong* and escort it on its way to Kaohsiung, but a look at the ship and its passengers from close up and one could see that this option was too dangerous. The refugees were in poor condition; many wouldn't have survived another long sea journey.

And it was the conditions aboard the ship that eventually settled the matter. They were so bad that the Government felt they had no other option but to allow the refugees to land, which is what happened. The *Huey Fong* was first escorted to an anchorage off the small island of Kau Yi Chau in the West Lamma Channel and the refugees were ferried into the Government Dockyard in Yaumatei where medical

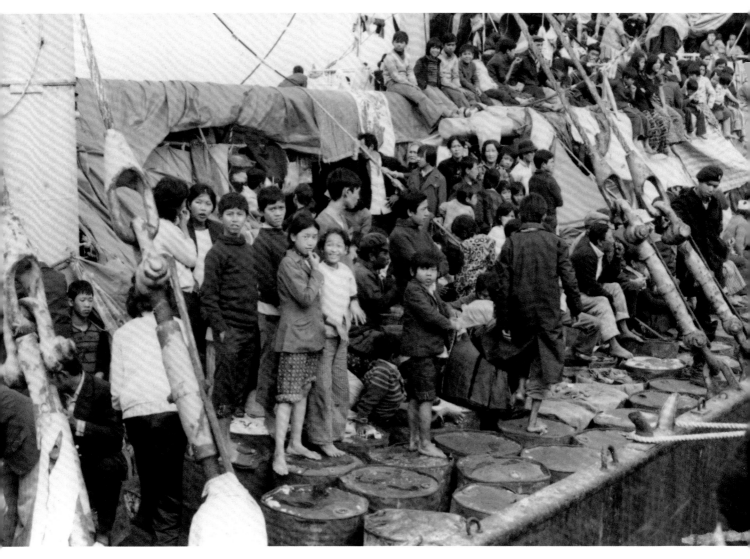

*The day the refugees from the* Huey Fong *were landed. Almost all 3,318 of those who arrived in Hong Kong, on what we know now as the first people-smuggling ship of the Vietnamese era, gather on the ship's main deck to watch and wait for the directive to disembark. Now dressed in winter clothing, provided by aid agencies during the one-month standoff on Hong Kong's southern sea boundary, young and old together clamber over rows of empty barrels for a better look at the action. Just off the port side of the ship a fleet of HYF ferries were arriving to transport the refugees to a land-based camp for registration and further processing. A Police Tactical Unit officer, wearing a blue beret, also watches and waits for the order to disembark.*

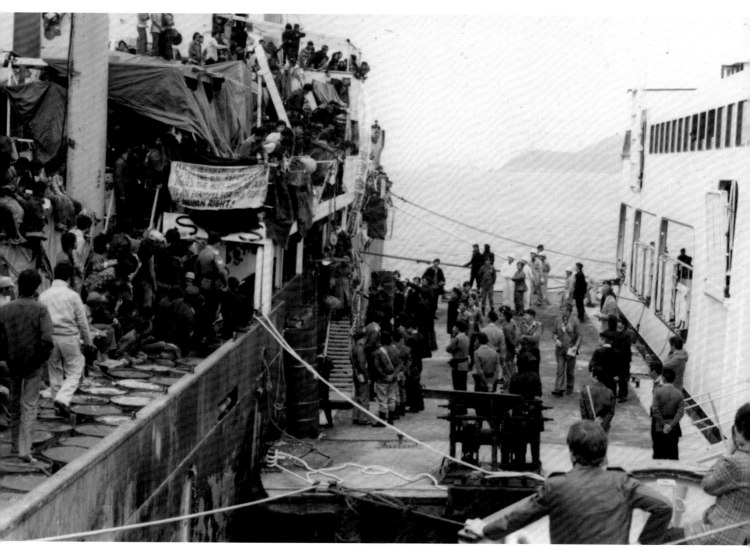

*Everyone on the* Huey Fong *strains to see the first refugee climb down the ship's gangway and on to the floating pontoon. Many of the refugees were sceptical that they had finally been accepted as refugees and were very keen to see how that first man was received. On the pontoon, Police Tactical Unit, Civil Aid Services and other government officers wait for the refugees to file down off the ship. At the opposite side of the pontoon the first of a fleet of HYF ferries waits to transport the refugees to a land-based camp for further processing. In the foreground, more government officials watch proceedings from the bow section of Police Launch 1.*

teams, immigration personnel and aid workers got to work in treating, feeding and documenting the Vietnamese.

On 20 January 1979 the Hong Kong Government gave permission for all 3,318 refugee passengers from the *Huey Fong* to land. The three photographs below were taken on that day.

## US$1.4 million

The crew of the *Huey Fong* were arrested, and a subsequent search of the ship found gold to the value of US$1.4 million hidden in the engine room. This turned out to be the crew's payment for smuggling these 3,318 Vietnamese refugees to Hong Kong. In the weeks that followed, and after being

  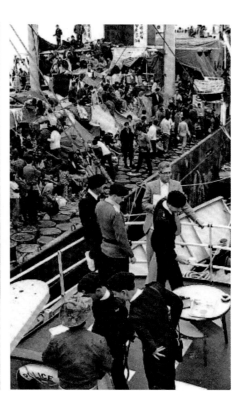

*Left: "Mr Fixit", the* Huey Fong *multilingual translator, reads out an announcement over Police Launch 1's public address system.*

*Centre: On the gangway down from the* Huey Fong *to the pontoon. The unofficial interpreter is introduced to the Commissioner of Hong Kong's Prison Services prior to the disembarkation of the refugees.*

*Right: The moments before the refugees were disembarked. On board the* Huey Fong *the refugees line up to get off the ship. They are supervised by officers of the Police Tactical Unit. In the foreground, on the upper deck of Police Launch 1, Marine Police and other Hong Kong Government officers discuss the disembarkation procedures.*

## HOT SAUCE, ANYONE?

Soon after the first people-smuggling ship, the *Huey Fong*, arrived in Hong Kong, one of the refugees became famous.

When Saigon fell in 1975, David Tran, a major in the South Vietnamese Army, went into hiding. Three years later, he managed to escape the new regime by securing a passage on the *Huey Fong*. Soon after landing in Hong Kong, Tran was identified by the Americans as a former South Vietnamese military officer and was given residence in the United States.

After settling in Los Angeles, Tran couldn't find a job, or a hot sauce that he liked, so he made his own – in a bucket at home. His Sriracha sauce is made from sun-ripened chillies puréed into a smooth paste. As the sauce became popular with friends, Tran had to think of a name for his brand of sauces, and "Huy Fong Foods" was born. Last year Huy Fong Foods sold US$60 million worth of Tran's sauce. Tran is quoted as saying that he never dreamed of becoming a billionaire – he just likes spicy, fresh chilli sauce.

As a postscript to this story, I can advise those unaccustomed to eating spicy food to be extra careful if they ever dare to add Huy Fong Sauce to anything they intend to put into their mouth.

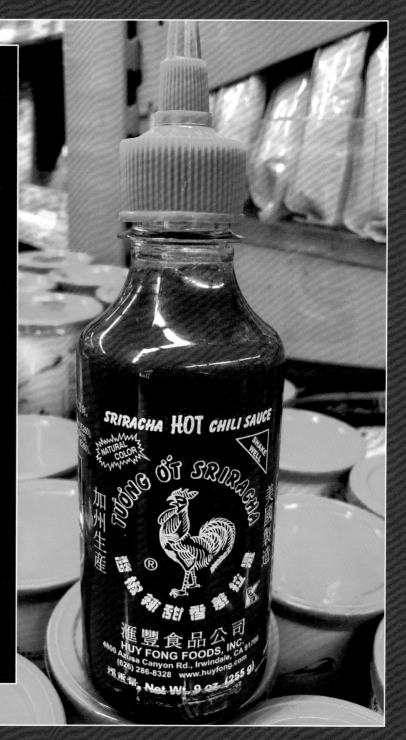

found guilty of several conspiracy charges, trafficking in human cargo, endangering life at sea and a number of other international maritime offences, Shu, the Taiwanese captain and crew were sent to prison for a total of 50 years. Shu got seven years.

At the end of the trial the judge referred to the whole saga as "a voyage of deceit from beginning to end". This, we all hoped at the time, was going to act as a deterrent to any further such illegal and immoral big-ship people-smuggling activity. Unfortunately, it did not have the desired effect, as just a few weeks later a freighter calling itself the *Skyluck* arrived in Hong Kong.

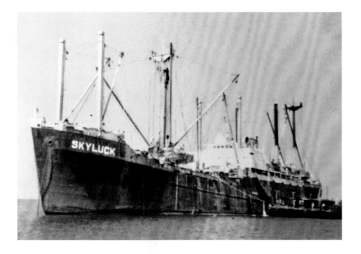

*The 3,500-tonne Panamanian-registered freighter the* Skyluck *at anchor in Ha Mei Wan, Lamma Island, in June 1979. The second of the big people-smuggling ships arrived in Hong Kong on 7 February of that year and had, since that day, been waiting for news of the fate of her passengers and crew. On the pontoon secured to the ship's port side are rows of prefabricated showers and toilets, as the ship itself had insufficient facilities for so many people.*

## The *Skyluck*

This ship, of similar size and design to the *Huey Fong*, had also picked up her cargo of 2,651 Vietnamese refugees off Vung Tau in the south of Vietnam. However, on this occasion, after news of the outcome of the *Huey Fong* saga had found its way back to Vietnam, the captain and crew of the *Skyluck* decided on a number of different "Hong Kong arrival" tactics. First, while en route to Hong Kong, the master and crew changed the name of the ship. When she collected her human cargo in Vietnam, she bore the name *Kylu*. By the time she arrived in Hong Kong, the vessel's name had acquired three extra letters and was now the unknown, untraceable *Skyluck*. The second thing the captain did differently was to send no radio message to the Hong Kong authorities requesting permission to enter Hong Kong. Obviously the master of this ship did not plan to spend one month at anchor on Hong Kong's sea boundary in similar fashion to the *Huey Fong*. The third, and most audacious, tactic was to arrive in Hong Kong under the cover of darkness and, showing no identification or navigation lights, steam directly into Victoria Harbour, where the skipper planned to offload all 2,651 refugees in the urban area.

This third tactic was, however, unsuccessful as the *Skyluck* was intercepted by the Marine Police before she made land and before anyone could get off the ship. The date was 7 February 1979, and the time was 0100. After several very senior people were woken up in the middle of the night for their wise opinion on what to do next, it was decided that the *Skyluck* would be escorted to an anchorage off Lamma Island, where the ship, its master, crew and passengers would be put under guard until the morning.

As with the *Huey Fong*, medical staff, immigration officers and police needed a stable access point to the ship, so for the time being Police Launch 1, once more, became the government's floating command and control platform. Very soon the much-needed food, fresh water and medical supplies were delivered to the ship. And so, just as with the *Huey Fong*, a standoff began. It was obvious to all that the Hong Kong Government did not intend to be held to ransom by the *Skyluck* situation.

When the *Skyluck* arrived, Chief Inspector Paul Lai was once more alongside on PL 1.

After the *Huey Fong* case was resolved, the *Skyluck* arrived in Hong Kong and my launch, Police Launch 1, had to stand by alongside the ship for the five months it was at anchor in Ha Mei Wan. During that time our crew became friendly with some of the refugees on board, in particular the kids, who always wanted to chat and play. Some six years after the case was resolved, and the refugees had been relocated overseas, a young woman in Hong Kong dialled 999 and asked for the Marine Police. After explaining to the operator what she wanted she was put through to the Marine Police operations control room. The woman's name was Annie Li and she had been one of the refugees on the *Skyluck*. She had returned to Hong Kong from Canada and wanted to thank the officers who had shown kindness to her and her family during that time six years before. By complete coincidence the officer who answered Annie Li's phone call at the control room happened to be one of the officers who

had worked on board PL 1 while she was alongside the *Skyluck*. Myself and some of the former PL 1 crew met with Annie at Marine Police Headquarters, and later we were able to arrange for her to take a trip out to Ha Mei Wan on board PL 1.

## Pressure cooker

When the *Skyluck* arrived in Hong Kong in February 1979, Wally Murison was the Subdivisional Inspector Cheung Chau. The vessel was now anchored off Lamma Island, which was part of that subdivision of Cheung Chau, Lamma Island and the Soko Islands overlooked by Lamma Police Post.

The vessel being anchored in my Subdivision did not cause us many problems as she was well policed by many different units including Police Launch 1.

Fast forward to Sunday 11th March. As the weather had improved, a barbecue had been arranged at Cheung Chau Police Station and various friends and relatives had been invited to join, including the Station Sergeant commanding the contingent on Lamma Island.

The Station Sergeant telephones me at Cheung Chau and launches into a very long apology that he would not be able to attend the festivities that afternoon and wished us all a lovely afternoon. It was only as he was about to put the phone down that I asked him if there was any particular reason that he could not join us, thinking perhaps a domestic problem.

"No, Sir, no domestic problems, the family are all

well, thank you. There are fifty refugees swimming towards the beach from the *Skyluck* and we are going to go and arrest them."

"How many officers do you have with you?" says I.

"Just me and the PC cook, Sir," came the reply.

"Carry on, Major," was the only reply I could think of.

The ones that made it ashore were all arrested.

Back at my job at Tai O police station, as the weeks went by, I became increasingly curious about the *Skyluck*. Unlike its predecessor, it had not been permitted to offload its passengers and had by now been anchored in Ha Mei Wan for two months. The government was determined not to be seen as a soft touch in this people-smuggling racket.

According to some of my colleagues who were working on board Police Launch 1, the *Skyluck* was in much better condition than the *Huey Fong*. And, as it was anchored in sheltered waters, and in easy reach of Hong Kong Island, it was far easier to ferry supplies and staff to and from the ship. Now, with more than 30,000 Vietnamese housed in camps in Hong Kong and all the camps full, it seemed to me that the government was in no hurry to allow the refugees to land.

Hugh Osborne joined the Royal Hong Kong Police soon after me. I recall that he arrived at the Police Training School to begin his basic training shortly before I graduated. Hugh was not a Marine Police officer; he worked in Kowloon before joining the Police Tactical Unit in 1978.

By 1979, I was a 23-year-old Police Tactical Unit inspector. I was on my first tour of duty in the Royal

*Hugh Osborne's platoon of PTU officers are ferried by launch for guard duty on the pontoon secured alongside the* Skyluck

Hong Kong Police and had been in Hong Kong for two years.

Our first *Skyluck* duty was in early June 1979, when the ship had been at anchor in Ha Mei Wan for four months. I oversaw a PTU contingent consisting of one sergeant and seven constables who were deployed to the pontoon that was moored between the ship and Police Launch 1. One of our duties on the pontoon was to keep an eye on the gangway to ensure there was no unauthorised use, but for us there was a lot of sitting around and very little to do. At that time, it seemed as though the refugees on board were resigned to the fact that nothing was going to happen quickly; swimming ashore and a hunger strike had not worked, and the Hong Kong Government was

refusing to allow them to land to discourage further such arrivals.

From time to time we would need to arrange medical evacuations ("casevacs") by a Marine Police launch, usually of pregnant women or sick children. Among the refugees, there was at least one trained doctor who would send a note with the casevac outlining the problem. If he suspected that the patient was trying to pull a fast one, he would write, "Patient insists on seeing a Govt doctor"; this meant that this doctor felt that there was nothing really wrong with the patient, who just wanted to get off the ship for a while. The casevac was still arranged but given a low priority and a close eye was kept on the patient. Young children who needed a casevac were always accompanied by an adult relative, usually the mother. Often when they

returned to the *Skyluck* the adult had several bags of purchases made onshore, presumably having slipped their escort while the child was receiving medical treatment. These bags were emptied and thoroughly searched on the pontoon in full view of the refugees on board the *Skyluck*, who would congregate on the upper deck to watch the action. On one occasion some flimsy ladies' underwear was discovered and held up for all to see, much to the amusement and cheers from all on board the ship.

PTU officers were not allowed on board *Skyluck* so I could only imagine what the conditions were like for the refugees. I had no comprehension of the ordeal those on board were suffering or indeed had suffered when in their home country or during the voyage. There was a feeling that a stalemate had been reached and that it seemed like *Skyluck* would be there forever. But I must admit that the cutting of the anchor chains came as a big surprise.

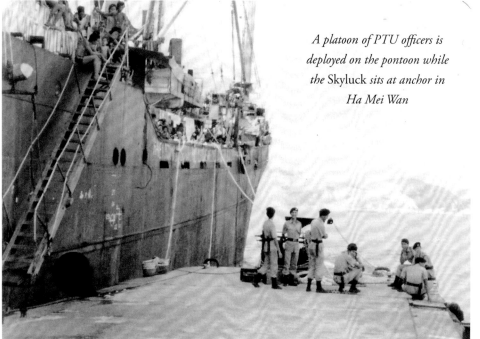

*A platoon of PTU officers is deployed on the pontoon while the* Skyluck *sits at anchor in Ha Mei Wan*

Unlike with the *Huey Fong,* I'd not been invited to join any official visit, so I decided to arrange my own unofficial look-see. I knew some of the senior officers serving on board Police Launch 1 so using the Marine radio set that sat in the corner of the report room at Tai O Police Station I called the Marine

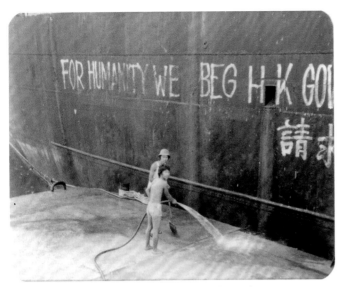

*Two refugee volunteers help to hose down the pontoon*

Police South Sector patrol launches and asked if there was, by any chance, one of their vessels anywhere near to Fan Lau Point – preferably one that was, at any time soon, returning to the Marine Police base at Aberdeen – one that would be passing close to Ha Mei Wan as it did so. I was in luck.

The day I went was a sunny, cloudless, afternoon. It was April 1979. The sea was calm, but the bay where the *Skyluck* was at anchor, Ha Mei Wan, was a hive of activity. Police Launch 1 was moored alongside the *Skyluck*'s starboard side, and a large, flat pontoon was moored on the ship's port side. This pontoon had become a permanent fixture in this arrangement. It not only served as the delivery platform to the ship, it also housed a long bank of small structures that I was soon to discover were toilets and showers for the refugees, as obviously there weren't enough bathrooms on a cargo ship for 2,651 people.

On the outer side of the pontoon was a large Marine Department tug, on which several men dressed in white

overalls and white hard hats were busy arranging some form of rope and pulley system up to the main deck of the *Skyluck*. There was lots of shouting and swearing from this Hong Kong Government team. As we approached from the south I could also see that a set of steps had been lowered down the side of the ship and was now full of people awaiting their turn for the bathrooms on the pontoon. This queue of people was being supervised by what looked like a team of Police Tactical Unit officers. I'd read in a report that a platoon of PTU were now stationed on the *Skyluck* to provide an element of security. At the top of the gangway a group of refugees were sitting and watching the proceedings below. Further along, another group were hanging over the side, also watching what was happening.

My South Division launch dropped me off on to Police Launch 1, and I went off in search of the officer in charge to pay my respects. As I walked around the upper deck of the police launch I looked up at the *Skyluck*. Large banners made from cardboard sheets hung over the sides of the ship. "We Only Want To Land" read one. Another, this one painted on the side of the ship in large white letters in English and in Chinese characters, read: "FOR HUMANITY WE BEG HK GOVERNMENT TO LET US LAND".

"They put new ones up from time to time," said Paul Lai as he stepped out of PL 1's wheelhouse. Chief Inspector Paul Lai was the commander of PL 1 and had also been given the unenviable job of "minder of the *Skyluck*". He told me they were about to go on board the *Skyluck* and invited me to join them.

Paul Lai had more than 20 years of service in Hong Kong's Marine Police. He was a Marine sector commander and all-

## THE SQUARE BOUNDARY

Hong Kong territorial waters are defined by an invisible "square boundary" that was marked on all of our charts and maps. The area was mapped and agreed between the British and Chinese back in 1898 when Hong Kong acquired the New Territories and the Outer Islands on a 99-year lease. Everything inside the boundary was Hong Kong, and everything outside wasn't. All waters, or sea, inside the boundary was Hong Kong Territorial Waters and all waters outside the boundary were international waters.

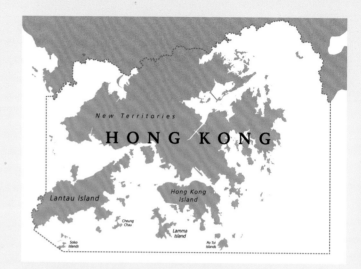

When we were out at sea it was, obviously, imperative that we always knew where we were. But it was also important that we knew where we were in relation to this invisible boundary, for several reasons. Firstly, the Hong Kong Marine Police, together with Hong Kong's Marine Department, were responsible for all search and rescue operations at sea inside this square boundary. Secondly, it was only inside this boundary that we had constabulary powers. However, when it comes to saving life at sea, all international boundaries are overruled. The International Convention for Safety of Life at Sea states that "the master of a ship at sea, on receiving a signal from any source that a ship or aircraft or survival craft is in distress, is bound to proceed with all speed to the assistance of the persons in distress". In other words, when patrolling along the southern territorial boundary, if we became aware of a vessel in distress – in danger of capsizing or sinking – we would leave Hong Kong Waters to effect a rescue. Officially, we would need permission from the Hong Kong Government to do this. But in reality, we would request this permission after setting off at full speed.

In the late 1970s and 1980s I spent most of my duty time patrolling along the horizontal line that forms the bottom of this square boundary – from its westernmost point, just south of Fan Lau, to a dog-leg bend south of the Soko Islands, then eastwards passing south of Cheung Chau and onward to a point south of the Po Toi group of islands. During those years this was an important patrol area as it was from the southwest that the majority of vessels from Vietnam arrived in Hong Kong.

While our own local knowledge and experience told us exactly where we were in respect of this invisible boundary line, the combined use of the launch radar and an Admiralty chart would confirm that position. Enhanced radar positioning is a maritime system of fixing one's position. Remember, GPS was a thing of the future, so back then, tuning our radar scanner in the wheelhouse to a range so that the picture would display several known land masses, such as islands, enabled us to fix distances from these known points and transfer them on to the chart. Once our position was marked on the chart, we then would know the exact position of our launch.

An ocean-going vessel approaching Hong Kong waters would, upon reaching the square boundary, be bound by the laws of Hong Kong, both maritime and otherwise. It was for this reason that, when vessels from Vietnam began arriving in Hong Kong in the mid/late 1970s, they were met on the boundary so that we could ascertain their purpose of entry into Hong Kong, and also inform them of their rights in terms of their request to seek refugee status.

round good guy. As he was fluent in Mandarin he had been involved with the questioning of the master and crew of the *Huey Fong* some months before. And, as the skipper of the *Skyluck* was also a Taiwanese national, Paul's language skills were once again proving invaluable.

"I have been meeting the skipper on a daily basis," Paul told me as we looked down at the activity on the pontoon. A group of Vietnamese, supervised by a government officer, were washing down the main work area of the pontoon with a hose. The refugee working the hose playfully squirted his friends and the officer told him to get on with it.

## Checkmate

"What's the skipper like?" I asked.

"Crafty, not willing to say much in case he drops himself even further into trouble," replied Paul, "but I found out that he is very fond of chess. So I got hold of a chess set and gave it to him. He and I play most days."

"So you are getting to know him?"

"Yes, as the days and weeks go by he's starting to relax and talks more. I've been able to get some interesting stories from him about what's happening in Vietnam."

"Ready, sir," said one of Paul's crew.

As we climbed the gangway up the side of the *Skyluck*, I looked up to see a large group of Vietnamese men sitting on the upper deck watching us ascend.

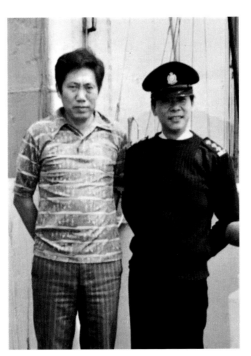

*Marine Chief Inspector Paul Lai (right) and Siu Hung-bun, the skipper of the* Skyluck

Others were hanging over the side, pointing and discussing this new movement of officials. I figured any visit to the ship would be of interest to the Vietnamese as there was always the hope of it bringing some good news.

## Plywood huts

In terms of the ship's condition and its passengers the *Skyluck* was a different story to the *Huey Fong*. Conditions on board were not nearly as squalid. The Vietnamese had obviously been maintaining a cleanliness routine. Also, unlike the *Huey Fong*, the *Skyluck* had a cargo other than refugees. For reasons that were unclear at the time the *Skyluck* was carrying a cargo of large sheets of plywood, plus enormous rolls of cardboard. The significance of this cargo became apparent to me as we walked around the main deck. The upper areas of the ship were entirely covered in small structures, "huts" for want of a better word, built by the refugees using the wooden sheets and cardboard rolls. I could see around 15 small abodes and half a dozen people could fit in to each one quite comfortably. The refugees had even cut square holes, about one metre square in size, for windows and ventilation in the sides of their huts. Living in these would certainly be preferable to living down in the ship's hold, I thought.

In addition to these wooden and

cardboard structures there were dozens of ropes, stretched taut, zig-zagging in different directions high above the decks. On the lines hung the refugees' washing: shirts, shorts, trousers and bed sheets. The washing was white, blue, yellow, green and red. It flew around in the breeze like a set of admiral's flags.

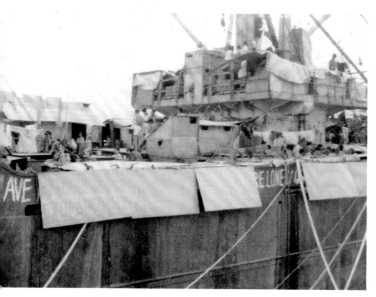

*The ship's cargo of plywood is put to good use by the refugees with the construction of huts on the deck of the* Skyluck *whilst anchored in Ha Mei Wan*

In the two months that the *Skyluck* had been at anchor in Ha Mei Wan she had evolved into a floating squatters' village. Huts, queues of people, lines of washing, people carrying things or just sitting around. People watching, people waiting.

"We are going to take a look below decks," Paul called over to me and motioned me to follow.

We went down a set of metal stairs and through an open doorway into a corridor. At the end of the corridor was the entrance to the ship's main cargo hold. Paul and his guys were filing in so I followed and the enormous hold opened up just below me. For some reason I'd expected to find the cargo hold full of cargo, but it was full of people. From one side to the other, there must have been about a thousand people sitting or lying down. They were mostly women and children, and lots of toddlers and babies.

"This is where most of those on board spent the journey from Vietnam," said Paul. "As you can see, it's very crowded now, but imagine what it was like when all two thousand six hundred were in here."

Among the faces looking up at us from the crowded cargo hold there was one which was unmistakably European. He was a little boy of about six years old. He had fair hair and bright blue eyes. My first reaction was – what is he doing down there? Then I gave it a bit of thought and realised that there must have been thousands of Vietnamese children who had been fathered by American soldiers. I wondered if, with his lineage, both he and his mother would eventually end up in the US.

The captain and the crew were initially segregated from the refugees and kept locked away in a cabin under armed guard. But as time went by, Paul had decided to allow them out in order to help with the daily routine tasks that were required to look after some two and a half thousand people. The skipper and his men were put in charge of meeting each delivery of food and then helping out with the distribution of the food to the refugees. All this, of course, was done under the supervision of a government officer. Paul didn't want the skipper and his crew involved in any form of food distribution scam.

I sensed that the mood on board the ship was tense. Having been here for more than two months, the refugees were, understandably, quite desperate and keen to know what was going to happen to them. I didn't envy Paul Lai, his men or anyone else who had been sent to work on the ship. No one here, refugee or government officer, could see an end to this situation.

## Pride of the fleet

A number of my early years patrolling Hong Kong's territorial boundary were spent aboard Police Launch 1. Built at the Taikoo Dockyard a decade before, PL 1 was the pride of the fleet. Purpose-built as a command launch, she was quite different from all those that had preceded her and was almost twice the size of the other vessels in the Marine Police fleet. The then-governor Sir David Trench was one of the first visitors.

While Police Launch 1 operated day-to-day as a general patrol vessel, she really came into her own during major incidents at sea. With her purpose-built search and rescue operations room, she became the on-scene command platform that could respond to and take control of "people (or vessel) in distress" incidents very quickly. During her lifetime PL 1 proved to be a lifesaver on many occasions.

One of my duties as the junior inspector on PL 1 was to carry out regular inspections of all four decks of the launch to ensure that her overall condition was of a high standard. It was my job to ensure that all equipment was in good order and that it was properly stowed. I usually began these inspections below decks, in PL 1's engine room.

PL 1 was powered by two enormous engines, twin Lister

*All police launches had a commissioning plaque. It was presented to the launch's commanding officer when the launch was introduced into service. It would be affixed in a prominent place on the launch for all to see. PL 1's plaque was positioned on the forward bulkhead, immediately below the wheelhouse. All commissioning plaques would include details of who built the vessel, where it was built and when.*

Blackstone diesels, both the size of a medium-sized family car. They were always kept in immaculate condition and would hum with power. The engine room had a variety of handles, levers and dials that included a large brass telegraph repeater.

This piece of equipment relayed the instructions from PL 1's wheelhouse above. When the officer of the watch up in the wheelhouse wanted PL 1 to go "full ahead" on the starboard-side engine he would shift the starboard-side controls on the wheelhouse brass telegraph to "full ahead" and the arm of the repeater in the engine room would respond by doing the same. The chief engineer, who worked in the engine room, would then follow these instructions and adjust the appropriate Lister Blackstone accordingly.

*The engineer's telegraph repeater, located in the engine room. This mirrors the Officer of the Watch's (OOW) engine order telegraph (EOT) up in the wheelhouse. When the OOW wishes to change the speed of the launch or for it to go ahead or astern, he aligns the pointers on his EOT which rings a bell in the engine room and moves the pointers of the engineer's repeater to the same position as in the wheelhouse. The engineer, upon hearing the bell, moves the reply handles to the same position to signal to the OOW his acknowledgement of the order. He then adjusts the engine speed accordingly. Such an order is called a "bell". For urgent orders requiring rapid acceleration, the handle is moved three times so that the engine room bell is rung three times. This is called a "cavitate bell" because the rapid acceleration of the ship's propeller will cause the water around it to cavitate, causing a lot of noise and wear on the propellers. Such noise is undesirable during times of covert operations because it can give away a vessel's position.*

All of this would be accompanied by the ringing of a repeater bell in the engine room, set off by the action taken in the wheelhouse. The bell was just in case the chief engineer's attention to his copy of *Racing Weekly* was a little more focused than it should have been.

The deck above the engine room housed the main crew's accommodation where the off-watch crew could rest between shifts. PL 1's duty system meant that we were out at sea for three days at a time, so the sleeping accommodation was an important feature of this launch. Located towards the stern, the crew's accommodation was a rabbit warren of a system whereby double bunks, one above the other, ran along both sides of the ship, with a walkway down the middle between them. The bunks, made of wood, were permanently fixed to the bulkhead and came with rough-weather boards to help prevent the occupants from being thrown out of their bunks if PL 1 was fighting one of the big rollers that frequently hit Hong Kong from the southeast. Also on this deck were the crew's "heads" or bathrooms as well as their own galley. The main feature of the galley was a gas-fired range for the crew's cook to prepare the meal, plus a long table with collapsible stools where the crew sat, to eat and discuss the events of that day or night. Further along on this deck was a system of storage compartments in which ropes, lifesaving equipment and other maritime paraphernalia were stowed. During my inspections I became very unpopular with the crew by insisting that every item of kit was pulled out of these lockers, every day, so that its condition and reliability could be checked before returning it to its original place.

Further forward on this deck was the officers' accommodation, which consisted of two separate cabins and

a shared shower and toilet. One cabin was for the Sector Commander. It had one bunk, a desk and a locker, all made of polished wood with brass fittings. The other was the inspector's cabin and had two bunks, one either side of the cabin.

*There were two cabins below decks, both in the forward section of PL 1. One cabin was for the Sector Commander (the chief inspector) and the other was the inspector's cabin, which had two bunks. This is a photograph of the bunk I was allocated. As with all fixtures on PL 1 it was made of hard wood and came complete with side-board to prevent me from being thrown out during rough weather. A shared desk separated the two bunks. An interesting feature of the inspector's cabin was that it was 'below decks' and so it was below the waterline. This meant that it had no porthole, which meant no natural light.*

During my time on PL 1, I shared this cabin with another junior inspector, Bruce Venables, a Tasmanian who had joined the Hong Kong Marine Police four months before me. Both the inspectors' bunks came with a curtain that could be pulled across when sleeping, but Venables and I didn't use them as we worked separate shifts. Being below the waterline, the inspector's cabin had no porthole, so no natural light. There were no luminous digital watches in those days, so Venables and I had to bring along two important pieces of kit each time we reported for duty – an alarm clock and a torch.

Up a set of steps from the accommodation deck was the main deck outside. PL 1's main deck was wooden, which I rather liked. I felt that it gave the vessel character. This main deck included a side hatchway that could be opened to allow people to come on to and leave the launch. The officers' mess was also on this lower deck. Here the senior officers could relax when off watch and, if they chose to, take their meals. To the rear of the mess room itself was the officers' galley. PL 1 and her sister PL 2 were the only launches in the Marine Police fleet that came with two cooks. On PL 1 we had a crew's cook and an officers' cook. In the 1970s the officers' cook was Mr Chan, who had been the officers' cook on PL 1 for more than 20 years. His steak and kidney pie was famous, and visiting officers would always enquire about dinner in the hope of securing an invitation.

The main deck was also where most of the physical work was done – throwing and receiving lines when going alongside another vessel as an example. Hauling rescued people up on to this deck was another. At the stern area of the main deck was the launch winch and the vessel's small

boat. If the tender was required for operations it would be lifted up and lowered into the sea by use of this winch.

*The photograph is taken from outside of PL 1's wheelhouse looking back toward the stern of the launch. Interesting features in this photograph are the hard wood balustrade and, further toward the stern, the stern of PL 1's dory and the dory's rudder.*
*The dory was PL 1's tender, or small boat. It was an open fibreglass boat. It had an inboard engine that gave it a speed of about 10 knots. It also came with removable rollicks and long wooden oars, in case the engine wasn't behaving itself. On the lower stern deck (not in this photo) was a large winch, which would be used to lower and raise the dory from the sea.*

My inspection always concluded by going up one more deck to the bridge. This is where the decision makers worked – it included the wheelhouse and operations room.

Standing at the ship's wheel, steering the launch, would be the coxswain. He would be an experienced officer, probably a PC (constable) with 15-20 years' service, mostly on this launch. Many officers, once posted to PL 1, remained on her for their entire careers, a family within a family. Standing next to the coxswain would be the OOW (Officer of the Watch). He would be standing in front of the brass telegraph. The safe navigation of the ship was the responsibility of the OOW. He was an important man, usually a sergeant or station sergeant with in excess of 20 years' service. Again most of it would have been spent on this launch.

Standing next to the OOW would be either the on-watch inspector or, if the circumstances dictated, the Sector Commander. It would be this officer's responsibility to monitor the radar repeater, verbally announcing distance and angle readings to his team. These three men, the coxswain, the OOW and the radar operator, were responsible for the navigation and safe passage of PL 1.

Immediately behind the on-watch team was a large chart table. On the table would be the Admiralty chart of the area of sea the launch was in at the time. The on-watch team would, from time to time, turn and check their position on the chart, looking out for any hazards. During a search and rescue operation the officers commanding would gather around this chart table to discuss and formulate a rescue plan. It was my job to ensure that all charts were in order and filed correctly so that in an emergency the correct chart could be located quickly.

*The main features of the wheelhouse on PL 1 were the large brass engine order telegraph (EOT) and the wood and brass ship's wheel. It was from this position that the Officer of the Watch (OOW) would command the launch. The coxswain would be standing at the wheel and a radar observer would be standing over the radar repeater. In this photograph the radar repeater (the large grey piece of equipment on the right) is fitted with the observer's daytime view cover. This provided the observer with a darkened environment, which was necessary for the observer to see the scanner during daylight hours with radars of that era. Reinforced glass was fitted into the forward screens due to the ferocity of the storms that police launches faced when working out at sea. A 'windscreen wiper' can be seen to the right of one of the screens. These wipers were frequently used to keep the screen clear from waves and spray, even though this screen on PL 1 was 30 feet above sea level.*

*The radar platform immediately above PL 1's wheelhouse. All radar and communication transmitters and receivers were located on this platform, which was the highest working area on the launch. Of interest is the waist-high binnacle, the white, dome-topped column in which navigation instruments were positioned. These instruments included PL 1's magnetic compass, which was mounted on gimbals to keep it level when the launch pitched and rolled. The national ensign, the Hong Kong colony flag, is being flown as the courtesy flag, indicating in whose waters PL 1 was operating at the time. Running from the yardarm (the short horizontal mast just above the radar scanner) are the flag lanyards.*

To the rear of the wheelhouse was the communication cabin, divided from the wheelhouse by a black curtain. During major ops, the curtain would be pulled back so that the comms cabin became part of the ops room. In the comms cabin were all the launch log books that included the communications log, the operations log and the crew's duty roster. As part of my inspection I was required to check all log books and ensure they were filled in correctly and were up to date. I would then be required to sign off that I had performed these checks.

Police Launch 1 had many brass fittings and polished wood balustrades. It would be the duty of the junior officers who were off watch to keep their launch in pristine condition. There were always groups of men, dressed in PT kit, doing the brasses or polishing the wood or touching up the paintwork. They did this job voluntarily for reasons of pride in the appearance of their police launch. PL 1 was the flagship of the fleet and it was an honour to serve on her.

For me PL 1 had a special feel to her. PL 1 felt more like an ocean-going ship than an offshore patrol launch. People tended to serve on PL 1 for long periods of time, and most of them contributed in one way or another to the fabric or appearance of the vessel on which they spent their lives. Crew members enjoyed serving on the command launch and regarded her with affection. Prior to each three-day patrol, fuel, water and food would be stocked up onboard and off we would go. It really did feel like we were off for an adventure out at sea.

### Sik fann sigan!

The Chinese take their food seriously and, on a police launch, the two main meals of the day are important affairs. They are times when most of the crew would come together, to eat and discuss what had happened that day and what the night might have in store for them. During those very busy years, mealtimes at sea were selected, as best they could be, for when it was hoped that there would be a lull in proceedings. Radar pictures would be carefully examined for incoming vessels. If a window of opportunity was found at around the middle of the day and then again during the early evening, it would be 'sik fann sigan' – time to eat rice. The Hong Kong Marine Police must be one of the last of its kind to still carry "ship's cooks" – men who have no constabulary or nautical duties, their only function being to feed everyone else on board the launch. Back then, each crew had their own cook. He would report for duty at the same time, go to sea with the launch and would work exactly the same hours. The only difference was that he had no constabulary powers, and he also had the very important duty of going to the market before each trip in order to buy supplies for the entire crew for that specific trip until they returned to base to go off duty. He was an important cog in the well-oiled machine. A cog without whom it would have been difficult for the crew to function. The cooks, although part of a disciplined service, were civilian staff.

There were a few cooks who received commendations for their service. One in particular, the cook on Police Launch 1, was awarded a commanding officer's commendation in 1971 for his actions during Typhoon Rose, when he lashed his pots on to the galley range but continued to serve tea and noodles throughout the night for his own crew and those on two other police launches that were involved in a search and

rescue operation in very heavy seas.

Upon joining the Marine Police every cook was provided with one set of "cook's uniform", which comprised three items. One white cook's smock, one pair of white cook's trousers and one tall stovepipe cook's hat. All cooks would carefully fold their uniforms and put them away for the day of the annual commanding officer's inspection. Inspection day was the only day a cook would wear his "whites". Many years later, after I became a commander myself and had to carry out these annual inspections, I found it hard, at times, to take galley inspections as seriously as I should have done. This was down to the fact that I would invariably forget that, upon entering a launch galley, the cook would be standing to attention next to his cooking paraphernalia dressed in his whites and wearing his cook's stovepipe hat. Some of these cooks were not that tall, but the hat was.

*In the 16th century some kings were being poisoned by indignant chefs, so in order to better identify them in the kitchen, and keep an eye on them, they were presented with a unique piece of headgear. In the Marine Police some cooks doubled in height when wearing theirs.*

But at least the command launches such as Police Launch 1 had reasonable galley facilities. In the late 1970s and early 1980s, during those very busy years, I recall serving for a time on one of the old but classic all-wood "70 footers". These were police launches that were built in the mid-1950s and remained in service until the mid-1980s. The bridge, or wheelhouse, was open to the elements. The wheelhouse was no more than a large windscreen with wooden sides. The coxswain, lookout, sergeant officer-of-the-watch and myself would stand side by side, either sweating profusely in the hotter weather or wrapped in blankets in a futile attempt to keep out a biting wind. The cook would prepare the meal in a galley no bigger than a broom closet down below decks where the temperature was often well in excess of 40 degrees Celsius. He would then emerge, balancing our meal on a huge tray, up a short flight of steps from down below, into whatever the weather was throwing at us.

## The freighter *Sen On* – 'Hong Kong is that way!'

"It was a beautiful sunny day on Sunday, April 22, 1979. Around noon, two buses packed with passengers and luggage drove out of a state-owned fishmeal factory in Ben Da Fishing Village in Vung Tau, 60km southeast of Saigon."

So begins Cang Dang's account to me of his escape from Vietnam. A former soldier in the South Vietnam Army, he would make it to Hong Kong 35 days later, and three weeks after that be whisked out by the Americans. I know this because after the people-smuggling freighter he was on ploughed into a beach on Lantau, I was the first officer on the scene and would later help document and process every refugee on that boat. And while many would go on to camps before being given refugee status, with the majority heading on to Canada, Cang suddenly disappeared after just three

weeks – a person of value taken by the Americans. We've had a lot to do with one another, Cang and I, over the past couple of years. Two men of a similar age, both young when we met, yet our lives have been so completely different. He had been wounded in battle, and then the Americans headed home, leaving their Vietnamese allies to find their own way out.

*Cang Dang in the early 1970s, during his time as a soldier in the Army of the Republic of Vietnam (ARVN)*

Cang has written a full account of his escape: how they started off with a few belongings and hope, having saved up the money for the gold to bribe the government authorities and later pay off the crew. Cang and some others had initially bought a boat – but it was a government con. They were told: "Spend this and we'll permit you to leave and we'll even build a big wooden boat for you." They called the boat "Gold #999". Ironically they not only never saw the boat, they never saw the gold again.

Cang told me: "I recall our last evening in Vietnam, April 22nd, 1979. There were a few kerosene lamps illuminating the inside of the dim cottages in which we had been told to wait. Although people were hungry and ravaged by mosquitoes, they did not say a word. Then the following morning, we were told that our boat was ready. But instead of the boat we had been promised, we were driven to a rusting hulk. Then the officials made us hand over our identity cards and any remaining money we had. They also made us sign over any remaining property we had, so we left Vietnam with what we carried. One of the crew came ashore and made our group line up along the river bank. They carefully checked everyone against the name list provided by the Vung Tau Police Department."

Group by group they were transferred via a small boat out to the rusting freighter. The word "Panama" was painted on her stern and "Sen On" was painted on the bow. *Seng Cheong* was the real name of the ship. It was a Panama-registered ship belonging to a shipping company based in Macau. The vessel was about 45 metres long and about six metres wide and weighed about 800 tonnes. The freighter's crew had smuggled rice to Vietnam and colluded with the Vietnamese

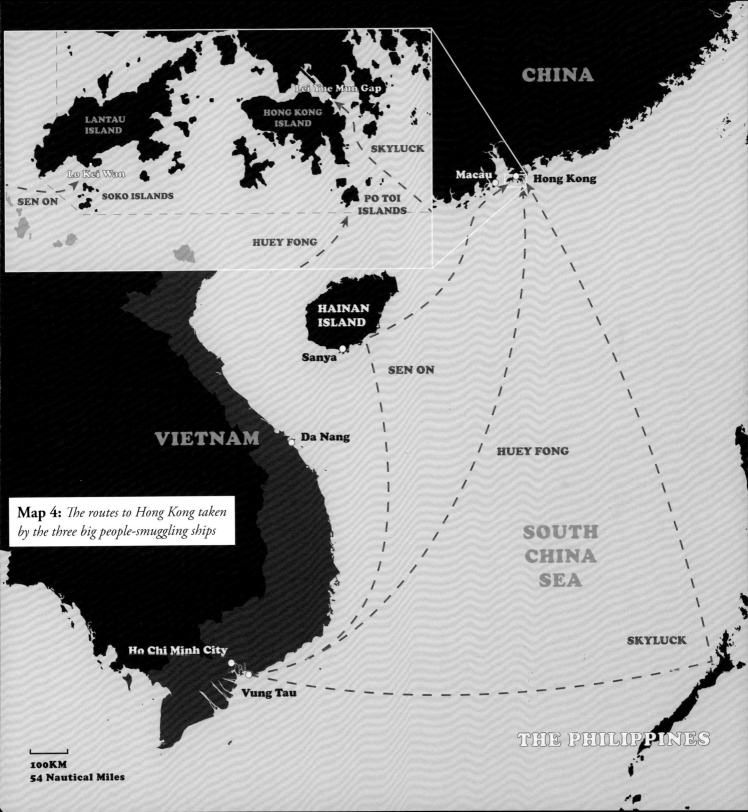

CHINA

Lei Yue Mun Gap

LANTAU
ISLAND

HONG KONG
ISLAND

SKYLUCK

Lo Kei Wan

SEN ON          SOKO ISLANDS

PO TOI
ISLANDS

Macau          Hong Kong

HUEY FONG

HAINAN
ISLAND

Sanya

SEN ON

VIETNAM          Da Nang

HUEY FONG

**Map 4:** *The routes to Hong Kong taken
by the three big people-smuggling ships*

SOUTH
CHINA
SEA

SKYLUCK

Ho Chi Minh City

Vung Tau

THE PHILIPPINES

100KM
54 Nautical Miles

authorities on the return trip to illegally transport refugees.

"At this point," says Cang, "before the ship was allowed to leave, the police asked the ship's captain how much fuel he needed for the journey to Hong Kong, and then to the captain's visible alarm, they came aboard and siphoned off the rest, leaving the *Sen On* with no buffer for the journey. In a panic, the captain quickly poured some fuel into another tank, but it leaked into and contaminated the drinking water tank next to it. Our drinking water for the trip was going to be a mixture of water and engine oil."

The Vietnamese authorities were willing to pay the captain, Lee Nai-hao, two gold taels per passenger. He agreed to take 800, and by the afternoon the ship was full of people. But they continued to send people on board. There were now more than 1,400 refugees on the ship, but the captain had only been paid 1,200 gold taels. He tried to negotiate, but at gun point he had no bargaining power. And at 3pm that day, the *Sen On* set sail, escorted out of Vung Tau by a Vietnamese patrol boat.

The freighter had originally only had two decks – an upper and a lower deck. But there was a "pseudo-deck" in the middle with ladders connecting up and down. Passengers were packed in there, too, and there was no ventilation apart from the openings to the upper deck. The whole ship, including the bridge, was crowded with people. The upper deck had hanging canvases that hindered ventilation but did provide some shelter from the hot sun. Eighty per cent of the passengers were ethnic Chinese, including the community of formerly wealthy residents Cang knew on board, alongside his extended family. Now they were reduced to huddling in the greasy and dirty lower deck, where the lack of air made it

suffocating in the heat. The passengers were already hungry and dehydrated. And then, says Cang, the captain initially ordered the crew not to hand out drinking water. All the six or so former refugees who have talked to me about their experiences on board the *Sen On* describe how the water they drank tasted of oil and made them sick. There were four toilets on the ship, all very basic; two were just planks and sack cloth. Passengers would stand in long queues, and some just urinated where they were. The whole ship stank, a toxic, cloying air of vomit, sweat and piss.

Phan Dang is Cang's niece. She was a teenager when her family decided to leave Vietnam. They had sided with the ARVN, the Army of the Republic of Vietnam, during the war.

"I was just a teen, together with thousands of other people, when I boarded the *Sen On*," she told me. "My family, nine children, including me, was stuffed like sardines in the bottom of that ship. We had never been out at sea before, so the smell of human waste and the lack of oxygen soon made us feel sick. Later, my mother with a couple of her younger kids (the youngest was four at the time) had to fight for a spot by the staircase to sit on the upper deck and I remember some of us older ones suffocating in the heat, and breathing in the foul air, would clamber over the other passengers to reach the upper deck to get some fresh air and clear our heads. I remember all of the horrible living conditions on that ship – the water tainted with crude oil, the lack of food, and the toilets hanging out by the side of the boat. I remember walking dangerously close to the edge of the ship holding on to a thin rope with one hand while balancing porridge distributed to my family with the other

hand. I remember trying to hold up plastic bags with my sisters to collect rainwater, because the oil-tainted water had made us sick. I remember sharing a cup noodle with my aunt and savouring every drop of liquid in that golden cup!"

There were nine crew members on board. Cang described to me how the captain, who was around 50 years old, would, from time to time, throw paper money from the bridge to ask the sea gods for good passage. On board, the passengers created a committee to get more food distributed by the crew. But even that required the passengers to pay more money for instant noodles, porridge and boiled water. As the journey continued, every day some men and women would bathe in the sea, but everyone on board had head lice.

And they didn't all make it to Hong Kong. On the fifth night, Cang told me, "a woman at the stern died of frailty and exposure to the bad environment. She was called To-Phuoc, aged 69. She was buried at sea, and according to custom, the captain circled the ship three times while scattering paper money to send her off."

While conditions were awful, after nearly a week at sea, the mood was lifting, says Cang, because the passengers could see Chinese navy boats and the crew were excited about going home to Hong Kong and Macau. So excited that one night they drank heavily and celebrated their homecoming

*Cang Dang and his wife, Yen, in more recent times in California*

– but something was amiss with their navigation and on April 28 the *Sen On* ran aground near Hainan Island. Two Chinese naval vessels arrived the following day to tow the vessel off the reef, but as the *Sen On* was towed off, the rudder was damaged and the ship started taking on water from a tear in the hull.

"We were at the bottom of the ship when the water came pouring in," says Phan Dang. "I still remember that to this day."

Everyone had to be taken off the ship for the repairs to take place. Cang and some of the other men started to help the women and children over to Hainan Island. Already exhausted from malnutrition and dehydration, they swam back and forth in the water with small inflatables, helping to ferry the families on to dry land.

Cang Dang's young wife, Yen Dang, was also aboard at that time. I spoke to her recently. "Les, we were fortunate that although the freighter was trapped by a surrounding reef, we were not too far from the shore of Hainan Island. Cang had to work in shifts to ferry people off the freighter. He was extremely hungry and exhausted, but on his last trip back to the shore, he had the foresight to remove some canvassing from the ship. While that was going on, I went with our niece, Phan Dang, to search for food. Some of the villagers gave us sweet yams and we were so grateful. I hadn't

eaten for days, but I knew I needed to save some food for Cang after his exertion to get people off the ship."

Cang's daily account really brings home how this ethnic Chinese community was stripped of everything and left fighting for survival. He describes how another woman in her 60s dies on the island and is buried, how a young woman carries her dead baby in her arms for days, and how another gives birth to a baby girl while they are there. For more than two weeks, the passengers were marooned on Hainan Island. Local villagers would sell them food in return for their watches and whatever else of value they could sell. Cang described to me how selfishness and intolerance grew among the refugees and friendships held less value than a bowl of porridge. Finally, on May 11, the boat had been sufficiently fixed for the journey to continue but now the journey became far slower.

One night, as the *Sen On* arrived off Macau, the captain and the crew began changing their clothes and it became obvious that they were preparing to leave. First Captain Lee was picked up by a small motorboat; he was carrying bags containing something heavy. And then others began preparing to leave too, shouting instructions to the refugees to continue past Macau, going east, then run the ship aground, so that the Hong Kong authorities would be forced to take them.

Cang told me how they all waited for the dawn to see where they were. A group of men had gathered in the *Sen On*'s wheelhouse and had figured out how to start the engines. One of them was a former navy man and another was a fisherman. Cang watched as the ship slowly made its way towards Hong Kong waters. There was a radio in the wheelhouse and they listened to see if there was news of their ship approaching Hong Kong, but there was nothing.

"Throughout that morning, most of the refugees were packed into the lower deck, where the air was terribly hot and humid. Hearing Hong Kong mentioned, people climbed up from below to look around. As we came to some land, we were spotted by a marine police boat. They immediately turned on warning lights and shouted loudly over a loudspeaker: 'Stop! This is Hong Kong territorial waters.' However, the marine police launch was connected by ropes to several fishing boats and needed to release themselves. They had to cut off the towing ropes quickly before being able to give chase at full speed.

"Of course, we did not want to be intercepted and the *Sen On* accelerated at full speed. We could see through binoculars that there was a white line of sandy beach directly to our left, so we turned the ship's wheel until the beach was directly ahead. This was our target. We could hear the sirens behind us, but the *Sen On* freighter kept forging ahead as the marine police began to catch up.

"On May 26, 1979, at 2.30pm, with no captain, no crew, no compass, no navigator or communications system, and with refugees manning it, this dilapidated and disabled *Sen On* cargo ship, carrying 1,433 refugees, headed straight for the deserted beach. Behind us the Marine Police patrol boat was still chasing. At the ship's helm were community representatives, former sailors of the South Vietnamese Navy, as well as us army guys. There was lots of nervous and excited shouting. Amid a mix of loud cheering and screams of the refugees, the ship crashed aground on the sandy beach and tilted to one side, but was fixed there. And then the

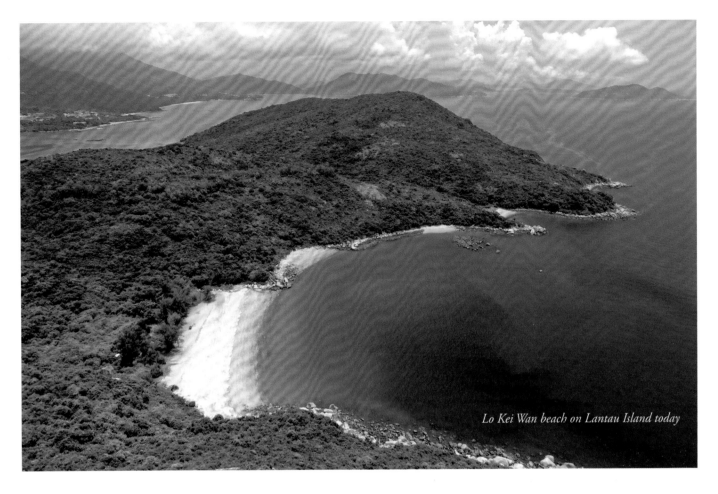

*Lo Kei Wan beach on Lantau Island today*

younger male refugees began to jump overboard or try to climb down into the sea from hanging ropes."

At that time, I was the police inspector in charge of West Lantau and was the first on the scene after receiving a call to my Land Rover. When I looked down from the top of the hills above Lo Kei Wan, the scene below was surreal. A large freighter had sliced the beach in two. Once it had hit the sand, it had just kept on going, ploughing up the beach. As it was wedged and listing in the shallows, the refugees began scrambling down a broken ladder, jumping over the side into the water and trying to swim ashore. Some were having trouble staying afloat in the heavy surf. Others were retching on the sand from all the seawater they'd swallowed.

Cang told me that he remembers meeting me on Lo Kei Wan beach that day. I am afraid I don't remember him as there were hundreds of people needing help from the moment I arrived. It was frantic. I spent the next half an hour helping people ashore, whilst also trying to make sure no one ran away. At that time, I didn't know that the captain and the crew had already left the ship. I was keen to ensure they

didn't get away before officers from the following Marine Police launches could get ashore.

One of those on the *Sen On* was a seven-year-old Caroline Wu. Throughout the journey she had stayed at her mother's side, and they were fortunate that on the first few days of the journey they were able to eat the rice cakes her grandmother had made for them early on the morning of their departure and forced them to take.

"I can remember arriving in Hong Kong and the moment we got off the ship," she wrote to me. "When the *Sen On* hit the beach, it was chaotic; everybody was rushing to get off. People were shouting. They weren't fighting but just trying to figure a way to get off and how to do it safely with all the children and elderly. I remember climbing down a rusty stairway on the side of the boat and all of a sudden that staircase just ended, and I was still so far away from the water. I heard my cousin telling me to just jump and that she had got me. So I let go. I blacked out and only realised we were halfway to the beach when my cousin called out to me. She swam with me on her back to shore. She was only a teenager herself. She was a hero. She saved my life."

Phung Dang, Phan's sister, was 14 years old at the time.

"I remember the journey," she told me. "We did not eat a normal meal, we drank water mixed with gasoline, so horrible. There was such a stench, because people just peed on the spot. One day, I got a chance to go up to the upper deck to breathe some fresh air, and out of the blue there was a flock of flying fish. They were flying parallel to the boat. It made me smile for a moment.

"Later, when we got near Hong Kong, I got transferred to the upper deck by my parents and hid under a big plastic cover and was told to stay still. Things happened so fast; I can't remember clearly. I just remember a lot of people jumped off the ship and swam to the shore. I got off the ship later using the hanging rope because I couldn't swim. But I wasn't scared at all because my family were by my side."

"After the ship ran aground in Hong Kong," Phan Dang told me, "in the midst of the chaos we were told to jump if we could, and I remember going down to the sea on a rope, being caught by someone at the other end, and then wading through the water to reach the shore. I had no idea what had happened to my other family members until, one by one, we found each other again on the sandy beach. I just remember being anxious the whole time, and that all of us just wanted to reach land safely before the ship sank."

Now down on the beach myself, I could see more and more people jumping and dropping from the side of the ship into the sea. Some appeared to be in difficulty in the surf and were being helped by others. Someone had lowered a broken and twisted ladder over the port side of the ship. Although the ladder only reached halfway down, people were scrambling over it. Some, those already at the end of the ladder, looked terrified of the drop and were still hanging on. Others climbed over them in their haste to get off the ship, which was now listing heavily to the starboard side. I couldn't help but think of the photograph I had seen a few years earlier of a line of desperate people trying to board a helicopter on a roof in Saigon in their attempt to escape. Here the same thing was happening, only this time in reverse.

There were small groups of people sitting, lying and standing in front of me who had barely made it ashore.

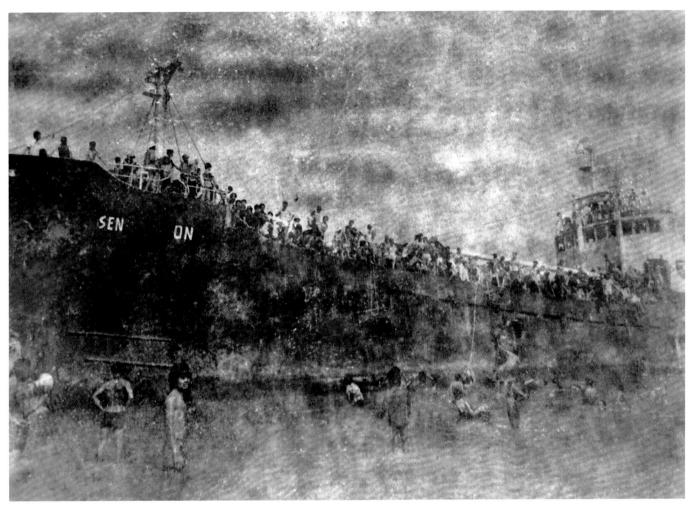

*I took this photograph using a Polaroid camera that I borrowed from a trailing police launch, shortly after the* Sen On, *with 1,433 people on board, ran aground on Lo Kei Wan beach on 25 May 1979. At that moment most of the refugees were still on board the ship and were desperately trying to get off as the* Sen On *was listing to starboard and was in danger of capsizing. Some of those trying to get off can be seen, halfway along the side of the ship, scrambling down a broken ladder, whilst others are either swimming ashore or have already made it to the beach. It was a manic moment. I remember quickly stuffing this photo into the pocket of my shorts, throwing the Polaroid camera back to the Marine officer who had loaned it to me, and running down the beach to find out what was happening on the other side of the ship. I didn't know at that time whether the master and crew were mixed up with the refugees, and I needed to find them.*

Some were on their hands and knees in the sand, retching and gasping for breath. They were young, mostly teenagers, those young and brave enough to jump from the ship. I figured there must be older ones, sick people, women with small children. Where were they? How were we going to get them off this ship that was still moving, still listing? The *Sen On* looked as though it could capsize at any moment.

It was difficult to know which way to turn, or who to try and help first. One man was up to his waist in the surf dragging another semi-conscious man out of the water. He dropped him on the wet sand and went back into the sea to help another. I was surrounded by a group of about 50 young men, all shouting at me at the same time. Whilst trying to calm everyone down, it occurred to me that the master and crew of this, what-appeared-to-be a people-smuggling ship, could well be mixed up in this group or in the process of trying to make good their escape. I looked both ways along the beach but could see no one running away. All of those who had managed to get off the ship were now either here in front of me or were coming ashore. An old man explained to me how the crew had left and how they had paid their passage in gold.

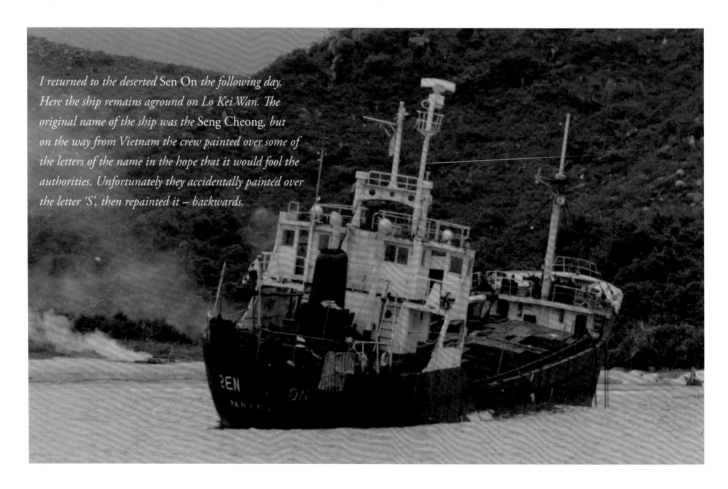

*I returned to the deserted* Sen On *the following day. Here the ship remains aground on Lo Kei Wan. The original name of the ship was the* Seng Cheong, *but on the way from Vietnam the crew painted over some of the letters of the name in the hope that it would fool the authorities. Unfortunately they accidentally painted over the letter 'S', then repainted it – backwards.*

Two large Marine Police launches arrived, and the men were ordered to not let anyone run off. I borrowed a Polaroid camera from one officer – we used them for evidence usually – and took a quick photograph of the listing *Sen On* and hundreds of people midway on a rope, or ladder, or scrambling over the side. While half an hour previously I had stood alone, now we had some 50 officers, but while many of the younger refugees had scrambled down, there were still hundreds inside.

I boarded the ship by standing on top of a Police Motor Boat and then on to the stern of the *Sen On*. And from down in the hold in the middle of the deck, hundreds of faces looked back up at us, many of them women and young children. And we would spend the next four hours evacuating them.

At first light the following morning I returned to Lo Kei Wan in order to take a closer, and less frantic, look at the *Sen On*. Information had been received overnight from the Marine Department that the real name of the vessel was the *Seng Cheong*. The first thing I noticed as we approached the ship from the seaward side was that the letter 'S' in the name had been painted backwards.

Now, with the beach deserted, the hulk sat exactly where we had left her the evening before, listing to starboard. The tide had come in, and the entire hull was surrounded by sea, but she remained stationary and was obviously still aground. I had travelled from Tai O in the same Police Motor Boat that I'd climbed up the stern section from the day before. Today I performed the same boarding procedure, pulling myself over the balustrade without much of an effort.

It was quite an eerie feeling, walking alone around an old

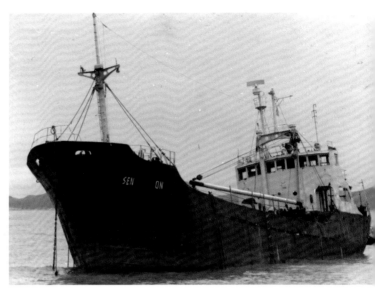

*The* Sen On *was in very poor condition and still listing to starboard. At least it hadn't capsized and sunk.*

empty ship, particularly one that had been the scene of so much anxiety and heartbreak for so many people. Whatever belongings the people on this ship had brought along with them from Vietnam were left here onboard the *Sen On*. Small parcels of clothing, dirty and wet, littered the entire ship. There was the occasional bag of food, rice, a half-eaten packet of biscuits, crushed underfoot. I kicked at some of it and it sloshed in soggy lumps across the deck. There was nothing of any value that had been left behind.

I climbed the ladder back up to the bridge and looked around for a second time, wondering if I'd missed anything the day before. The story of how the master and crew had abandoned the ship while off Macau on the Friday was now public knowledge. I looked out of the bridge window at the open hold and the bows, wondering what it would be like to live down there for over a month, not knowing where

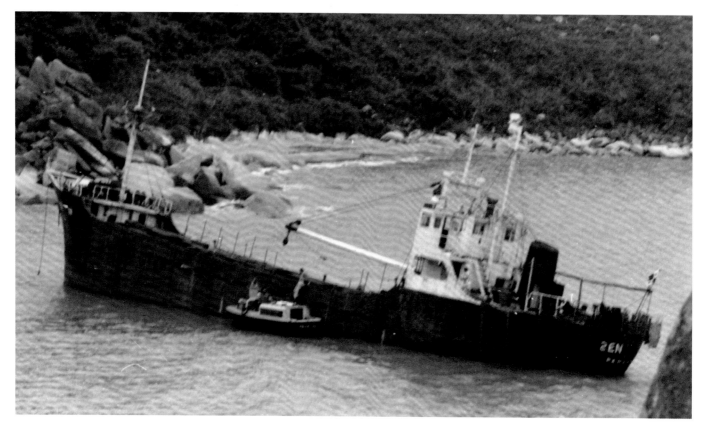

*Above: I scramble down the side of the* Sen On *after finishing a second sweep of the ship. This was 1979 and Vietnamese refugees were arriving in Hong Kong in their thousands. As I walked around that ship that morning I recalled the faces and voices of the people from the previous day. It left me with a lot of unanswered questions.*

*Left: The wheel was removed from the bridge by a Marine Department officer prior to the ship being broken up for scrap. The wheel now hangs in the Mariner's Rest, the Marine Police officers' mess in Sai Wan Ho, Hong Kong.*

you were going or if you were going to survive the journey. There was a chilling silence throughout the *Sen On*. I didn't want any more of this ship. There was nothing more here for me. I climbed back over the side, back into the PMB and we motored away, back toward Tai O. I resisted the urge to turn for one last look.

In recent weeks, I asked Cang's wife Yen, in America, if she'd do it again – risk her life, lose everything she owned. Yes, she said, if it meant settling in a country without persecution.

Cang told me: "It was 42 years ago that you and I stood on that beach together. I had been a soldier fighting in a war since I was just a boy. Then I was a refugee. Now I am an American living in California. Our lives have been so different – yet we have that one moment in time, and now, because of your book, our paths cross once more. Life is strange."

## If at first you don't succeed

I was introduced to Steve Le by other former refugees. Steve now lives in London and we have become good friends. When Steve made his first attempt to leave Vietnam in 1978 he was 21 years old. He didn't make it. He spent the next 10 months in prison, only being released after his sister paid the guards a bribe. It wasn't long before Steve tried for a second time.

After the war ended, the lives of the South Vietnamese underwent tremendous change. I come from Saigon, and after the end of the war in 1975 all I wanted to do was get away. I just wanted to settle in a free and democratic country and to be self-reliant. I hoped to make a living without fear. Leaving Saigon, the place where I had grown up, and leaving my family and friends behind, was so hard. But I had to try and get away.

On New Year's Eve, 1978, I met with four friends. We planned to try and escape together. First we drove to a prearranged secluded spot by the river, just outside of the city. We had paid a middleman 10 taels of gold each to arrange our passage, and the small boat that met us that night was to take us out to sea to meet a bigger boat, one that would take us to Hong Kong. After boarding the small boat we travelled for about four hours in the darkness. As the sun came up we met the larger boat. It was a wooden motorised fishing vessel about 10 metres in length. To the stern of the vessel was a small cabin. When we boarded the vessel we found that there were another 20 people on board, all wanting to escape like us.

The captain of this fishing boat sailed out into the open sea, but very soon a storm came up and our boat was tossed around on the ocean. The waves were so high I couldn't see anything outside of the boat. Our captain lost control in the heavy seas. There were very strong winds and big waves and, when we began to take in water, I was sure we would sink. Suddenly there was a loud crash and we found that we had been thrown against some rocks. As the storm began to subside we could see, for the first time, that we were aground on an atoll. The boat was stuck.

Some hours later a Vietnamese government patrol

boat turned up and took us off our wrecked boat. They took us to a nearby island where the only structure was the Duyen Hai prison camp. I lived in the camp for five and a half months. Each day all prisoners were put to work, mostly manual labour. I was not told what was happening to me or how long I would have to stay there.

After almost six months I was sent to another prison – the infamous Chi Hoa Prison built by the Japanese during World War Two. I was put inside a large cell with about 70 other prisoners. There was only one bare light bulb hanging from the ceiling and one toilet inside the cell. A lot of the prisoners were sick, infected by skin disease, some were covered in abscesses. The place was filthy. I was very worried I would become infected with whatever the other prisoners had. We were only allowed out of the cell three times a week to wash under a single shower, each time for just 10 minutes. The remainder of the time, day and night, we were locked inside the cell. Many of the other prisoners were taken out and beaten. I was very worried every time the guards came, as I thought it was my turn.

After almost 10 months in prison I was released. It was then that I discovered that my sister had bribed the guards to set me free. I also discovered that my sister had been paying the guards every month not to beat me. After being released, I was even more determined to get away from Vietnam.

As soon as I could raise the money for another attempt, I did so. This time I became one of the 1,400 passengers on the freighter the *Sen On*, arriving in Hong Kong in May 1979. Six months later, in November 1979, after spending most of that time in Kai Tak camp, I was told I was being accepted by the British government as a refugee. I have resided in East London ever since. Many of my relatives still live in Vietnam. They are very poor. I have only been back once in the past 40 years.

# Chapter Three

# And Still They Came

In the days that followed, the *Sen On* was towed away and was eventually scrapped, but two more months would go by before the *Skyluck* saga was concluded. Although this tinderbox of a situation had dragged on for more than four months, the Hong Kong Government remained firm while investigations into the ship's background continued. Then, on a particularly blustery morning of 29 June 1979 – four and a half months after its arrival in Hong Kong – everything changed. While Police Launch 1 was back in Aberdeen taking on fresh water and refuelling, a small group of refugees slipped the *Skyluck*'s moorings and cast the ship adrift in rough seas. The 4,000-ton *Skyluck* swung wildly on its single stern mooring. At first it looked like the ship would be swept out into the West Lamma Channel. Police Launch 1 returned and made several attempts to re-secure the ship as she swung out of control, but the wind and sea swell caused the last mooring to give way and the *Skyluck* was buffeted towards the north coast of Lamma Island, where she ran aground on the rocks, listing heavily. Many of the younger refugees jumped overboard and scrambled ashore, while a rescue operation got underway to evacuate the remaining 2,000 people off the battered and sinking ship. Paul Lai and his crew managed to perform this rescue in very difficult conditions. There was only one minor injury during the whole evacuation.

The grounding ended the *Skyluck* saga. After those who had swum ashore had been rounded up, all the 2,651 were officially "landed", and the process of health checks and immigration interviews began.

"John Baker", who asked me not to print his real name, was an inspector at Special Branch at the end of the 1970s, when a new section was set up within the branch to interview "persons of interest" among the Vietnamese coming in on the boats. And, of course, it wasn't just the colonial government here wanting to know if any players were coming out of Vietnam. The United States also had a keen interest.

The three people-smuggling ship cases were over by then, so this was the latter part of 1979 when the Vietnamese began arriving in their hundreds each day in small craft. All newly arrived vessels were escorted to the Government Dockyard by the Marine Police, where the initial medical examinations and general processing took place. In my team was a Vietnamese-

speaking Hong Kong Police constable. His mother was Vietnamese, and he was fluent in the language. But most arrivals at that time could speak Cantonese, so we didn't have much of a problem communicating. It was our job to interview anyone identified by ourselves, or by one of the other government agencies, that we thought of interest. There were no guidelines or written orders or directives for us to follow when doing this; sometimes it would depend on the look of the boat or the person's clothing. From time to time, one Vietnamese person would point out another, identifying him or her and telling us stories about the other.

In addition to Special Branch, there was also an American team that included a former South Vietnamese Army soldier who had recently escaped from Vietnam. He was assisting the Americans with their interviews. This former soldier spoke very good English and I recall him telling me that he had been a member of the Army of the Republic of Vietnam (ARVN). He had escaped Vietnam at the fall of Saigon in 1975 and had been working with the Americans ever since. His main role at the Government Dockyard was to identify any of the new arrivals that could possibly be North Vietnamese infiltrators, sent by the new government in Vietnam to try and gain access into the US on the pretext of being a refugee. Spies, in essence.

We co-operated with the Americans on the surface. They could not operate without Hong Kong Government agreement and we needed their inside knowledge. Although we shared information, there were two separate agendas – the Americans wanted to identify people they could either avoid taking in or use in the future, whereas we wanted information about the situation in Vietnam and the potential threat to Hong Kong from large numbers of further arrivals.

Between us we probably shared about 80 per cent of what both sides knew. But generally we tended to work together, let's face it, we were in the same interview room. This shared accommodation arrangement was deliberate on our part, as we did not want the Americans getting the jump on us… but I dare say they did.

The Americans' former ARVN guy would, from time to time, say something like, "You see him, he was in the South Vietnamese Army" or "he was Viet Cong…". Of course, there must have been many others that he knew about that he simply kept to himself, as was his brief. He was working for his own Green Card, which he eventually got. He certainly deserved it. I remember him as being a good guy.

Each day at the Government Dockyard in 1979 threw up an interesting case. I recall on one occasion that the leader or captain of a small boat of people who had been waiting their turn to be interviewed began waving to me from his place towards the back of the queue. We sat him down inside one of the huts and asked him what he wanted. There he produced a bag that contained a large amount of gold jewellery and small gold bars. Via our interpreter this man explained that if we would arrange for him and his

family to go to the US, he would give us this bag of gold, no questions asked. After calling my boss at Police Headquarters it was decided to get the local CID involved, and so an inspector from the police station nearest to the Government Dockyard turned up.

"What do you want me to do about it?" he asked. "This man hasn't officially arrived in Hong Kong." We could see his point. So, after some scratching of heads, the bag of gold was returned to the man, who in turn was then put back on his boat and told to sit down and wait his turn for the processing interview. I have no idea what eventually happened to him or his bag of gold as we immediately moved on to the next interview.

Another time one man produced a bag full of human bones and American military ID dog tags. Of course, military dog tags were very easy to come by in Vietnam at that time and the medical examination that followed identified the bones as human, but not Caucasian or Black. This was just another example of a new arrival attempting to single himself out for some form of special treatment.

Frank Lai was an Assistant Immigration Officer in Hong Kong. In 1979 he was posted to the Vietnamese Refugee Division, located at the Government Dockyard in Yaumatei. His team was involved in receiving newly arrived Vietnamese refugees whose vessels had been escorted from the southern boundary by the Marine Police. Frank eventually settled in Australia and has, by chance, met a number of former refugees who passed through Hong Kong's Government Dockyard system.

My job was primarily conducting interviews and taking statements from the Vietnamese to verify their origin and their port of departure from Vietnam. The number of boats we processed in any one day depended on the number of passengers. But it averaged out at two, occasionally three vessels. We were assisted by some Vietnamese speaking officers from Special Branch.

The Government Dockyard Reception Area was at that time managed by the Prisons Department. They were responsible for the daily operation within the dockyard.

The conditions there were very basic. It was always crowded, hot and humid, and smelly.

Quite a number of the refugee boats in 1979 had initially landed in Thailand, where they were given water and rations before the Thai police towed them back out to sea and left them to their own devices. Others told stories of how they had made many attempts to flee Vietnam but were recaptured and sent back, but only after having to pay a substantial fine. They believed local police were playing a game in order to squeeze more money out of them. We were told stories about some boats being attacked by pirates along their journey. Some of the female refugees on board told us they had been raped, whilst some of the male refugees were beaten, even killed, if they resisted.

As part of our investigations we also conducted physical searches of the vessels to gather more evidence to substantiate the stories. We checked the log book, if there was one, and compared it against their stories of their voyage and the conditions and design of their boat. Some of the boats were hardly seaworthy for an open sea voyage. We asked about the time taken to reach Hong Kong. We would also check their knowledge on current events happening in Vietnam at the time. We also checked the amount of navigational equipment and food they had, their appearance and state of health of the passengers. We found many US military compasses, watches, blankets and emergency rations on these boats. We never found weapons.

In 1979 the refugees we interviewed were mostly from South Vietnam, especially from Saigon. They were mainly ethnic Chinese and almost all of them spoke fluent Cantonese. They were entrepreneurs and merchants who dealt with a diverse group of Chinese business people from the rest of Asia. They told us that they had to bribe the local Public Security officers in Vietnam with gold bullion to exit their port.

We found that many of the ones we interviewed had made many attempts to leave before they actually succeeded. Many had been recaptured shortly after. After being recaptured they were sent to hard labour camps in the New Development Zones. We were told they were sent to them for at least six months.

Many of the refugees who settled in Australia started their new life by working at several jobs at the same time. Some opened their own shops and businesses. They did very well and made wonderful contributions to the Australian community.

*Frank Lai*

**It was a brave move**

One month later, a United Nations conference titled "Refugees and Displaced Persons in South-East Asia" was convened by the Secretary-General of the UN in Geneva. The Governor of Hong Kong, Sir Murray MacLehose, attended, as did representatives from many countries from around the world, including Vietnam. On his return to Hong Kong on 23 July Sir Murray held a press conference at Kai Tak Airport. He said, "The root cause of the problem

is Vietnam itself. The problem is of a racial type, applied with great force to a minority in Vietnam." The governor further commented, "One thing that has been proved is that Vietnam can turn the tap off if it wants to. I suppose that it can also turn it on again if it wants to. Just what they will do can only be judged by the number of boats that actually arrive in the future. At present we just don't know."

After the Vietnamese government had basically been called out in Geneva, the big-ship racket stopped. But then came a further development that was not only to seriously impact our southern boundary duties, but also Hong Kong as a whole. In response to China's attempted invasion of Vietnam, the Vietnamese Government began repressing ethnic Chinese in Vietnam, causing many to seek refugee status in Hong Kong. The Hong Kong Government, with backing from London, declared itself a "port of first asylum".

This meant that no Vietnamese refugees arriving in Hong Kong would be turned away and, once in Hong Kong, they could, with the assistance of the United Nations High Commissioner for Refugees (UNHCR) organise resettlement in a third country. With Singapore, Malaysia and Thailand quickly moving to shut their doors at the same time, Hong Kong became the "safe haven" – the destination of choice for Vietnamese determined to start a new life.

During the second half of 1979, with Hong Kong now the go-to destination in Southeast Asia, people continued leaving Vietnam in large numbers, this time in smaller wooden boats. And, not surprisingly, people kept arriving in large numbers along Hong Kong's southern boundary.

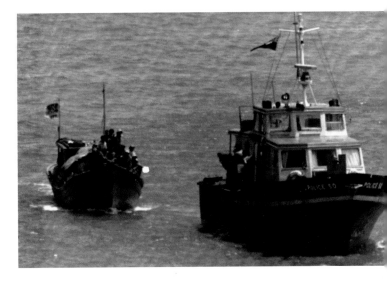

*Police Launch 50 (Sea Cat), the sister to my own launch, PL 56 (Sea Falcon), escorts a motorised Vietnamese vessel into Hong Kong waters in 1979. The Marine Police fleet of the late 1970s included seven of these 78-foot patrol launches. Built in Singapore by Vosper Thornycroft, they were powered by twin Cummins diesel engines which gave them a top speed of 20 knots. Throughout that very busy year of 1979 these launches were the backbone of our fleet, intercepting a high percentage of the Vietnamese vessels that arrived in Hong Kong during that year.*

## The sharp end

As 1979 drew to an end, Hong Kong took stock of the previous twelve months. Some 68,700 boatpeople from Vietnam had arrived in the territory in that one year alone. And while some had already been resettled overseas, more than 30,000 remained in camps in Hong Kong awaiting placement. Out on the southern boundary more and more vessels were arriving every day. They came in every type of craft imaginable, from sailboats to motorized sampans, from flat-bottomed river boats to homemade rafts – basically

anything that the occupants thought would carry them the 1,000 sea miles to Hong Kong. Sadly, thousands misjudged the enormity of this undertaking, attempting to cross the South China Sea in vessels that were never meant to travel such a distance on the open ocean, and with so many people on board, many were never seen again.

This tragic aspect was made very apparent to me in July 1979. Throughout that month, Vietnamese were arriving along the southern boundary in small wooden boats at a rate of about 500 a day. Then, in early August, Super Typhoon Hope struck Hong Kong. More than 100 people lost their lives in Hong Kong and then the storm careered across the South China Sea. For the remainder of the month of August 1979, the average daily boatpeople arrival figure was zero.

It was towards the end of 1979 that I began my second tour of duty in the Marine Police and was posted to Marine South, which was the division tasked with patrolling the southern boundary, with the primary task to intercept and handle all incoming Vietnamese vessels. I was pretty pleased with this posting. After living and working at Tai O for over a year I was keen to be back at the "sharp end", as some senior Marine officers referred to working on the frontline.

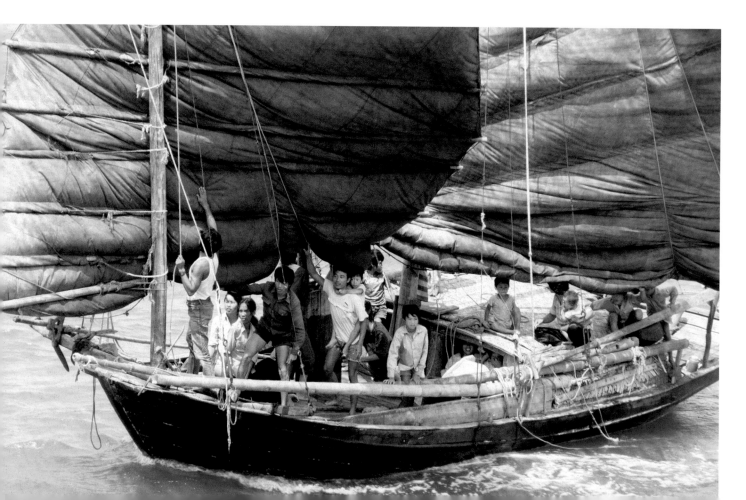

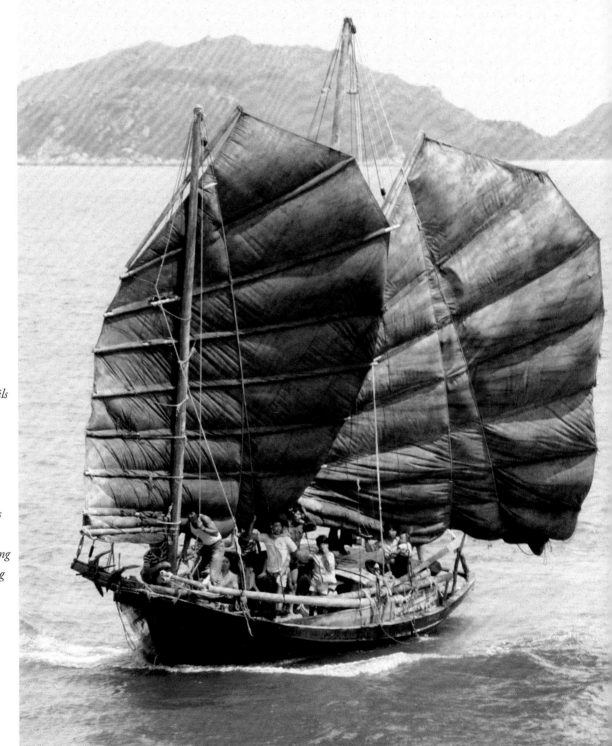

Left, right and overleaf:
The master of this twin-
masted sailing junk
prepares to lower his
orange, sun-bleached sails
after being intercepted
off the Soko Islands,
just inside Hong Kong
waters. Although these
photographs were taken
several years later, this is
a typical example of the
Vietnamese coastal fishing
vessels that were arriving
in 1979 and 1980.

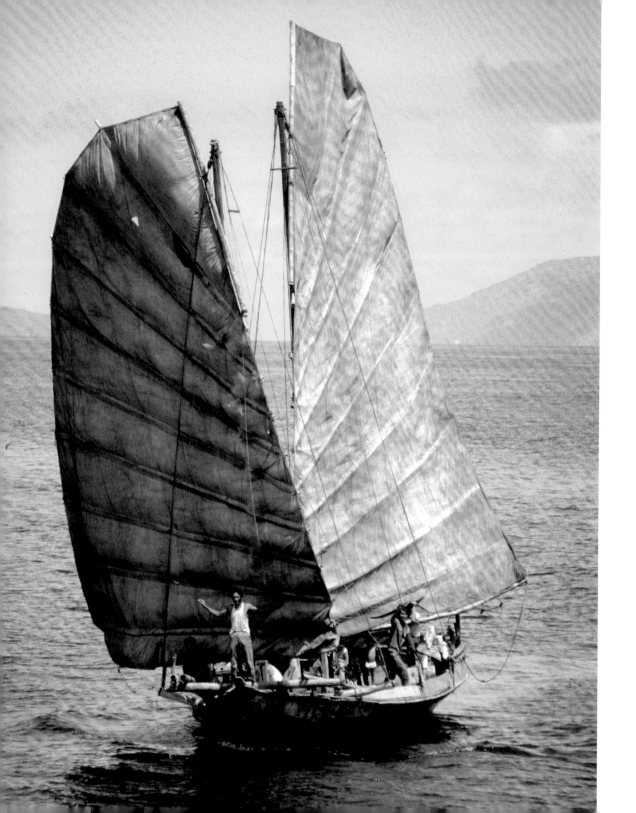

# Chapter Four

# **Human Chess**

Iwas now "launch commander of Police Launch 56". PL 56 was one of four major patrol launches deployed to Marine South. She was a 78ft offshore patrol launch. Built by Vosper Thornycroft in Singapore in 1973, PL 56 was powered by twin Cummins diesel engines and had a top speed of 20 knots. She had a complement of 12 Marine officers, who were divided into two four-hour watch shifts.

Upon returning to launch-going duties I quickly realised that we were stretched to the limit in dealing with this new influx of vessels from Vietnam. Along the 30km-long southern boundary, in addition to four Marine Police launches, there was, from time to time, one of the Royal Navy's Hong Kong Squadron ships. So, a maximum of five, sometimes four, patrol craft. They'd need to refuel, which took several hours back to Aberdeen, and pick up fresh water. We lacked vessels. Just taking any Vietnamese to the inner harbour area was a round trip of 50km.

Many Vietnamese craft were sinking as they arrived in Hong Kong. A rescue could take one, sometimes two, police launches a number of hours to complete. During a rescue the Marine officers involved were not free to look out for other incoming vessels. Then there was the immediate medical

care needs to address for mothers and children.

If two or three Vietnamese vessels arrived within a couple of hours of each other, it wasn't uncommon for most, sometimes all, of the sea boundary to the south of Hong Kong to have no Marine Police vessels actually on patrol. All would be busy tending to vessels that had already arrived.

By 1980, I'd been given the job of operation commander of Marine South – which covered the area on the southern boundary where most Vietnamese were coming in. With the Admiralty chart spread out on the command launch's chart table I felt, at times, as though I was playing a giant game of chess, with the chess board being the South China Sea and the playing pieces the Marine Police launches and the Vietnamese vessels. And the pawns – they were the thousands of people with their lives at stake. We needed more patrol craft urgently. Something had to be done, and so a number of vessels that belonged to other government departments were pressed into Marine Police service. While we were grateful for these additional boats, I must point out that none of them were new, or designed for patrol and interception work on the open ocean.

One of these vessels, the *Sir Cecil Clementi*, was built in

1959 for commissioners of the Tai Po district office. She was the D.O. Tai Po's personal run-around. The *Sir Cecil Clementi* came with a boardroom complete with a long, highly polished, rosewood table – just what we needed for rescuing refugees. There was also the incredibly slow and cumbersome *Tin Hau*, described as a "HKG general-purpose vessel". Incidentally, the *Tin Hau* was scrapped very soon after completing her short spell as a Marine Police vessel owing to her "slow speed, small size and increasing maintenance costs" – read, it was forever breaking down.

In addition to these two stalwarts of the Hong Kong fleet there was also the Environmental Protection Department's general-purpose vessel, the *Chop Yat*. This boat had spent most of its life in the Deep Bay area collecting samples. The EPD reported that the *Chop Yat* "suffered from limited deck space and no on-board facilities". She was not a popular addition to our fleet. I also remember an unnamed Fisheries Protection vessel that smelled of fish and a Marine Department tugboat that took so long to reach the southern boundary from Aberdeen that by the time it actually got there it was time to turn around and go back again.

While these vessels did help to a certain degree, I seem to recall spending large amounts of time on duty helping to fix one or more of their multitude of problems, mechanical or otherwise. And when Marine Police officers reported for duty, only to be informed they were to spend the next 24 hours patrolling on the *Chop Yat,* their language could best be described as colourful.

But help was at hand. Real help this time. Marine Police Headquarters in July of the previous year had the foresight to apply for, and have approved, the construction of a fleet of nine new divisional patrol launches. In mid-1980, the first of the nine, Police Launch 60, named *Aquarius*, came into service and was deployed to Marine South. It became the division's command launch, and I lost no time in moving all of my gear into the air-conditioned "commander's cabin".

The first reception area for the incoming Vietnamese vessels was inside the Government Dockyard basin at Yaumatei. At times it was full of vessels and people. One day in 1979 it held 9,700 people waiting to be processed. The actual reception platform itself was a pontoon moored to the sea wall, upon which teams of Immigration Department officers and medical staff sat, all under a green plastic awning. Behind the pontoon, on the quay, was a line of large maritime equipment storage sheds. These sheds had, some years before, been painted black. Once the Vietnamese had completed their initial interviews they were relocated from their boats into these sheds, where they stayed for one or two days until space in one of the established camps could be found.

Then came the move from the GD to the Western Quarantine Anchorage, decreed necessary by the Port Health Department as Vietnam was at that time still one of the world's declared bubonic plague areas. The WQA was simply the same pontoon as had been positioned inside the Government Dockyard. It still had the green awning. It was a heaving pontoon in the Western Harbour, open to the elements. At times there were up to 50 small Vietnamese craft moored around the pontoon. It resembled a floating market, the only difference being there was nothing for sale.

## The flaming bed

The smallest, and probably the strangest, Vietnamese vessel I ever encountered was one I nicknamed "the flaming bed". The flaming bed arrived from the south one night in 1980. As usual I was on the bridge of my police launch on the lookout for incoming Vietnamese vessels. We were positioned midpoint between the Soko Islands and Fan Lau Point on the southwest of Lantau Island. Being deployed to this position was referred to as being "on point" as it was the busiest patrol area, with many of the Vietnamese vessels that had crossed the South China Sea arriving from a southwesterly direction towards Hong Kong.

Usually at night the only way to locate these incoming Vietnamese vessels was by use of the patrol launch's radar, as almost none of the Vietnamese vessels were equipped with navigation lights, or lights of any description. We usually set the range of the radar to cover the sea surface for five miles outside of Hong Kong waters. That way, once a suspected Vietnamese vessel was spotted, we would have plenty of time to prepare for an interception. But the flaming bed was different: we saw it through binoculars coming from much further away. This "vessel" was, in fact, a raft. It was five metres square, made mostly of plywood sheets, bamboo poles and plastic barrels, all lashed together with thick ropes to give it both buoyancy and some degree of stability. On board the raft were three Vietnamese men, all of whom were kneeling down and rowing the raft towards Hong Kong using short planks of wood as paddles. The reason we could see all of this from quite a long way off was that at each of the four corners of the raft was positioned a six-foot-high bamboo garden torch. All four torches were alight with a

*By day and night our launch radar scanners were invaluable. Not only could we see what was coming, but by calculating a vessel's distance and speed, we knew when it would arrive.*

naked flame. At first glance the raft looked like an upturned four-poster bed, one that was on fire. As we approached this flaming bed I ordered my deck sergeant to turn on our main searchlight as I needed to get a clearer look at this gondola-like craft before we made an attempt to go alongside. There was silence in the wheelhouse of our launch as members of the crew tried to make sense of what we were now looking at. As the beam of the searchlight swept across the surface of the water a few things went through my mind. How did

these three men get here on this "upturned bed" contraption? How was it possible to cross the 1,000 miles of South China Sea on it? Plus, four flaming garden torches?

In the interests of safety of everyone concerned, rather than try and take our launch alongside the flaming bed, I decided to stop our engines and invite the three men to row their contrivance towards us, which they eventually managed to do after going in circles a few times. To us onboard the police launch it became apparent that other than going forward, these three men had not yet mastered the art of paddling their flaming bed with any degree of efficiency in any other direction. After much shouting, pointing and swearing, accompanied by lots of suggestions that were not very helpful from my officers, the three Vietnamese men managed to secure their bed alongside our launch. The first thing to do, I decided, again in the interests of safety, was to extinguish the live flames. Three of the flames proved no match for our cook armed with a wet cloth. He took repeated swipes at the flames, scoring direct hits, but the fourth proved stubborn, as it was fuelled by some form of paraffin-base attachment. It simply refused to yield to a deftly aimed wet tea towel. The matter was concluded by the arrival on deck of our engineering sergeant who placed a large metal cooking pot, upside down, over the top of the torch. The flaming bed flamed no more.

Once on board our launch, the story the men told us was that they had left Vung Tau three weeks previously in a large motorised wooden boat with 30 others. Two days ago, somewhere west of Macau, there had been a dispute on board the boat about where and how they were going to try and enter Hong Kong waters. These three, so they claimed,

wanted to arrive as quickly as possible and surrender to the authorities, but most of the others thought that it was best to try and sneak in without being spotted, make land and then surrender to the authorities. This later plan, the others mistakenly believed, would give them all a better chance of being accepted as refugees, because they had set foot on dry land prior to announcing their arrival. These three, in a mixture of very excited and heavily accented Cantonese, Vietnamese, a little English and a lot of sign language, told us that during this heated discussion, the others had forced them out of the boat, and they then had to swim some distance to shore. Once ashore they then somehow acquired the paraphernalia to build the flaming bed and then row the final 50km to Hong Kong.

All this seemed quite remarkable. But it was a time of things remarkable, and as they were certainly Vietnamese and had arrived by sea, we treated them in just the same way as any other Vietnamese arriving in more conventional craft. But I felt I had to ask about the four flaming garden torches. "Lights," exclaimed one of the men, his face itself lighting up at my question. He then rattled on for several minutes, describing how he had convinced the other two that they needed lights on their raft in order to safely cross the Pearl River estuary and reach Hong Kong. Looking at the enthusiasm with which this man spoke, and the utter boredom on the faces of his two companions, I realized that here was a man who was an engineering fanatic, a mariner, and probably a thief, all rolled into one. I also had no doubt that somewhere west of Macau there was someone still wondering where his four garden torches had gone.

## Even smaller?

While the flaming bed was the smallest Vietnamese vessel I intercepted in the whole saga, one clear calm sunny day off the Soko Islands I, and everyone on board PL 56, mistakenly thought we had located an even smaller craft.

Our lookout alerted me to a dot on the horizon. This dot was moving (it turned out to be drifting) towards Hong Kong at no faster than walking pace. We sat on the territory boundary and watched the dot slowly get nearer. "It's one man," announced the lookout, adjusting his binoculars. "He's in a basket," he added. I took a look for myself. It was one man in a tiny circular craft. He was rowing towards us using a single wooden oar. As he got within fifty metres the name of this type of craft came to me.

"That's a coracle," I announced to the crew, who looked back at me, expressionless. We allowed the man to row up alongside the launch, and the on-watch sergeant stepped out onto the deck and called out in Cantonese, asking the

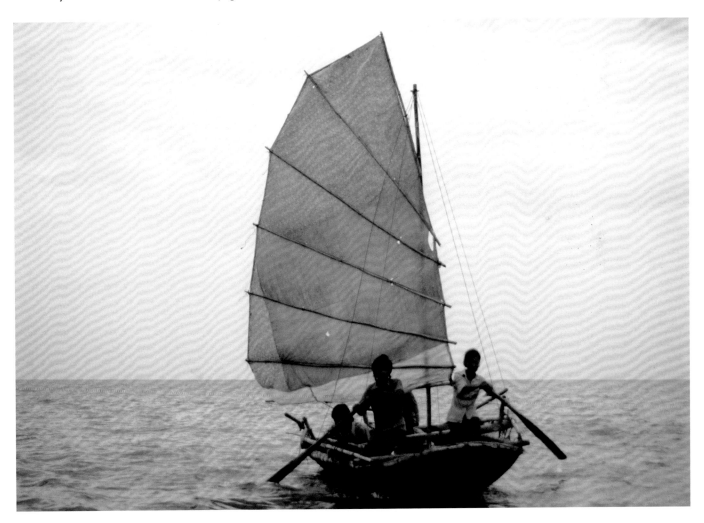

man if he was okay. The man was Asian, he was stripped to the waist and had very dark skin. Sunburnt, I thought. But he looked strong and muscular. He rowed with a powerful stroke. This was not a typical Vietnamese boatperson. Upon hearing the sergeant's question, the man stared back, blankly. It was obvious that he hadn't understood the language. I went out on to the deck and looked down at this man and his small vessel. His coracle wasn't quite circular, more of an oval shape. It was about three metres in diameter and made of interwoven bamboo strips. The craft had been waterproofed using some form of black resin. "Do you speak any English?" I asked the man. He smiled, the white of his perfect row of teeth accentuated by his dark skin. "Yes, Sir," he replied. "English, I speak English."

I recognised the accent immediately. "You are Filipino?"

He nodded. "I was fishing off Pasaleng Bay, my home, and the tide and current took me offshore. I have been drifting for eight days." He was still smiling, as though he'd been out fishing for a just few hours.

After helping the man on board PL 56, and after we lifted the coracle on to the deck, I took the man into the wheelhouse and gave him water and food, which he quickly devoured. He told me how he'd survived this past week by eating the raw fish he caught on the way and by drinking rainwater that he'd collected in the bottom of his small boat. After he'd settled down a little I grabbed a blank piece of paper and pencil from the chart table and drew a rough diagonal line across the page. "China coast," I said, pointing at the line. The man stared at the paper. I put a dot on the line. "Hong Kong, here," I continued. The man looked at me. I drew a squiggly line a few inches below Hong Kong. "The

coast of Luzon," I said to the man, who smiled once more. Now he understood. "Where did you come from?" I asked, handing him the pencil. He made a mark on the northern tip of Luzon, some 300 nautical miles to the southeast of our current position. "Here," he said.

I went over to the radio cabin at the rear of the wheelhouse, picked up the microphone and asked to speak to the Duty Controller at Marine Headquarters. I began my message, *"From Police Launch 56. To Marine Command and Control Room. You are not going to believe this…"*

## Not another people-smuggling big ship?

Another "you are not going to believe this" vessel arrived one clear and sunny afternoon in late 1980 from the south. I was on board PL 60 just to the southwest of Lamma Island when our lookout, through binoculars, spotted an odd-looking vessel heading in our direction. "It's big," he shouted, turning to look back at me as he spoke. I picked up my binoculars and took a look for myself. I immediately thought, "Oh no, this could be another people-smuggling ship."

"Get on the radio now," I told our deck sergeant. "Inform Marine Control that we might have another big ship heading for Hong Kong. Also, give me the positions of our other patrol launches. We might be needing some help here to stop this ship."

I took another look. The vessel was too far away to be properly identified. It certainly was big, and it was certainly moving slowly towards us, but as yet that was all I could make out. "It looks to be over five miles out," I said to the sergeant. "See if you can get a clear contact on the radar scanner. See if you can estimate the length of this ship."

All police launches kept their radar equipment turned on 24 hours a day, even on clear days like this. The radar was one of the best navigational aids we had, and we frequently used it to estimate our distance from other vessels or from a land mass.

"It is at 5.9 miles due south," called out the sergeant, "currently heading in a northerly direction." I looked at the sergeant expecting more. "It could be 200 feet in length, but not so clear yet," he said, looking up.

"Damn," I thought. The *Sen On* was only 150 feet in length. This could well be another attempt at a forced entry into Hong Kong waters. I put the binoculars down and went into the radio cabin. "Give me the microphone," I said to the radio operator at the desk. "Marine Control, this is PL 60, I need to speak to the duty controller, urgently," I began. The duty controller came on-set immediately.

After explaining the situation, I asked, "Can we get a helicopter up, get a description of this ship?"

"I am already in communications with POLMIL," the duty controller said. "The Royal Naval patrol craft has been informed and air surveillance is being arranged now. Please confirm your current position, over."

POLMIL was the joint police-military operations room located at Police Headquarters. It was staffed by senior officers from both the Royal Hong Kong Police and the British military. It was from this operations room that all major security operations affecting Hong Kong were directed.

I looked out of the wheelhouse at the South China Sea. I knew that the duty Royal Navy ship was presently out in the eastern waters and it would take over an hour for her to get here. I also knew what was coming next, so I pulled out the Admiralty chart for the waters south of Hong Kong and spread it across the chart table. "Give me the position of that ship," I said to the sergeant. I looked out of the wheelhouse at the state of the sea. Flat calm. At full speed it would take us 12 minutes to get there.

"PL 60, this is Marine Control." Here it comes, I thought to myself. "You have permission to leave Hong Kong territorial waters. Proceed at full speed to the vessel in question. Your ETA, over?"

I checked my watch, 14:17. "14:29, over." I looked at the sergeant, who had been listening in. I pointed towards the ship. "Let's go, full speed." I hit PL 60's alarm and the whole launch exploded in a mix of revving engines and ear-splitting alarm bells. Almost at once the off-watch crew came running and scrambling through every door into the wheelhouse, pulling on their uniform tunics as they came. The off-watch sergeant was unlocking the armoury, while at the same time trying to figure out what was going on.

"ETA ten minutes," I called out at the top of my voice. "Action stations, this is not a drill."

Hong Kong's Marine Police have no jurisdiction outside Hong Kong's territorial waters. We had no police powers south of the southern boundary. However, in an emergency, and in order to save lives at sea, we were permitted to take action in international waters. As far as I was aware, this was not a search and rescue mission. I assumed, therefore, that someone towards the top of the decision-making tree was making overseas phone calls as we went. For sure my own formation commander, the Marine district superintendent, would be in the Marine Control Room listening to the radio

chatter, as would his boss, the head of the Marine Police. And over in POLMIL, at Police Headquarters, I felt sure the commissioner of police would be doing the same thing. If this was another people-smuggling ship the whole of Hong Kong's hierarchy, right up to the governor himself, would be wanting frequent updates. "Don't screw this one up," I muttered to myself.

"Distance to target?" I shouted out above the din that now filled PL 60's wheelhouse.

"Two point four miles," shouted the sergeant at the radar. We were going to get our answer pretty soon. I looked around. Everyone was in position and armed. Of course, I didn't expect that we would be required to use any force here, but the "action stations" situation required everyone to be armed, and there wasn't sufficient time now to start making amendments.

I raised my binoculars once more, adjusting the focus. "That's odd," I said to no one in particular. Then, to the whole bridge, "That's not a ship, that's a barge."

What we had coming toward us was a 200-foot long motorised barge, a vessel designed for carrying a cargo of sand or rocks. This was a vessel used in dredging operations, not an ocean-going ship. Through binoculars I estimated this barge to be about 40 feet wide. The whole thing was oblong in shape. It had no bow, just a flat, 40-foot-wide front. The vessel also had only a couple of feet freeboard, which meant that any wave or sea swell higher than two feet would swamp the vessel. To the stern of the barge there appeared to be a small wheelhouse structure. And now, as we closed in, I could see quite clearly that the barge was full of people. Hundreds of them.

I stepped back. "Take us in close," I said to the deck sergeant. "Pass me the radio microphone." I reported what we were seeing. This was not a people-smuggling ship, this was at least two hundred people crammed into a dilapidated coal barge – which appeared to be taking in water. In fact, it looked as though it was sinking. We needed help, and we needed it fast.

"Police Launches 65 and 62 have been deployed to your position," came the voice of the duty controller at Marine Control. "ETA PL 65, one-five minutes. PL 62, two-zero minutes, over."

It was obvious to all on PL 60 that we needed to get these people off this barge very quickly indeed. The barge was listing to one side and the people on it were becoming hysterical. Many were waving their arms and shouting out to us. I suddenly had visions of our launch going alongside the barge and all the hysterical people clambering over to one side in order to try and get off, which would cause the barge to capsize right in front of us, taking all two hundred people down with it.

"Don't go alongside," I shouted at the sergeant, who immediately pulled back on the engine throttles and we came to a dead stop about 100 metres away from the barge. "Circle around the barge," I ordered. "I want to get a better idea of what's going on here."

I called forward our radio operator. "Get on the loudhailer, tell them we are the Hong Kong Marine Police, and they are safe. Tell them not to move around, but to sit or stand where they are. Don't move around." The radio operator relayed the message over the launch P.A. system in Cantonese. Many of those arriving in Hong Kong at that time were from the

south of Vietnam and were ethnic Chinese Vietnamese. I felt sure this message would be understood.

As we cruised around the stern of the barge, dozens of anxious, silent faces peered back at us. Men, old and young, women and children, lots of frightened people. The barge itself was grimy black. What we could see of the hull above the waterline was black and pockmarked with rust patches. The stern superstructure looked filthy. Clouds of black smoke billowed from a broken exhaust pipe at the rear. This barge looked like it had been used for transporting coal or earth. I couldn't figure out how this thing had made it across the South China Sea.

As we manoeuvred around the barge, a light aircraft came into view. I immediately recognised the red-and-white markings of the Royal Hong Kong Auxiliary Air Force. The plane circled the scene, no doubt reporting back to POLMIL what was going on.

"PL 65, sir," called out the deck sergeant, pointing towards the horizon. I could see the white bow wave of 65 coming towards us at full speed. "Who is the officer on PL 65?" I called out. "It's Inspector Barry Chan," came the reply from the radio cubicle.

"Get him on the radio now, I want to talk to him."

I explained to Inspector Chan what I planned to do. I told him to cut his speed and approach the scene at one or two knots. My plan was for our two launches to go alongside opposite sides of the barge slowly and simultaneously. We were then going to evacuate everyone from the barge on to our two launches. I felt that doing this as a simultaneous manoeuvre gave us the best chance of keeping the barge afloat and would not encourage everyone to rush to one side, which could well capsize the whole thing.

The barge was now listing even more than when we had arrived, I felt that there wasn't much time before it was going to capsize and sink. My crew were already making preparations. Our tender, a Zodiac inflatable powered by a 35hp engine, was already being winched into the sea. This small inflatable was going to be very useful if we needed to pull people out of the water. And by launching it, we were also freeing-up space on our stern deck for some of the Vietnamese to gather. I saw that PL 65 was doing the same.

My deck sergeant was also supervising the distribution of lifesaving equipment. Grappling nets were being lowered down the side of our launch and lines, life rings and life jackets were being laid out on the deck. My crew were all in position, as were those on PL 65. There was silence in the wheelhouse for a second. Everyone on board knew that we were ready – and that we were about to try something very risky indeed. I nodded to the sergeant at the controls. "Slow ahead," I said.

I knew there was going to be panic on the barge. I knew people would come rushing forward. But I hoped that they would move to both sides of the barge and not to one side only. I also prayed that this sudden large movement of people would not capsize this enormous metal-hulled barge. If it did, it would certainly take most of these people with it. Our radio operator was on the P.A. system repeating our requests for people to remain where they were until called forward.

As we came alongside one side of the barge, PL 65 did the same on the opposite side. Some of the Vietnamese rushed forward. Before we were actually in position, three young

men climbed over our side of the barge and jumped at our grappling nets. Two made it and clung there as if superglued to the side of PL 60. The third man failed to make contact and fell in the sea. My sergeant rammed PL 60's engines in reverse. The young man was now down in the sea between our launch and the barge, and we couldn't see him. For a split second he was in danger of being crushed.

As my officers were dragging the other two men off the grappling nets and up on to our deck, another of my crew scrambled down the side and into the water himself. I ran out on to the deck and looked down to see the Vietnamese man thrashing at the sea surface in an attempt to stay afloat. My officer grabbed this man by his shirt and hauled him on to the net and safety. My sergeant edged PL 60 back towards the barge.

Over on the other side I could see a similar scene, but could do nothing about it. We had our hands full on our side. I had to put my faith in Barry Chan and the crew of PL 65.

As PL 60 came alongside for a second time, more people from the barge rushed forward and began climbing over the side and on to our launch. The younger, stronger ones came rushing forward, pushing and shoving the older ones, the women and the children, out of the way as they did so. My men were shouting at them, telling them to help those in need, but there was no way of controlling this hysterical scramble for survival by hundreds of people. One by one, we dragged people off the barge and on to the deck of our launch. The strongest came first and the weakest came last. It was a mass scramble, and no matter the amount of broadcasting instructions we made, it made no difference.

Ironically, after doing our utmost to rescue these people, I really felt like throwing the young men who had barged their way to the front into the sea.

Gradually we got everyone off the barge. PL 65, on the other side, seemed to have done a good job too and had about the same number on their decks as we did. I walked along the side of PL 60, looking down into the empty barge. The large open space that made up most of the barge, which had just seconds before housed 200 people, was now empty, except for water. The barge was taking in water.

I turned to look up at our wheelhouse. "Cast off, this thing is going to sink," I shouted up at my crew. "Tell 65 to do the same. Now."

As our two police launches backed away from the barge, there was a loud creaking sound as this old vessel listed further to one side. From the decks of our launch everyone strained to see what was happening. The barge listed further, and the sea came rolling over the submerged side. This large black vessel then turned on to one side, and slowly went down, sinking like a dying man who had given up on life. Everyone stared in silence at the empty patch of ocean where, just seconds before, the barge had been.

"That was a close one," said my sergeant.

On our way back to Hong Kong territorial waters I made my first report over the radio to the Marine Control room. I knew that the main points about rescuing the Vietnamese, and the barge turning turtle and sinking, had already been relayed to the various control rooms by the circling RHKAAF plane. As I came out of PL 60's radio cabin my sergeant came forward. "Sir, there is one of the Vietnamese, a girl, she speaks very good English. She asks to speak with you."

The girl was sitting among dozens of people on our forward deck. I estimated she was about 18. She stood up and introduced herself in English. She told me that the barge had been purchased by her parents in Hai Duong Thong in north Vietnam. A man, one of the ones we had rescued just minutes ago, had been hired to drive the barge to Hong Kong. On the night of their planned escape, the local police discovered what was going on and tried to prevent them from boarding the barge and leaving.

Most of this girl's family were caught by the police and were prevented from getting on to the barge, but she managed to jump on as the man steered the barge away from the dock. Only 15 people made it, and all the others were left behind. Also left behind were the charts and the compass that the man had arranged for the trip. The girl went on to tell me that they tried to get to Hong Kong by steering close to the Chinese coast, using the shore to guide them. Also, they were afraid of the barge sinking, and thought that if they stayed close to shore they would have a better chance of rescue if it did sink.

At one point the engine of the barge broke down and no one on board could fix it. After drifting for two days, a Chinese fishing vessel came to their aid and towed the barge to a dock on the Chinese mainland where they paid for the engine to be repaired. The girl said that they had taken a total of 40 days to get to Hong Kong. The barge was very slow and kept breaking down. On the way to Hong Kong they kept finding other refugees in small wooden vessels. Some, she explained, were floating in "baskets". All of these people were taken on board the barge, and so, gradually, over 40 days, 15 people became 200.

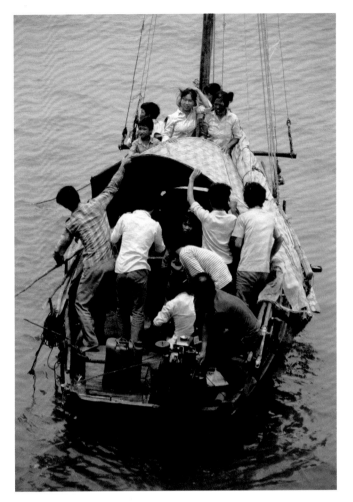

*After being intercepted just west of Lantau, this vessel has lowered its sail and prepares to come alongside a police launch. This is a typical example of the type of sailing vessel that was arriving in Hong Kong at the time. This flat-bottomed river boat was not designed for ocean passage. Having no keel and very low freeboard it would have been very unstable in heavy seas and certainly in danger of capsizing, coupled with the fact that most vessels arriving, like this one, were overloaded with people. Here, one of the men attempts to start a small outboard engine so that he can bring his vessel alongside the launch. Additional fuel can be seen in the black jerrycan next to the engine.*

It was a remarkable story, and it made me wonder about all the other people we had rescued during that year who, most probably, had similar stories, but were unable or afraid to communicate with us.

## It's in the blood

After training in the mid-1970s, I loved the fact that I was able to join the Marine division of the police. I was now the third generation of mariners in a way. My grandfather and father had both been in the Royal Navy. Among many of us in the Marine Police there was a love of the job but also a love of the sea, as is the case with a friend of mine, Rod Colson, who was an inspector in 1980 and a police launch commander patrolling Hong Kong's western waters…

I received a message that the Royal Navy Coast Watching Station at Tai O had spotted a sailing junk struggling to make its way to Hong Kong and on the verge of sinking. After receiving permission to leave Hong Kong waters I took my police launch at full speed across the Pearl River estuary toward Macau. Inspector Jeremy Collier, on another launch, followed. We intercepted the junk at a position far closer to the Lisboa Hotel [in Macau] than to Tai O Police Station. It was a sailing junk, all wood, about 60 feet in length, with single mast rig. There was decking fore and aft, but it had an open hull midship. It looked built for cargo.

The foredeck had a manual drum winch for raising the anchor and sail. The aft deck tiller bar was attached directly to the rudder. The hull was unpainted and the sail was a patchwork of tatty shades of brown canvas. The bilge level was being managed by the refugees, continuously bailing with an old tin can and plastic bucket. There were well over a hundred people on board, and the junk was taking in water pretty fast.

We came alongside and the crews of our two launches transferred all of the people from the junk to the two police launches. So that was all the people safely on board, but what were we now going to do with a sinking junk in the middle of the high-speed ferry route between Hong Kong and Macau?

As many of the refugees, including children and babies, were in need of urgent medical attention, both police launches, now fully laden with dozens of people, needed to turn around quickly and return to Hong Kong. Jeremy and I looked at the sails and looked at each other and I said, "Why not?"

So there we were, Jeremy and I, in Royal Hong Kong Police uniform, alone now and well out of Hong Kong waters in a sinking sailing junk. After a struggle, we got the main sail up and set course for Tai O. I have to admit, as the junk started to make way, I had a smile from ear to ear. The wind held, and even though we slowed as the hull flooded with several feet of water, we safely grounded and anchored the junk in a creek just south of Tai O.

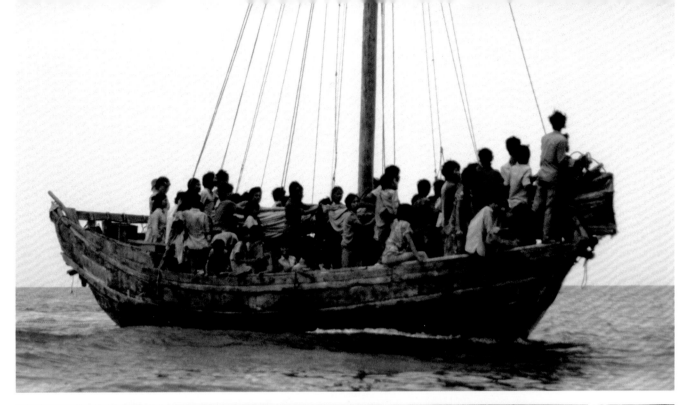
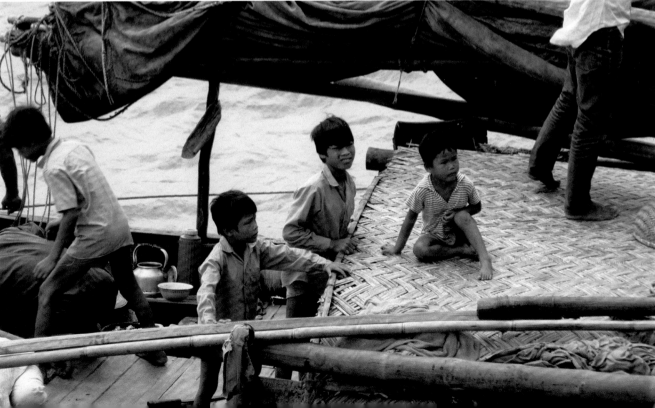

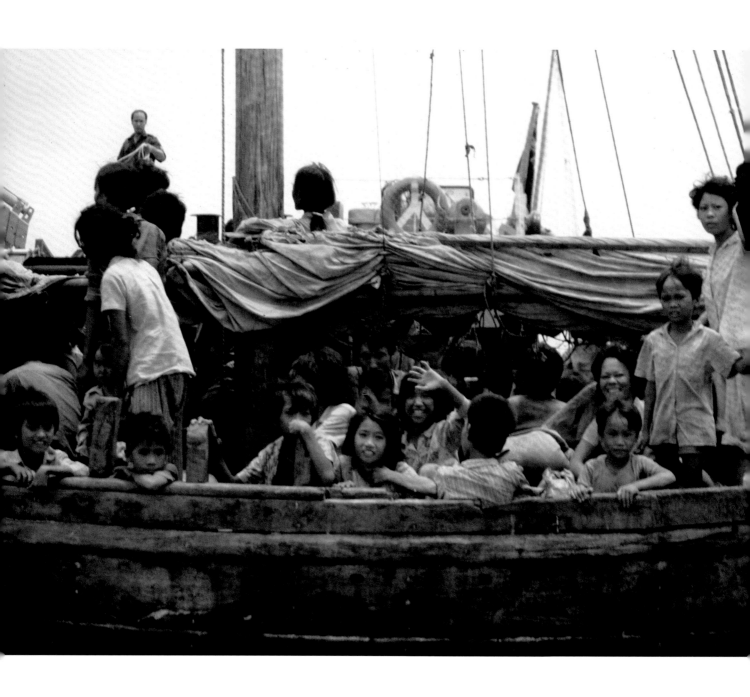

# Chapter Five

# **Refugee Fatigue**

In 1982, as the number of Vietnamese in the camps in Hong Kong increased, pressure from the international community mounted, particularly from the United States. Countries that up until that point had been accepting the Vietnamese as refugees were becoming more and more selective as to who they accepted. Some referred to this as "refugee fatigue". The Americans were quick to point out that while all of the Vietnamese that arrived in Hong Kong during the 1970s could, under the international definition, be classified as refugees, a significant amount of those arriving now could not. As 1982 progressed, it transpired that many of those sailing into Hong Kong had left home not because of some form of persecution, but for other reasons. So, on 2 July 1982, Hong Kong introduced a Vietnamese boatpeople segregation policy, which included a new open and closed arrangement.

All arrivals from that date would be interviewed to determine why they had come to Hong Kong. Those who had left in fear of persecution due to their ethnicity would be classified as refugees and housed in one of Hong Kong's open camps, just as before, and also be available for selection for residency in one of the countries that was taking them.

But if the new arrivals had left Vietnam for other reasons, they would be classified as economic migrants and placed in one of the closed camps. Hong Kong and London then began talks with the Vietnamese Government in the hope of initiating a repatriation policy.

So what did that mean for us out at sea? The Marine Police were issued with new orders, and a laminated A4-size notice that we would hold up to show each new boatload. The notice, written in English, Chinese and Vietnamese, explained that all new arrivals were free to continue their journey and would be given assistance if they wished to do so. But, if they elected to enter Hong Kong they could face detention in a closed camp and not be permitted to leave during their time in Hong Kong.

This segregation policy, which came in for some criticism, seemed to work. As the 1980s progressed, fewer and fewer boatpeople arrived in Hong Kong, and things out on the southern sea boundary returned to normal. One reason I was pleased about this was that with the reduction in arrivals I could now return all of those borrowed Government vessels to their rightful owners. I must admit that while this "Dad's Army" of a fleet did, from time to time, help us out, I was

NOTICE

All former residents of Vietnam seeking to enter Hong Kong since 2 July 1982 are detained in special centres.

If you do not leave Hong Kong now, you will be taken to a closed centre and detained there indefinitely. You will not be permitted to leave detention during the time you remain in Hong Kong.

You are free to leave Hong Kong now, and if you choose to continue your journey you will be given assistance to do so.

布　告

從一九八二年七月二日起，所有要進入香港的前越南居民，均須扣押在特別禁閉營內。

假如你現時不離開香港，我們會把你帶到禁閉營，並且無限期把你扣押在營內。留港期間，你將一直被扣押，不會獲准離開。

你現時可自由離開香港；假如你選擇繼續行程的話，你可以得到我們的協助，繼續你的行程。

THÔNG CÁO

Bắt đầu từ ngày 2 tháng 7 năm 1982, tất cả những người trước ở Việt-Nam mà tìm cách đến Hồng-Kông sau ngày này đều bị cầm giữ trong các trại đặc biệt.

Nếu các người không lập tức rời khỏi Hồng-Kông, các người sẽ bị đưa vào trại tập trung và bị vô hạn kỳ cầm giữ. Các người sẽ không được phép rời khỏi trại trong thời gian ở Hồng-Kông.

Hiện giờ các người được phép tự do rời khỏi Hồng-Kông, và nếu các người tuyển chọn để tiếp tục lên đường đi nước ngoài thì chúng tôi sẽ giúp đỡ về mọi phương tiện.

*The laminated detention notice that was issued to all Marine Police launches in 1982. After intercepting an incoming Vietnamese vessel and conducting an initial medical check of those on board, we were required to present this notice to the master of the vessel. It was then up to him to discuss the options with the others on his vessel. Almost all elected to enter Hong Kong and take their chances in the camps rather than turning back out to sea.*

relieved when the last one limped away, never to be seen again.

The laminated notice proved an interesting addition to the whole process. Whereas before the segregation policy was introduced it was a case of intercept, check health of those aboard, offer assistance and escort in, it then became: intercept, check health, issue notice and watch the reaction. Before issuing the notice we would always look for the master or spokesman of the group. For boats with a small number of people this was quite easy. But if the vessel had passengers from different backgrounds, people who didn't know each other well, the issuing of the notice could cause some form of upheaval among the Vietnamese. Fortunately, these cases were few and far between as almost every boat, after reading the notice and discussing the matter among themselves, elected to enter Hong Kong and take their chances with the segregation policy.

The Hong Kong Government remained hopeful that this

new "help them on their way to somewhere else" initiative would ease the burden of putting so many people into closed camps. They were so keen for a boatload of Vietnamese to accept the offer of assistance to continue their journey that there was much excitement when one finally did, with officials almost falling over themselves to make this first case work. The Vietnamese, who had sailed to Hong Kong on a former Vietnamese navy tugboat, agreed to continue their journey if certain upgrades were made to their ailing vessel. This was quickly agreed, and state-of-the-art navigation equipment was fitted to their tug. No expense was spared, as the Government believed that it was imperative that this first case actually succeeded. If it did, then others might follow suit.

When the tugboat was ready and fully kitted-out, a press conference was held at the Government Dockyard. Marine Department officials shook hands with the Vietnamese as they handed over the refurbished tugboat. Then, to great fanfare, the Vietnamese sailed away and out of Hong Kong waters. About one month later they were back. After leaving Hong Kong these Vietnamese, who were predominantly men, had sailed their tugboat up the Pearl River and pulled in at the first port they came to. There they sold all their newly acquired navigation equipment and had a grand old time with the proceeds. I don't think there was a second case of this nature.

## A chance meeting

In doing research for this book, I have met quite a number of former refugees who passed through Hong Kong in the 1970s and 1980s. I was introduced to Bau Vu in London, which is where the family eventually settled after being accepted by the British Government as part of the Vietnamese refugee resettlement agreement with the UNHCR. In the early 1980s Bau's father had fallen foul of the new government in Hanoi. He was arrested and sent to prison. It was evidently clear to him that there was no future either for himself or his family under the new regime. So, in 1984, whilst still in prison in Hanoi, Bau's father secretly made arrangements for his family to leave Vietnam.

My father work in high position in government in Vietnam and in that time there is big problem between China and Vietnam and my father is sent to prison. That's why we want to escape Vietnam. At the time we escape, my father still in prison in Vietnam.

My father has some friend in government. As I am the oldest, at 20 years, I sometimes meet his friends. So, I get the boat from his friend. The boat driver is also my father's friend, so that's how I find the boat. This driver is only 18 years old. This driver, he knows everything about the boat and sailing, so I ask him if he wants to go to Hong Kong and he says yes but he has no money, so I say that is OK, I take care of that. He takes me to the province called Quang Ninh in the north east, it is near the border, to buy the boat, because he has relationship with someone there.

We leave Vietnam on 2 July 1984, and we take 60 days to reach Hong Kong. We have a 21-foot sailing boat, we have no engine. There are 11 people on my boat, include my two younger sisters and my younger brother. Also, my wife, we got married just three days

before we escape Vietnam.

On the trip we nearly die twice in storms and the boat get damaged. I think 98 per cent sure we will sink. I don't know how we don't die. I think someone up in the sky taking care of us. We are 5km from the coast. One time our boat is sinking but we end up on top of a sand bar, so we don't sink. The Chinese police find us. The Chinese police told us we are very lucky to survive. The Chinese police they are very helpful to us, because of the politics (Vietnam/China), so they help people escaping Vietnam.

I am so young I really don't understand our chances to make it. And we only take food and water for one week journey. When we arrive China, the people sell us food. They are kind to us, and they know we escape and will not stay in China and they show us how to go to Hong Kong.

I remember as we pass Macau. In my memory I remember that big bridge. So, we are arriving Hong Kong in September 1984. When we get to Hong Kong the police stop our boat and take us to a very small ferry and ask us questions and give us food. They have to ask us question make sure we come from Vietnam.

We stay more than 24 hours at the ferry, then they take us to Chi Ma Wan camp, where we stay one week, then to Hei Ling Chau because at that time, in 1984, they separate the North from the South (Vietnamese), and we come from the North. We stay in Hei Ling Chau for 18 months. My daughter is born in Hei Ling Chau camp in July 1985. Eventually I am

told that we have been accepted by the British to live there. A few years later, my father was released after spending four years in prison in Vietnam. I was then able to arrange for my father to come to London to live with the family.

I still keep in touch with that young guy who sail our boat from Vietnam to Hong Kong. I still think he was our lucky spirit. I still don't know how he can sail like that. He is now living in Canada and I have been to visit him. He also sometimes come to England to visit me. We are still friends.

I'd worked with Marine Police Officer Peter Conolly on several occasions throughout the 1980s. Like me, he was a career mariner and had also joined the force in 1976. In 1988, he was the Marine Commander of the western waters of Hong Kong. His account here refers mostly to his collection of photographs taken in one 24-hour period.

I took these photos from the command launch, Police Launch 1, in the western waters. We had been deployed there rather than down south as there was an influx of small vessels from North Vietnam that had been "coast hugging" at that time. It was September 1988.

The boats that were arriving were more dilapidated than the ones in previous years and had obviously been stopping off for refuelling and anything else needed for their vessels in China.

They were also getting directions. PL 1 would usually sit to the north of Lantau near the international

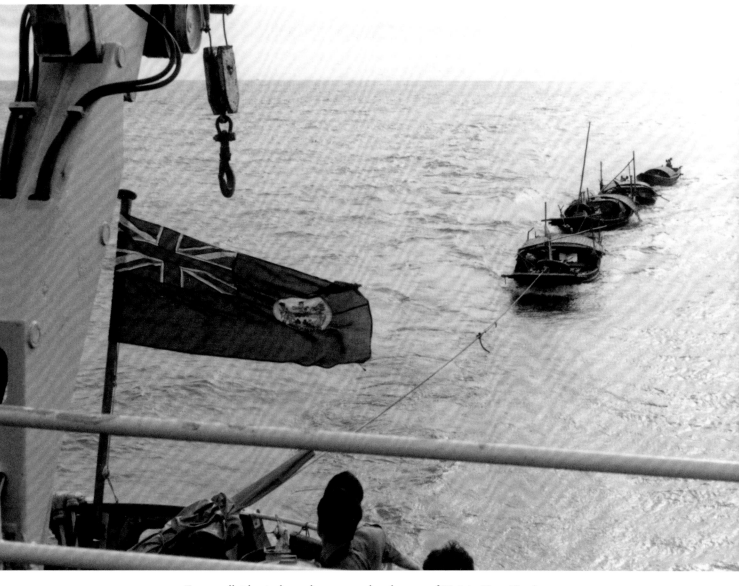

*Four small, identical, vessels are moored to the stern of PL 1 in Hong Kong's western waters in 1988. I recall that at that time many of the vessels arriving in Hong Kong had originated from North Vietnam and had 'coast hugged' their way to Hong Kong, stopping off in various locations in China en route. Some had made stopovers of up to one year prior to beginning the last leg of their journey to Hong Kong.*

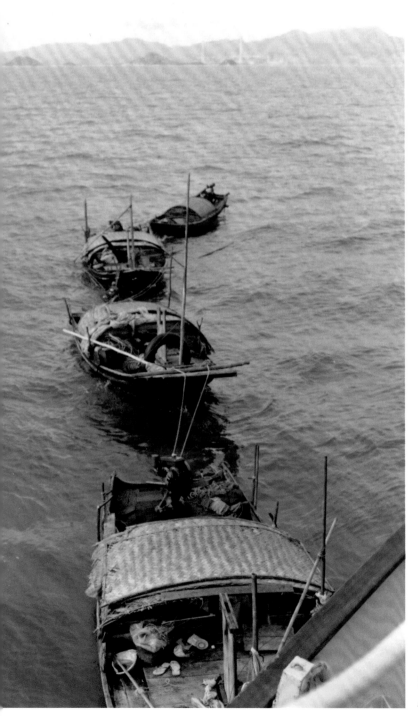

sea border, and generally it was the small patrol launches that would intercept and direct these Vietnamese boats to PL1 for processing – this was for security and practical reasons. To my recollection, unlike the South Vietnamese, those arriving from the North had in general little or no English language knowledge. All communications were either taped or we got one of them to read out prepared statements regarding their options. You can see that in one of the photos.

I remember that one of the options was that they could be given fuel and food and they could carry on and leave Hong Kong waters. None of the ones we intercepted ever did.

For practical reasons we always took all of them back to Tai Lam Marine Police Base rather than into the harbour for processing. My pictures of people on the Tai Lam pier are a mix of those we intercepted on that day and arrivals from the previous day who hadn't yet been found a camp to go to. We just shuffled them along the pier and told them not to mix.

The Vietnamese boats were then kept off the base. It just so happened that on that particular day a lighter, arranged by the Marine Department, had come to take dozens of them away for destruction. Most of them had already sunk.

*The four vessels moored alongside Police Launch 1.*

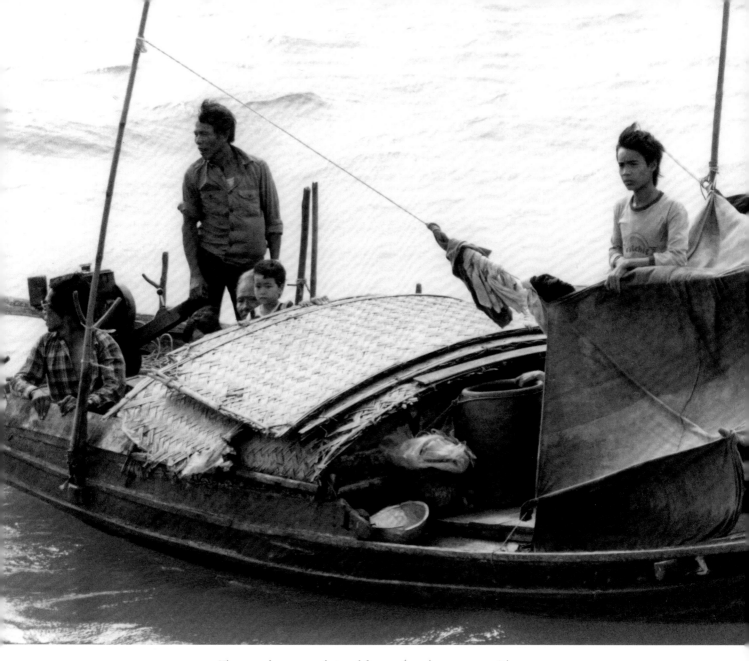

*These vessels were not designed for travel on the open ocean. The
freeboard is very low, and the boat would not have withstood rough
sea conditions. There were people of all ages on these four boats, three
generations, mostly families. Their cooking paraphernalia was of
reasonable standard and they were well fed and far healthier than
those who had arrived from the south in previous years.*

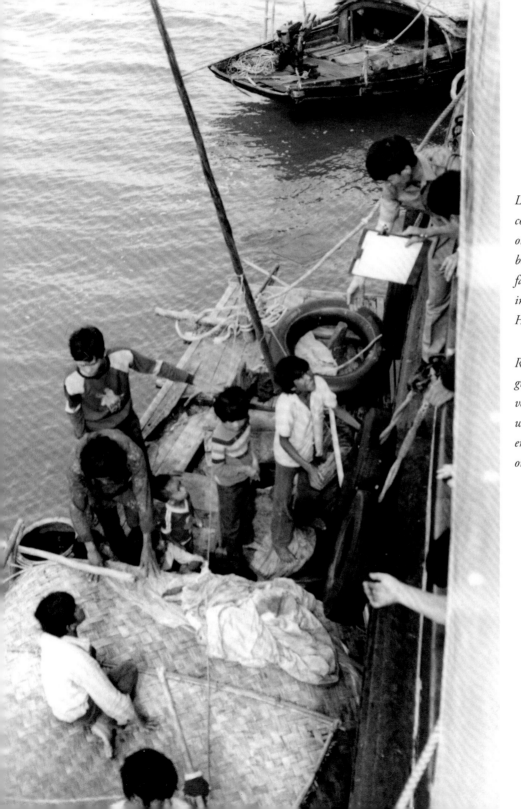

*Left:* A crew member of Police Launch 1 collects basic details from the adults on one of the boats. The warm clothing these boatpeople were wearing was a result of the fact that they had spent the previous winter in China prior to making their way to Hong Kong.

*Right:* A grandfather and his two grandchildren look up at the larger police vessel in anticipation. All four vessels were powered by identical small outboard engines that they had purchased in China on the way to Hong Kong.

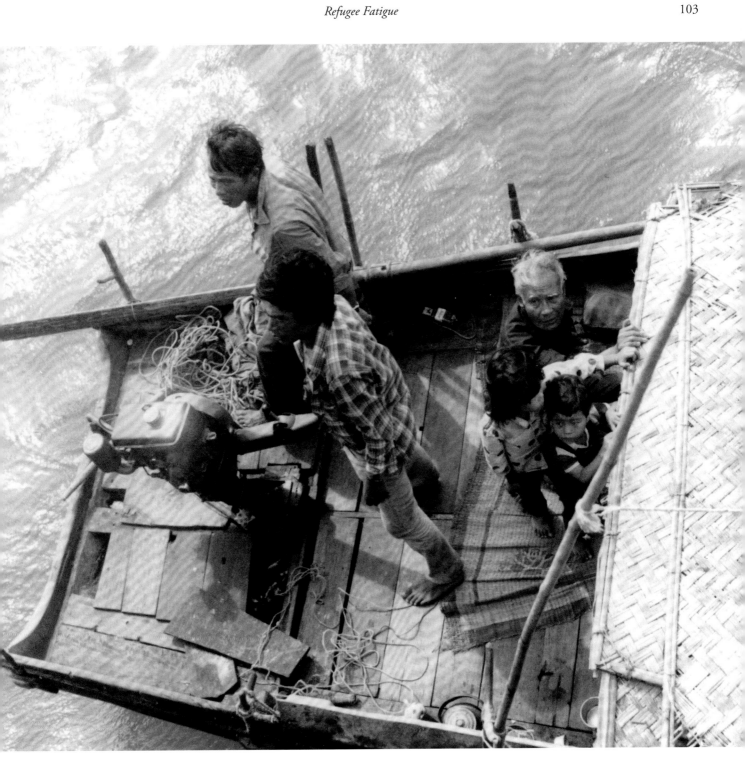

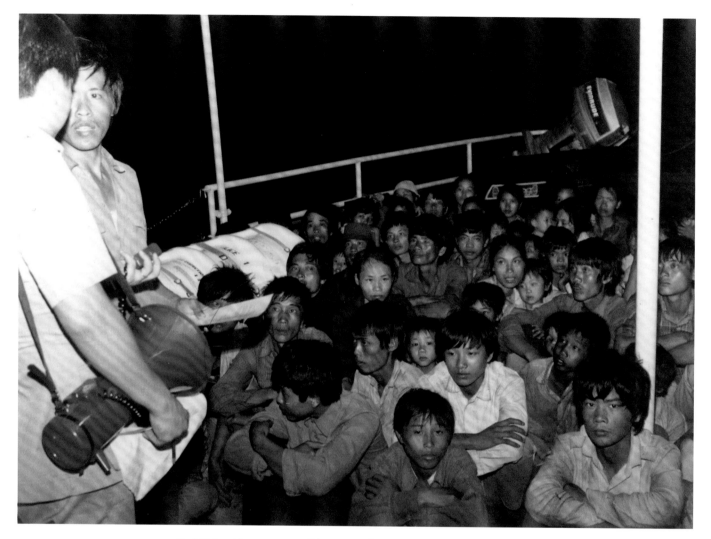

*By 1988, with so many small boat arrivals in Hong Kong, it was our duty to inform all new arrivals that if they wished to enter Hong Kong they could do so, but if they were eventually found not to be genuine refugees they could well face detention in one of the closed camps and possible repatriation. But if they wished to continue their journey then they were free to do so, and we would provide provisions. Here a Marine Police officer and the spokesman of the group discuss the situation. The Vietnamese man is holding a laminated notice, written in Vietnamese, Chinese and English, outlining this policy. Many of this group were recently demobilised soldiers from the Vietnamese Army.*

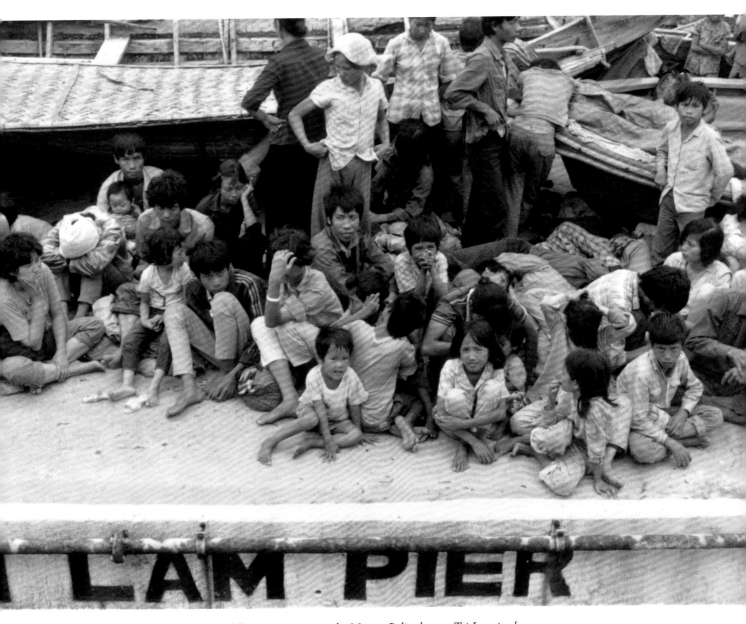

The following morning at the Marine Police base at Tai Lam in the
western New Territories. Those from the four boats intercepted the
previous day by Police Launch 1, having requested entry into Hong
Kong, now await land transportation to one of the reception centres
for further processing.

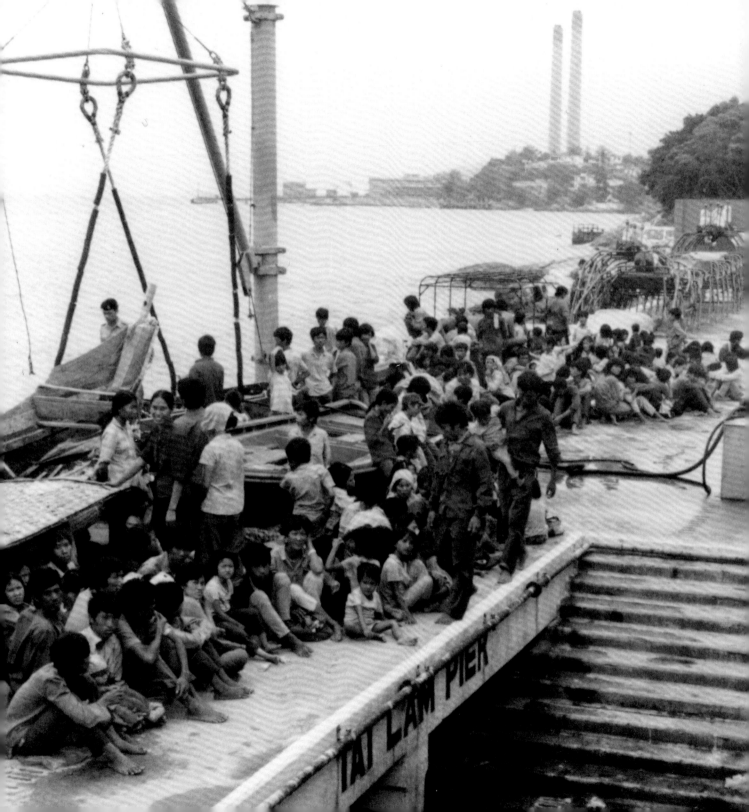

## Arms and ammo

The fact that some of those arriving in Hong Kong in 1988 and 1989 were recently demobilised from the Vietnamese military was always on my mind when we intercepted a vessel full of young men. It was common for arrivals at that time to still be wearing their uniforms. Often a demobilised soldier would have nothing else to wear. Some would make a half-hearted effort to blend in with others on their boat by removing their badges of rank; others didn't bother and arrived in Hong Kong dressed just as they had been on their final day in the army. My main concern at the time of interception was whether or not any of these men were armed. To me it made sense to bring a weapon on such a journey. By the late 1980s it was common knowledge that there were pirates who preyed on these boat people as they tried to cross the South China Sea. Had I been in their place, and had access to a weapon, I would have carried it with me until I was sure I was safe. I think many of these soldiers did just that, only throwing their gun or grenade overboard once Hong Kong's outer islands came into view. But we could never be sure. Of course, it would make no sense to draw a gun on someone that was about to rescue you. But just the fact that it was possible that someone onboard an incoming vessel could be armed always made me, and other Marine commanders, position one of my own armed officers on the uppermost position on my own launch, to keep watch and to be seen by those coming in.

Like me, my Marine Police colleague, Chief Inspector Alasdair Watson, was involved in dealing with Vietnamese boatpeople both at sea and on Tai Ah Chau island. And he told me about making such a discovery.

I was very particular about conducting thorough vessel searches, not least because a colleague had recently got into trouble when a female detainee handed a loaded semi-automatic pistol to an immigration officer at the Green Island Reception Centre.

In 1988, I recall intercepting a Vietnamese vessel just southeast of Lamma Island. I was on the divisional command launch, Police Launch 3, a big vessel. As the tiny boat came alongside our launch I was looking down from the lower deck of PL 3 when a Vietnamese man stood up in the boat, put his hand into a wicker basket and produced a live hand grenade. Understandably, this caused a reaction from myself and a number of my crew. Fortunately, the man just wanted to surrender the grenade to me, but I will confess that it did momentarily quicken my heartbeat.

Fortunately for Alasdair the hand grenade didn't go off and it was eventually dealt with by the Police Explosive Ordnance Disposal Unit. A year later, towards the end of 1989, Alasdair became the Marine Police operational commander along the southern boundary himself and, like me, when circumstances permitted, he took photographs of his work at sea. 1989 was a significant year in the Vietnamese saga. Over 34,000 boatpeople arrived in Hong Kong, making it the busiest 12 months along the southern boundary since 1979. Although very busy dealing with this large number of vessels and people, Alasdair was able to capture some remarkable shots.

*Above: The hand grenade handed over to Chief Inspector Alasdair Watson by a Vietnamese man shortly after his vessel was intercepted by Police Launch 3 on the southern boundary in 1988.*

*Right: After finally making the decision to leave home, to leave your family, to leave your country and to risk your life and the lives of your children on the open ocean in an overcrowded and ramshackle vessel – and finally making it to that unknown future – what happens next? Here, these new arrivals on the southern boundary are about to find out. In this picture some of the men are wearing green or khaki military shirts. A fair percentage of the Vietnamese men arriving in Hong Kong in the late 1980s were recently demobilised soldiers from the Vietnamese Army.*

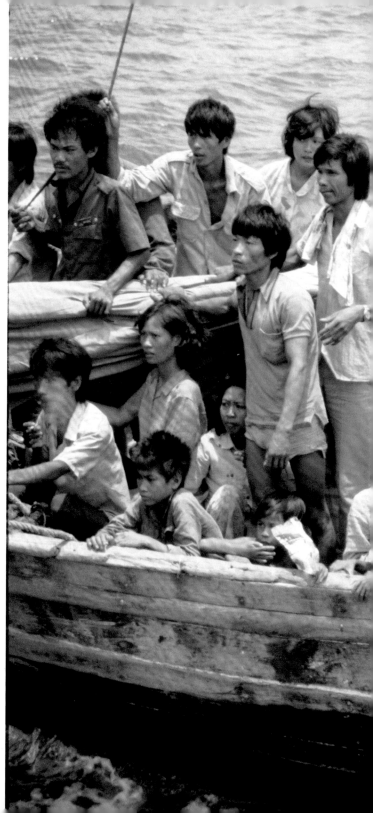

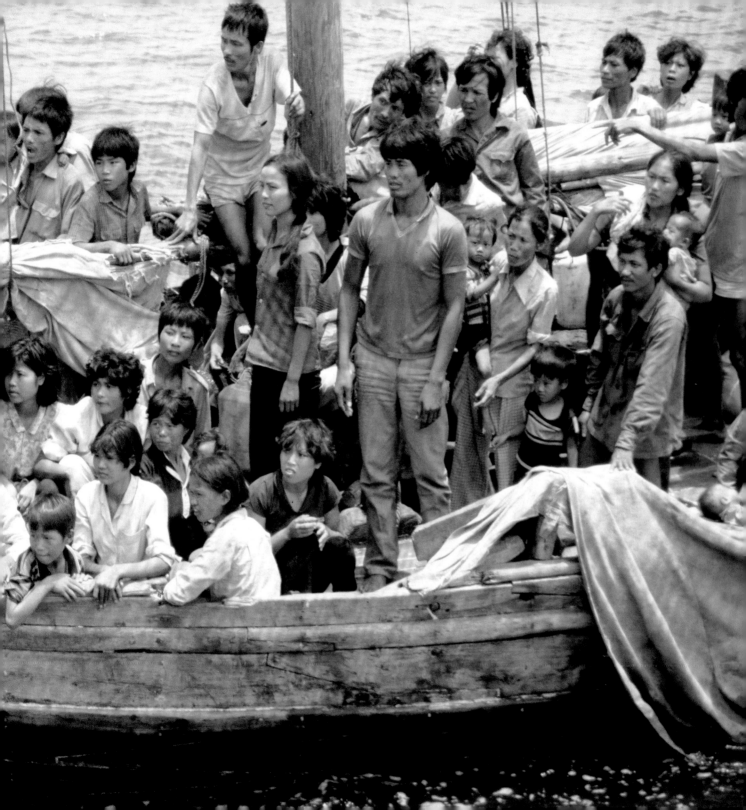

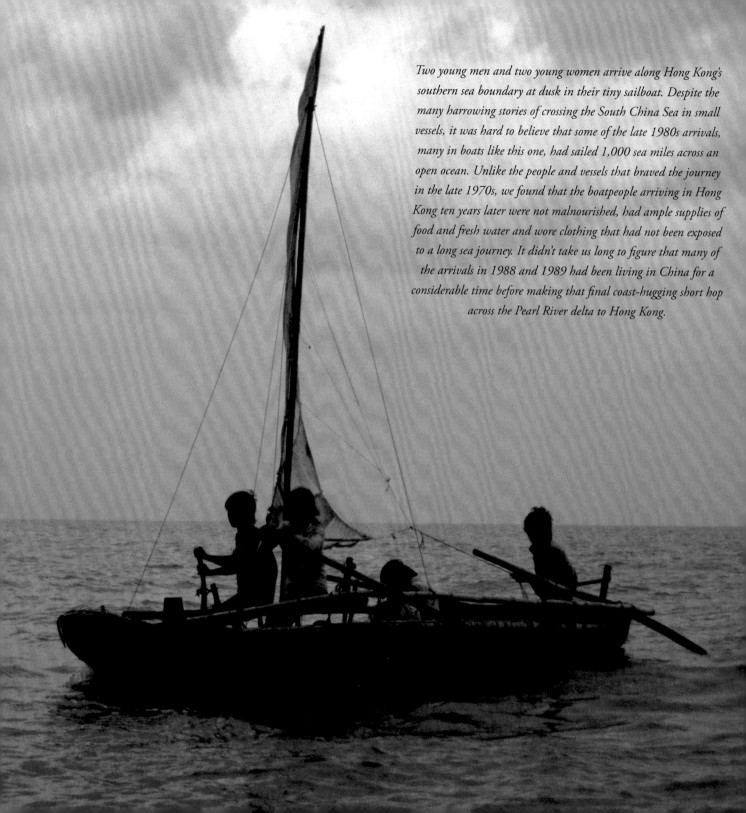

*Two young men and two young women arrive along Hong Kong's southern sea boundary at dusk in their tiny sailboat. Despite the many harrowing stories of crossing the South China Sea in small vessels, it was hard to believe that some of the late 1980s arrivals, many in boats like this one, had sailed 1,000 sea miles across an open ocean. Unlike the people and vessels that braved the journey in the late 1970s, we found that the boatpeople arriving in Hong Kong ten years later were not malnourished, had ample supplies of food and fresh water and wore clothing that had not been exposed to a long sea journey. It didn't take us long to figure that many of the arrivals in 1988 and 1989 had been living in China for a considerable time before making that final coast-hugging short hop across the Pearl River delta to Hong Kong.*

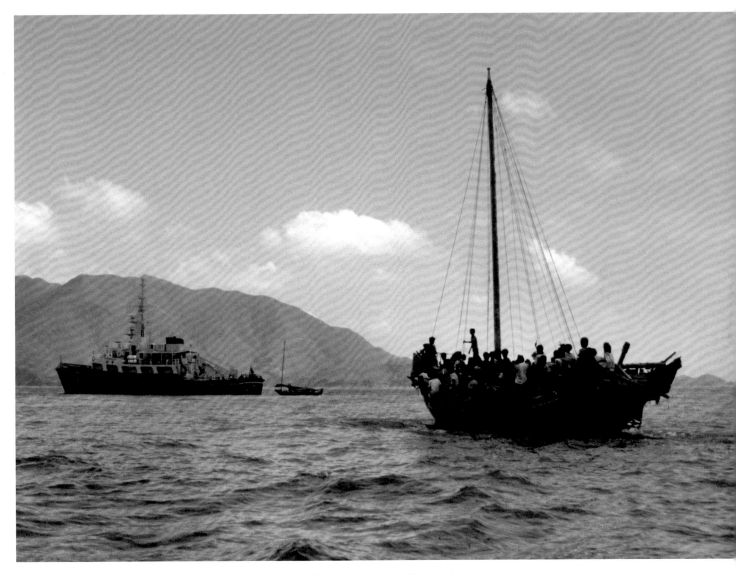

*Police Launch 4, the southern boundary command launch that came into service*
*in the mid 1980s, proved to be a great asset when dealing with the new influx of*
*Vietnamese vessels in 1988. In this picture, PL 4 sits and waits while smaller Marine*
*Police craft, patrolling further out to sea, make the initial interception of the incoming*
*Vietnamese vessels before escorting them to PL 4 for further processing. PL 4 provided*
*a stable platform for initial health checks and immigration procedures to take place*
*prior to transporting the boatpeople to one of the land-based reception centres.*

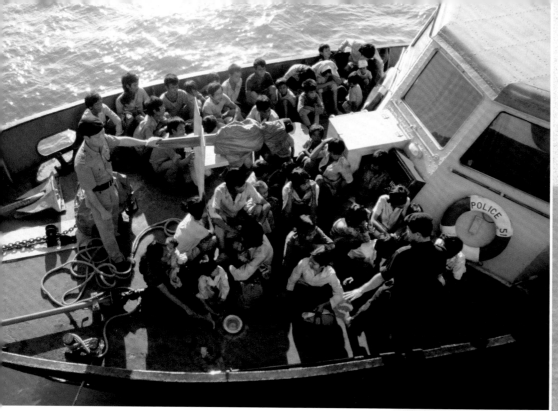

*Above: Once a newly arrived group of Vietnamese had been initially processed onboard PL 4, a smaller patrol launch, in this case PL 51, would be called over to take the boatpeople to one of the land-based reception centres. In 1988, when this photograph was taken, the reception centre was located on Green Island at the western entrance to Victoria Harbour.*

*Right: One of the Zodiac inflatable boats deployed from PL 4 signals to a small incoming Vietnamese sailboat. We found these small, speedy, police Zodiac boats were, during busy periods, invaluable. They allowed the larger 'mother' launch to remain stationary and focus on helping and processing new arrivals. The inflatables would buzz around, intercepting and directing the incoming Vietnamese vessels arriving along the southern boundary towards the larger police vessels.*

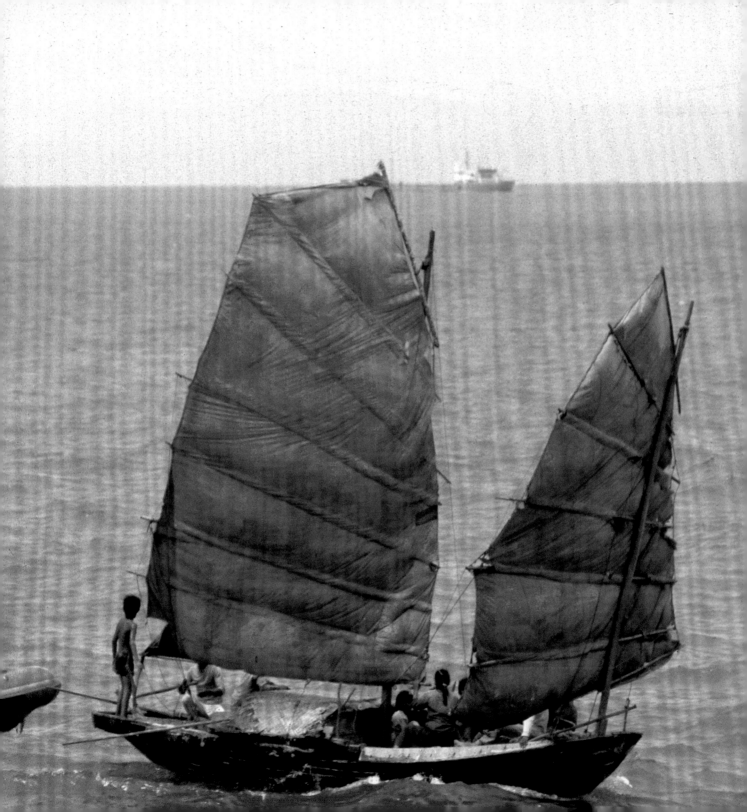

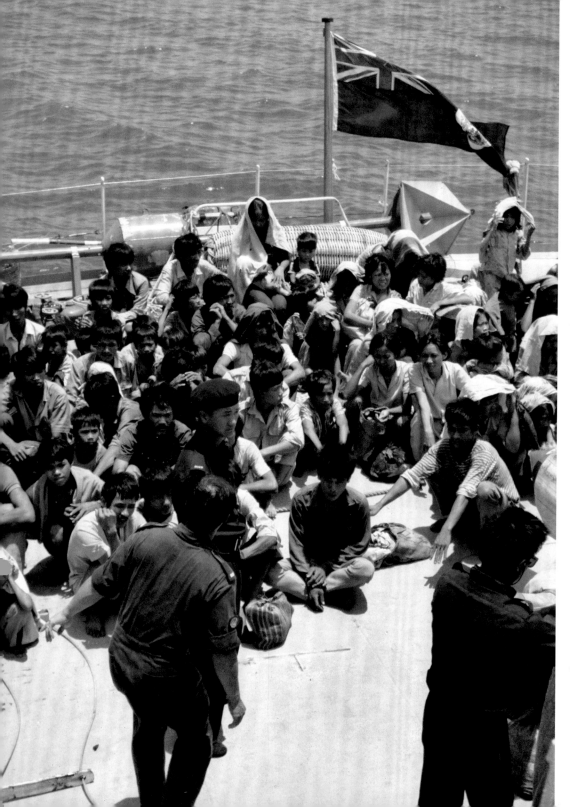

*Left: A group of newly arrived Vietnamese boatpeople sit on the stern deck of Police Launch 4 waiting for transportation to Green Island Reception Centre and further processing.*

*Opposite: During the influx of large numbers of vessels along the southern boundary, a Zodiac inflatable tows a small sailboat towards PL 4. The Marine Police in Hong Kong do not usually tow vessels, unless it is to save lives. However, in exceptional circumstances, we would do so. With several other Vietnamese vessels spotted on the horizon and making their way towards Hong Kong, this was one such case. The Zodiac was urgently required back out at sea.*

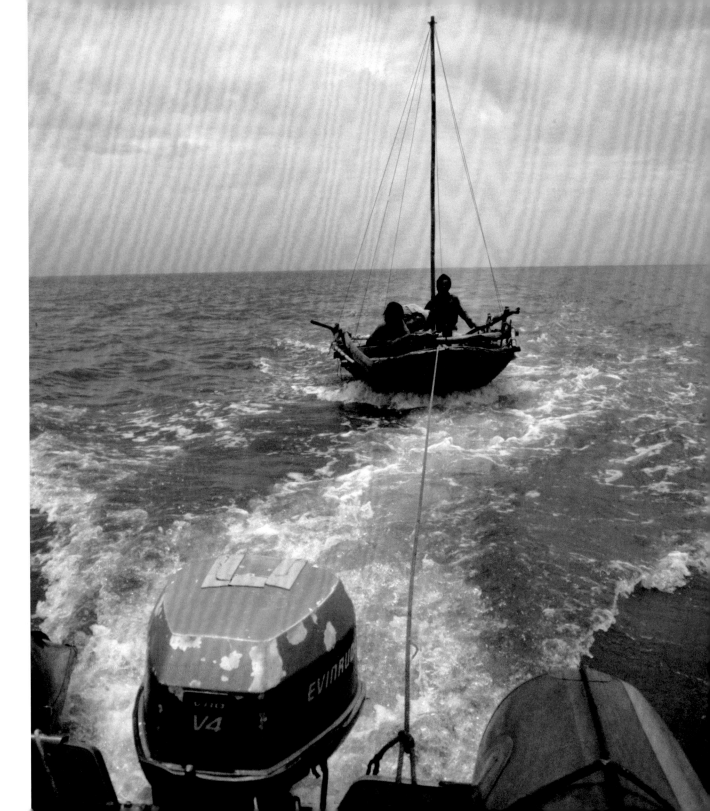

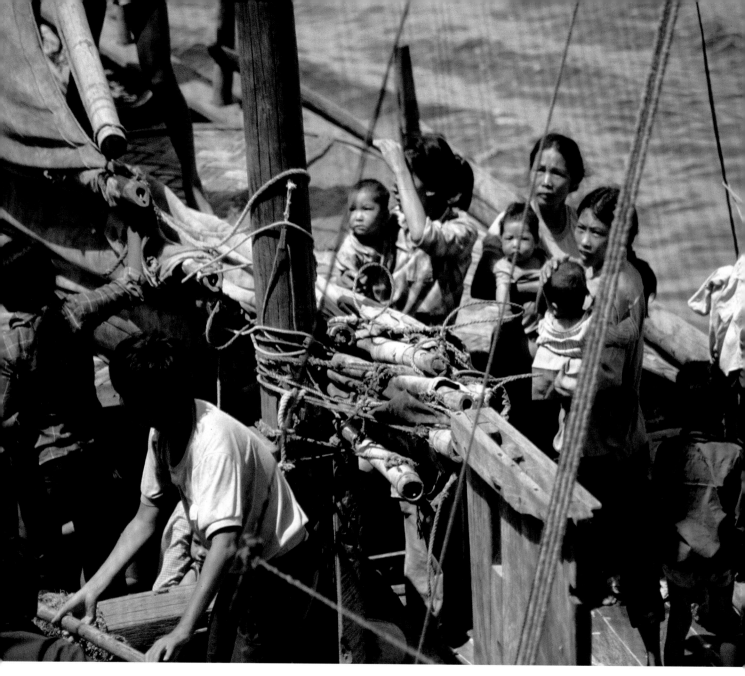

*Once alongside Police Launch 4, the passengers on this large wooden*
*sailing vessel prepare to cross over onto the much larger launch.*

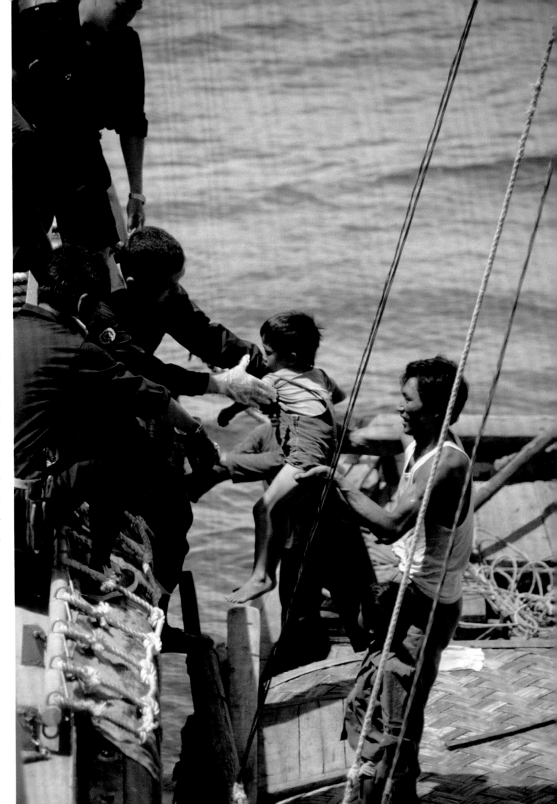

*A father hands his son to a crew member of PL 4. Note the grappling net lowered along the side of the police launch. These nets proved invaluable during the whole 20+ year boatpeople saga. Not only were they essential for allowing people in smaller craft to climb up on to the larger patrol vessels, they also helped save lots of lives. Many of the Vietnamese vessels arriving in Hong Kong waters were in poor condition, and some would sink before our eyes. Rescues from sinking or capsized vessels were an everyday occurrence, and the grappling net became one of the most valuable pieces of equipment we had.*

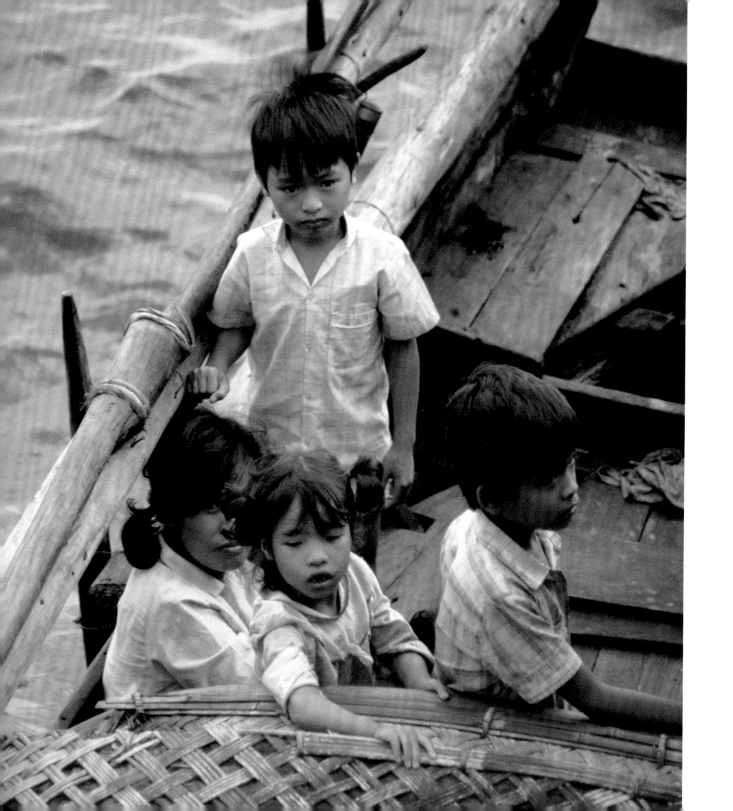

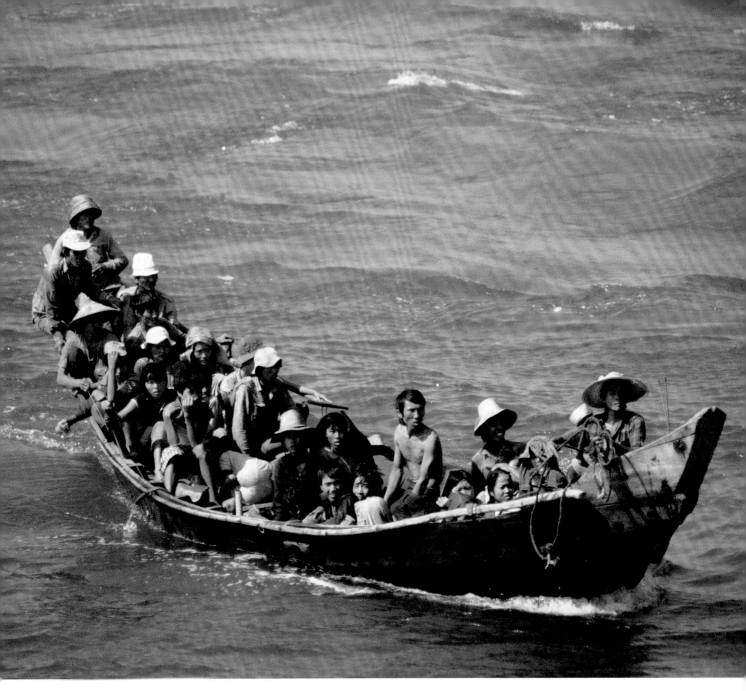

*Opposite: A group of children watch and wait as the
adults discuss matters with the crew of Police Launch 4,
off the Soko Islands in 1988*

*Above: As this small motorized vessel arrives in Hong Kong waters,
one of the men at the bow prepares to throw a line to PL 4*

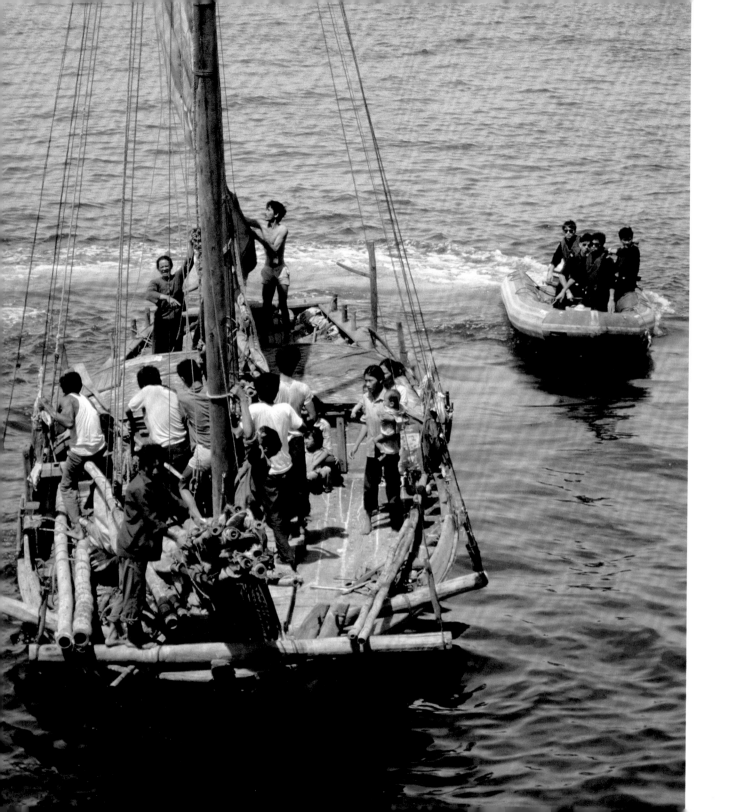

*Opposite: With its sails now lowered and secure, a Marine Police Zodiac inflatable prepares to assist a sailing vessel to go alongside Police Launch 4 off the Soko Islands in 1988*

*Below: A small motorised vessel arrives in Hong Kong waters from the southwest in 1988. Excitedly, and no doubt relieved to have made it, some of those onboard wave and smile at the sight of the Hong Kong Marine Police launch. In an attempt to protect part of the vessel from the hot sun and spray from the sea, plastic sheets and a canvas awning have been rigged along a section of the vessel.*

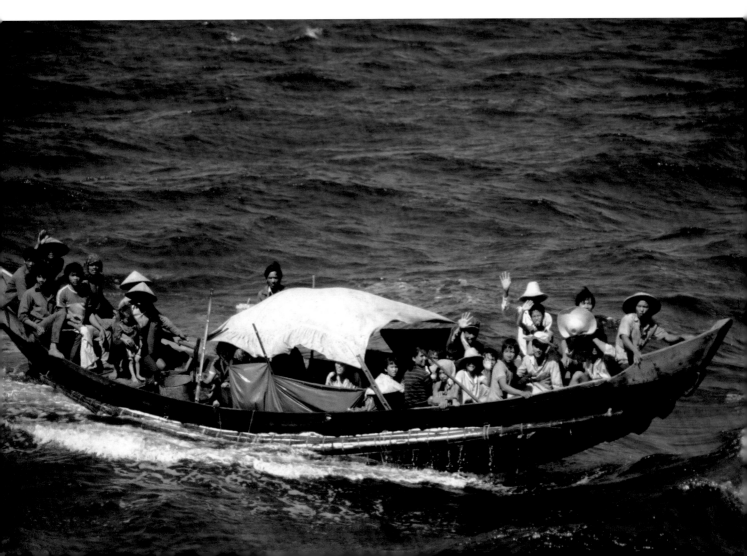

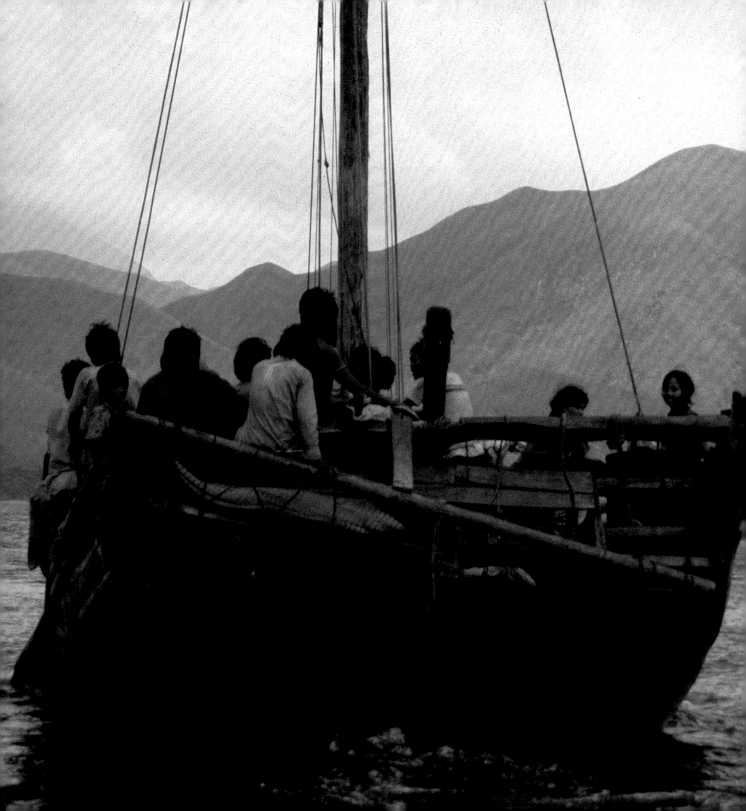

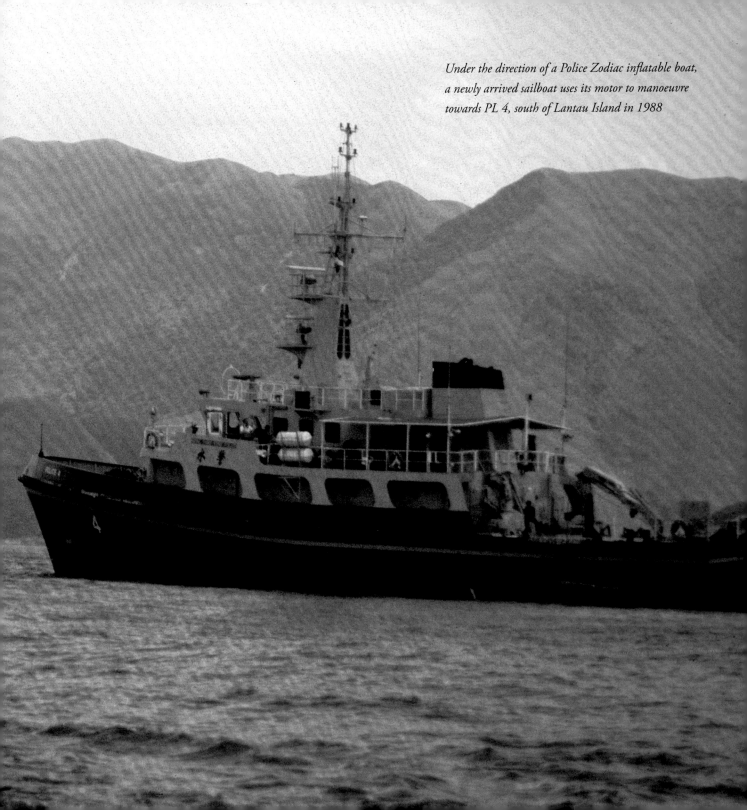

*Under the direction of a Police Zodiac inflatable boat,
a newly arrived sailboat uses its motor to manoeuvre
towards PL 4, south of Lantau Island in 1988*

*Two men hand over a child to the crew of Police Launch 4, south of the Soko Islands in 1988. Alongside the much larger police launch, another man keeps a firm hold of PL 4's grappling net to help stabilise his small craft whilst the transfer takes place.*

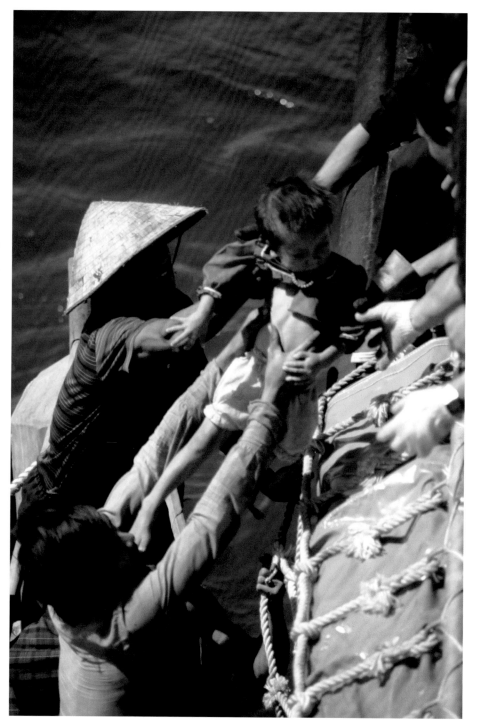

# Chapter Six

# The Island Camps:
# All hands to the pumps

After several quiet years in terms of arrivals in Hong Kong from Vietnam through the 1980s, I was transferred from working along the southern boundary to taking command of the Marine Police fast pursuit unit, the SBU. As a result, and in view of the increase in cross-border smuggling from mainland China, myself and my unit found ourselves deployed to the northern border areas of Hong Kong, in particular to Tolo Channel and Mirs Bay.

But this didn't last. In early April 1989, I received a telephone call from the Regional Commander Marine Police: "Mr Bird, yesterday Marine Police were handed a humanitarian crisis. I need you and your whole unit down at Tai Ah Chau tomorrow. It's a case of all hands to the pumps."

In some ways, I wasn't surprised at being redeployed back down south and to Tai Ah Chau. I had been following the news about how the Vietnamese boatpeople situation had been deteriorating. Recently, criminal gangs in Vietnam had begun spreading false rumours that an amnesty would be granted simply by landing on Hong Kong soil. Lured by the promise of a better life in the developed world, tens of thousands believed what they were being told and paid for a passage out of Vietnam. This in some ways mirrored the "big ships" racket of the late 1970s, only this time small wooden craft were the vessels of choice.

As this new scam became apparent, the United States, Australia and the European nations that had initially agreed to offer permanent residency to the Vietnamese, became far more selective about who they would accept for resettlement. They began imposing stricter entry requirements to their own countries. They preferred to accept only genuine refugees and not those now classified as economic migrants. This left Hong Kong with a problem: what to do with the continuing influx of Vietnamese, those no longer considered refugees. Hong Kong's Refugee Coordinator at the time, Mike Hanson, was reported in the press as saying, "The refugee problem is solved. What isn't solved in the non-refugee problem. And that's our problem."

A small territory such as Hong Kong couldn't absorb the large number of Vietnamese arriving by sea, so the Government felt it had to act, and it did. In accordance with the 1951 UNHCR Refugee Convention, Hong Kong

announced the implementation of a Comprehensive Plan of Action (CPA) separating political refugees from economic migrants. From this moment on, all economic migrants arriving in Hong Kong would be classified as illegal immigrants and be detained in closed detention centres with the intention of returning them to Vietnam. There were now 10 closed detention centres and three transit camps housing 60,000 people. On hearing that they would be sent back, some Vietnamese launched protests and hunger strikes, violence broke out between north and south Vietnamese, fires were set, and riots broke out.

The largest closed camp in Hong Kong, Whitehead, became a war zone as full-scale rioting broke out. One large group of men escaped into the New Territories after tearing a boundary fence down. Some climbed on to the rooftops and displayed "Long Live Freedom" banners, and the photographs of that went around the world.

And it was at this point in mid-1989 when the Marine Police were called into the fray. The government needed more time to sort this situation out, we were told, and meanwhile we were to escort all new arrivals to a bay off Tai Ah Chau, one of the Soko Islands, on the southwest territory boundary.

"Don't allow them ashore," was another instruction, while a decision was made where to take them.

One of the decision-makers at that time was the then-deputy secretary for security, Alistair Asprey. He told me how and why Tai Ah Chau was selected as a camp during the first half of 1989, and he recalls why it was necessary to evacuate the island so soon after it became occupied.

The initial decision to use Tai Ah Chau for new arrivals was taken very much on the hoof. At the time, we were desperately short of accommodation to house an increasing number of new arrivals, all the camps were full, and we were even using ferries anchored in the harbour as temporary accommodation until more space became available on land. We looked at uninhabited or abandoned islands as possible holding centres. I recall spending a morning walking around Ping Chau, in Mirs Bay. There were some army accommodation there, a holiday camp I think; but there were also a few villagers still living there, at least at weekends, and it was likely to prove difficult and time-consuming to obtain permission to rent the private land from the villagers, many of them living overseas.

The advantage of Tai Ah Chau was that Hongkong Land had bought out the villagers, and acquired all the private land on the island, so we were dealing with only one landowner who was quite willing to allow the Government to use the land on a temporary basis. I recall walking all round the island one afternoon with David Wilson, when we decided to use the island to house arriving boatpeople. The intention right from the start was to build a new holding centre there.

While plans for new buildings were being prepared, the Marine Police started to hold boatloads of new arrivals there, usually for just a few hours, until they could be taken to the arrival processing centre at Kowloon dockyard, and then on to other

accommodation. Sanitation on the island was poor, there was an outbreak of cholera, and those with cholera were evacuated to Shek Kwu Chau to be treated at the drug addiction centre there. Later, there was a typhoon, and everyone had to be evacuated at short notice to Shek Kwu Chau. I think by this stage we had built more accommodation at Whitehead, and also established the tented camp at Shek Kong, so we had a bit of breathing space and decided to use it to go ahead with the original plan and build a more permanent holding centre for as many as 10,000 boatpeople on Tai Ah Chau. This was run initially by the Police, and later by a NGO established for that purpose.

The main reason for expanding the camp on Tai Ah Chau was that we continued to be under severe pressure to find more accommodation for arriving boatpeople. Tai Ah Chau was in many ways an ideal location – it was isolated so its existence did not upset any nearby residents; and we could be confident that we could occupy it for as long as needed.

## Return to Tai Ah Chau

It's a dry, hot day in November 2020, and my first time back on the remote island of Tai Ah Chau in nearly 30 years. Last time I set foot on this tiny island there was a 10,000-person capacity purpose-built Vietnamese detention centre running right across the flat middle of the island. Now, there's just a concrete slab, a footprint of where the camp once stood.

There are two hills on this tiny 0.5-square-mile island, which sits three miles south of the western tip of Lantau.

*An aerial shot of Tai Ah Chau today, courtesy of marine conservationist Gary Stokes. Running through the centre of the island, the concrete footprint, on which the camp once stood, is all that remains of Hong Kong's 14th Vietnamese Camp.*

The island is uninhabited now, though I think fishermen still come here from time to time. Occasionally kids, enjoying a bit of paintballing, come out here for the day. And the natural wildness of the island attracts the botanists.

Up here on top of the highest of the two hills, I'm standing pretty much where I stood on my first day on Tai Ah Chau in April 1989. I'd come up here to get a better impression of the island. Today, as I look down at the pier, there's just the wooden junk that brought me here this morning. Back then, there were around 20 Vietnamese vessels out in the bay, none of them allowed to come ashore at that point. At that time, with all the other camps in Hong Kong full, and rioting breaking out, the government needed time to

work out what to do next. With the situation in some of the camps tense, the government wanted to avoid moving any people around from camp to camp.

We'd received an order to hold all of those arriving along the southern boundary out at sea – "Don't allow them ashore, keep them on their boats," we were told. But within 12 hours of being given that instruction, we had intercepted 16 boats with about 1,000 people on board, and some of these boats were sinking right in front of us. There was no option, hundreds of people were now coming ashore. And so the orders changed – "Keep them on their beached boats. Don't allow them to go wandering around."

*Below: After arriving on the island on that first day in April 1989 I climbed the highest hill on Tai Ah Chau and took this shot looking back over the main bay. This was before the order to allow the Vietnamese to beach their boats was received, so there is no one ashore at this point. There are about 20 Vietnamese vessels in the bay with about 1,000 boatpeople aboard. A Marine Department pontoon has just arrived, after being towed from the Government Dockyard, and is being set up in the bay to act as the main reception centre for this 'temporary' arrangement. A number of Vietnamese vessels are already clustering around the pontoon. At the top/centre of this picture, a Marine Police launch can be seen escorting in another Vietnamese vessel.*

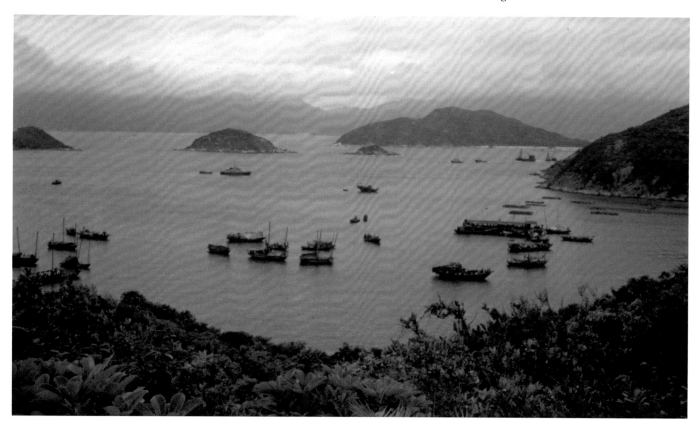

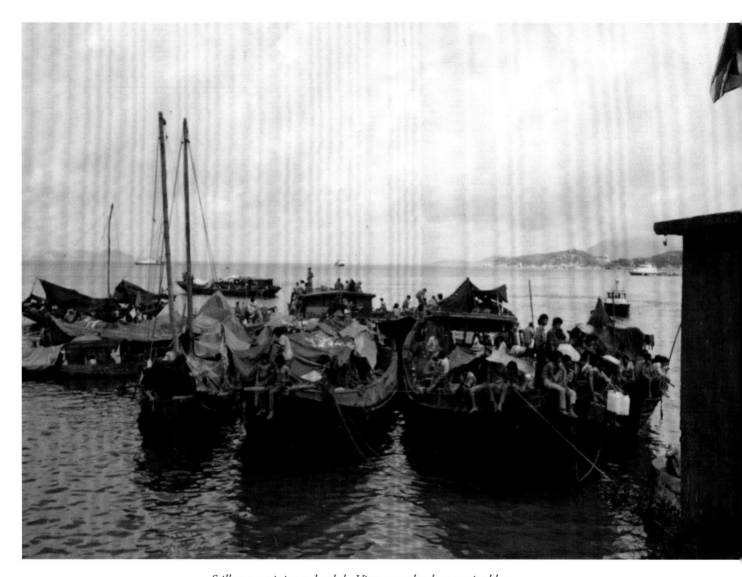

*Still no permission to land the Vietnamese has been received but, realising how impractical the 'keep them on their boats' order was, the Vietnamese vessels are beginning to now congregate around the small pier and the derelict house that we, suspecting that this was going to become a land-based operation, have begun converting into our Tai Ah Chau headquarters. The union flag is flying and three major police launches can be seen standing off in the distance.*

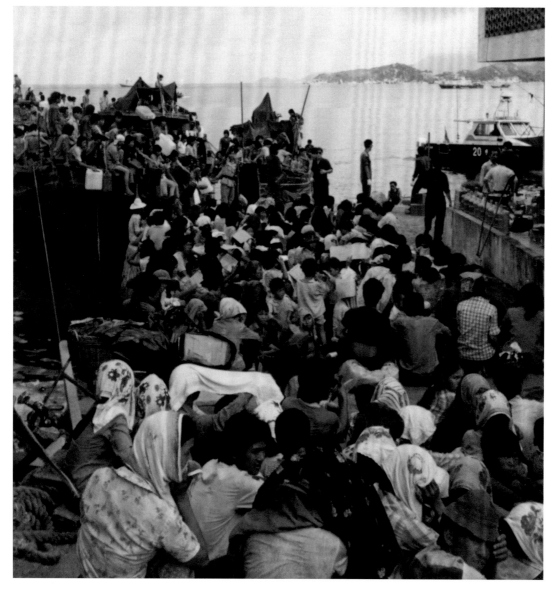

*I took this shot from the land side looking back along the pier. Although the order to allow the Vietnamese to land has not yet been received, some have already done so and are sitting on the pier. There really was no choice, as some of the vessels were sinking right before our eyes.*

Out in the bay was this mayhem of sailing junks, sampans, motorised wooden boats, and then our police vessels milling in between, trying to get people off. There were half-sunk "carcasses" of boats, one on fire, and everywhere the pervasive smell of diesel fuel. And then with the Vietnamese families we were also pulling them up on to the beach for basic accommodation. When you look at one of those photos – wooden hulls, old tatty sails, rope on the rocks and sand of Hong Kong – it could be from a hundred years ago.

I'm thinking these things looking through the photos.

My mind wasn't on the aesthetics then. It really was chaotic that first day. The numbers of people were overwhelming. But we'd been trained for this and there needed to be a set order to things.

A blue tarpaulin had been rigged up over the jetty to provide a bit of shade for an ad hoc reception centre, where crowds of people sat in the heat waiting to register and hopefully to receive food. It was about quickly identifying what needed to be done – registration, supplying water, sanitation, shelter – and as much as possible ensuring people didn't disappear.

And security. The security situation was a big concern. "Remember, there are both north and south Vietnamese arriving on those boats" – more advice from up top.

Normally I would have carried a sidearm, but not under those circumstances. There was no segregation, and the island was in total darkness at night. There were a good number of single men, too, many of them recently demobilised from the army. And we had families with young women. These ex-army men with their cropped hair and battle-hardened faces were a big worry for us. But they were typical of those arriving in Hong Kong at that time. They always stuck together in their groups and always eyed me and the other officers warily.

They were able to look after themselves. Years of jungle survival skills stood them in good stead for the rudimentary conditions of Tai Ah Chau as they bivouacked into the hillside.

*Day three. The order to allow the boats to land has been received. I took this photo after walking along the beach just south of the pier. Although we had been instructed not to allow the Vietnamese to get off their beached boats and go wandering around the island, we simply didn't have the manpower during that first week to enforce this order. Many did stay on their boats as instructed, but many didn't, preferring to build whatever accommodation they could on dry land. Some of the former soldiers bivouacked into the hillside or constructed fairly solid structures from whatever they could scavenge. The group in the foreground have built their huts using bits ripped off their boat, sailcloth and sheets of corrugated iron they found washed up nearby.*

*In 1989, almost all of the Vietnamese arriving in Hong Kong were from the north. Many were former soldiers, and arrived dressed in various items of military clothing, only bothering to remove the insignia. The young man on the right here is an example of that.*

As I walk along Main Beach today, I recall when a large military-looking craft motored into the bay. It came in at speed from the open ocean and made directly for the island, not bothering to stop and request entry from the police launch out on picket duty. This assault vessel was about 60 feet long and had a grey metal hull. There were just nine men on board, young, and dressed in military fatigues. They must have just driven it away one night.

Families tended to stick together in the centre of the island; it was safer there than out in the more remote areas. Walking around today among the scrub, acacia trees and occasional fine banyan, I can see their faces. Hope and uncertainty, mixed with apprehension at where they found themselves.

Then there were the children. There were lots of them. Whole gangs of little kids would follow us around wherever we went. For them it was an adventure. It was exciting, and they followed us, wanting to see what we would do next.

*Below: With no segregation on the island, people did what they could to provide security for their families. The father of this family has constructed a home using pieces of wire mesh that he found on the island and strips of bamboo. In that first week the Vietnamese scoured the island for flotsam and jetsam, putting to good use anything they could find that had been washed up along the shore to build whatever accommodation they could.*

*Left: Some found that they preferred to construct their accommodation within the island's natural resources. Here a family have rigged up the sail from their vessel over a crevice in the rocks. A cooking pot simmers over a fire immediately out front.*

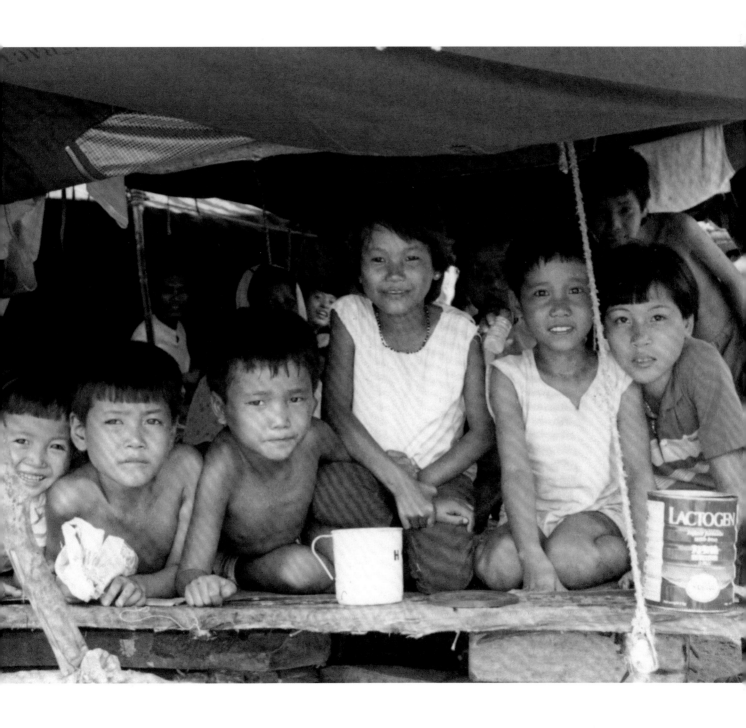

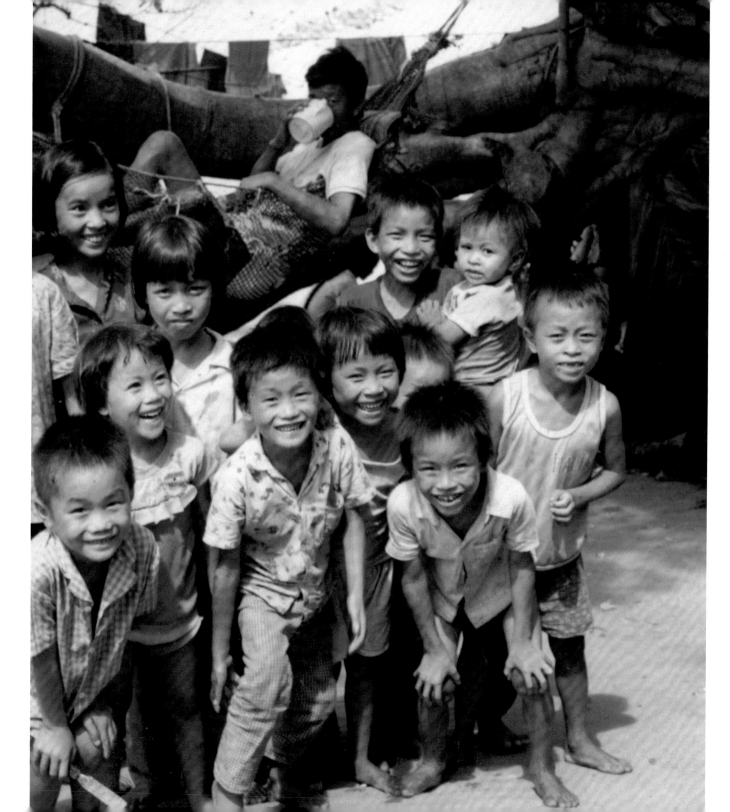

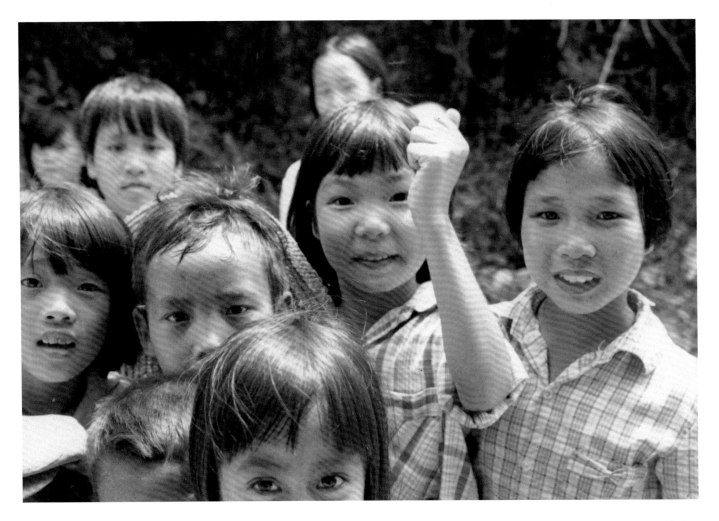

Up here on the hill, there's a helicopter pad, one of two that would be built years later. As I begin to walk down I can see a Chinese shrine partially obscured by the undergrowth. Further back, hidden in the thick foliage, I find a number of graves. They're marked with simple headstones. One inscription, scratched into the stone in Vietnamese, reads: "A Vietnamese man. Name unknown". Another reads: "Two Vietnamese people are buried here 1990".

Today there is little evidence of what happened here all those years ago, but there are a few reminders of that time. Main Beach is now reinforced with rocks to form something of a sea wall, but just at the end of the beach, there's a concrete block where the derelict white stone house once stood, the house that we utilised as the first reception centre. I am standing on that block and looking out to where thousands of people came ashore. I am looking out to where they all lined up, along the jetty that once jutted out from where I am now standing.

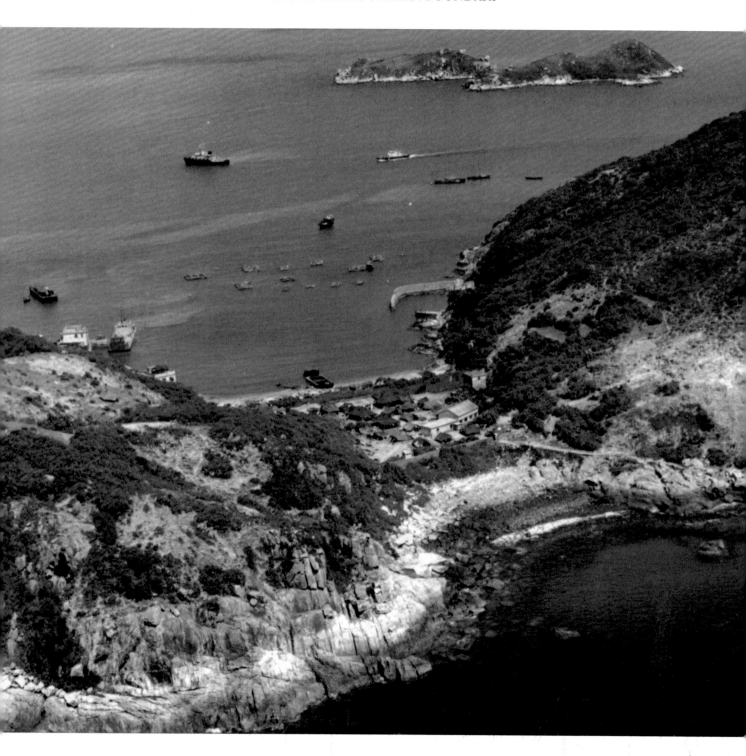

In early 1989, I'd actually been deployed elsewhere. Cross-border smuggling was rife, and I was based in Tolo Channel, a favourite waterway for the crews of the armoured speedboats, the *daai feis*, running cars, electronics and other – mostly stolen – goods from Hong Kong to the mainland or the other way. At that time, I ran the SBU, a fast pursuit unit tasked with catching these speedboats. But we were told to leave that and bring our RHIBs down to Tai Ah Chau. The sea is so shallow around the pier here that large police patrol launches couldn't approach the jetty, so back then our shallow-draught RHIBs were useful, light and mobile.

Within a couple of days, a large, flat Marine Department barge was towed down and secured in the deeper waters. This provided a working platform to handle new arrivals. From day three a British military landing craft arrived bringing in tents, food, detergent and other goods. I watched as the ramp from the flat-bottomed landing craft was lowered onto the sand and a human chain of Marine Police officers and Vietnamese volunteers formed up to carry the supplies from the landing craft on to the island. I can still see them all now, some up to their waists in the surf, carrying boxes of powdered milk above their heads.

But there were no toilets, no washing facilities. We couldn't magic those up. As I walked around the island on the second day with one of my men to do a reconnaissance, I came across a larger group of Vietnamese who were using a house for shade and shelter. And outside in the grass you had to watch where you stepped, with the faeces on the ground. It wouldn't be long before there was a cholera outbreak a few weeks later.

For now, exhausted mothers sat cradling their babies, recovering from their time at sea, while some fathers of families fashioned metal mesh around their small set-ups where they had scavenged what they could from the beach and stripped their vessels. The mesh was some form of protection and an attempt at privacy.

This outdoor living made the Vietnamese vulnerable to the elements. Old sailcloth was used as a screen from the sun, but worse was to come as we heard that Typhoon Dot was on her way up from the Philippines. Today, as I look across the sea at Lantau, the weather is hot and sunny, the sea is calm. But then – we literally had to clear the island in a day and we sat there trying to work out where to put thousands of people.

It was a fast turnaround as we gathered everyone and used two Royal Navy landing craft to evacuate the island. In the end the majority went to part of the drug rehabilitation centre at Hei Ling Chau and others to the Green Island Reception Centre as Hong Kong's Royal Observatory issued the Number Eight tropical cyclone warning signal.

*Opposite: This aerial view of Tai Ah Chau, taken from the south of the island and looking northward, was taken after the camp had been operating for several months. Tent City looks far more organised, and a protected "hooked" seawall mooring has been erected just to the right of the main beach. At the top of the picture is the other Soko island, Siu Ah Chau. Mud is churned up from the shallow seabed next to the pier by the propellers of a flat-bottomed military landing craft, while PL 4 can be seen standing off.*

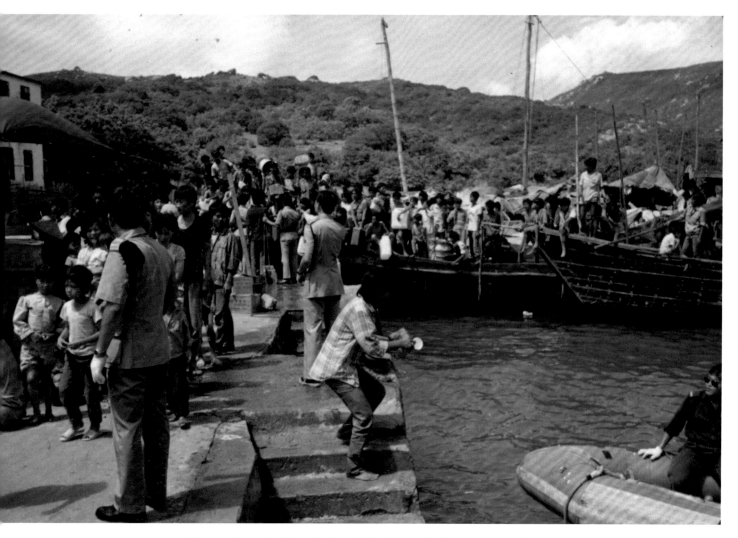

*Above and opposite: Towards the end of week one, the first reception and registration of new arrivals had moved from the floating pontoon in the bay to the converted derelict house on the pierhead – now our new headquarters. A table and some folding chairs were arranged at the front of the house and a blue plastic awning was rigged up to offer protection from the sunlight. Each newly arrived group of boatpeople was required to come forward, each to give their name, age, place of birth and on which vessel they had arrived. We then tried, as best we could, to keep each group more or less together. But with no infrastructure on the island, and the small workforce we had available at the time, that initiative didn't really work.*

The old house at the jetty survived the 185km/h winds, but nothing else did. The sampans and junks in the harbour were turned into driftwood, and there was nothing left of the makeshift shelters the boatpeople themselves had put together.

Previous Hakka inhabitants of the island had bred pigs, so initially we'd used sailcloth and the pig sties had even become temporary accommodation. Then the army brought in big tents that were erected on the central flat area. After that there were Nissen huts, less popular because they were very hot inside. Finally, the permanent camp designed for 10,000 people was erected as Tai Ah Chau officially became Hong Kong's 14th Vietnamese detention centre.

Before the Vietnamese were returned to the island, a dedicated team of Marine Police officers was assembled. These officers, it was decided, would be permanently posted

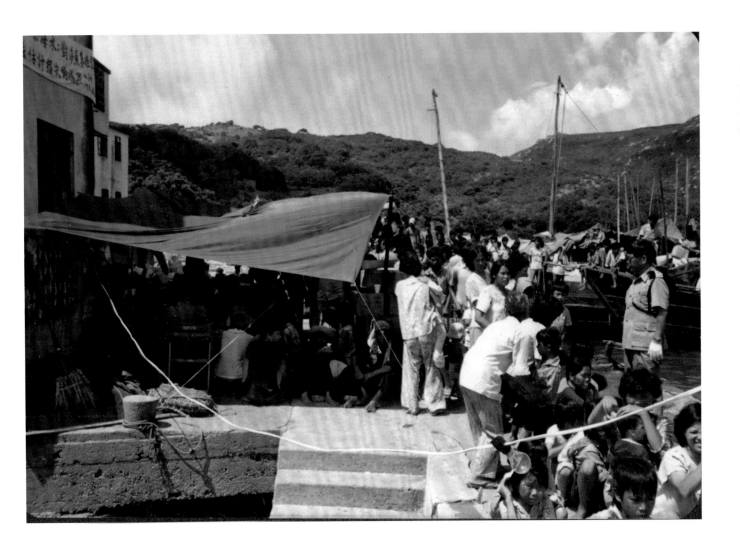

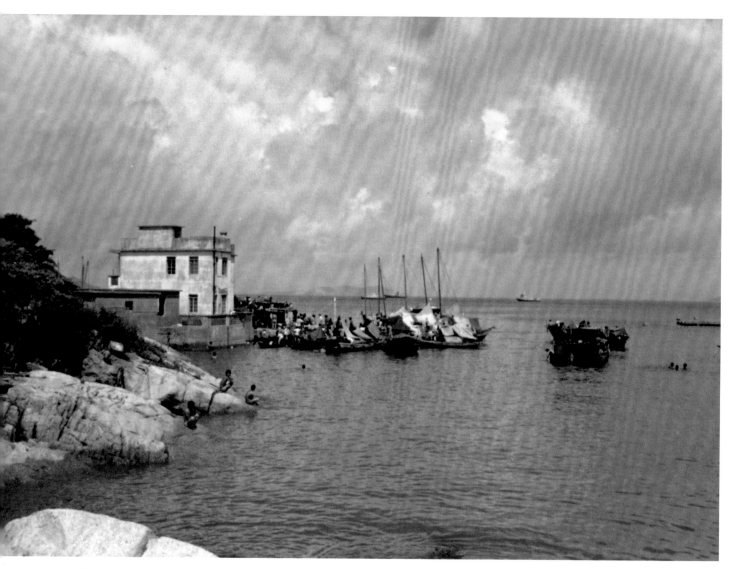

to work on Tai Ah Chau in order to run the camp on a day-to-day basis. Needless to say, they were not volunteers. But this move did allow me and my unit to be withdrawn from the island and return to our task of stopping the cross-border smuggling in the northern waters of Hong Kong, although not immediately.

*Vietnamese vessels form a queue at the pier immediately in front of the police post and await the initial registration formalities. Although we asked them to remain on their boats until the initial registration had been completed, some of the young men from these boats can't resist a swim in the clear, sheltered waters of the island.*

*The first delivery of food. As the depth of the water at the pier was very shallow, only two to three feet, large police launches couldn't get in close, so one of my own inshore patrol vessels proved very useful for delivery purposes. This first shipment comprised of tinned beans, biscuits and rice. Young male Vietnamese volunteers help my guys unload the boxes on to the pier.*

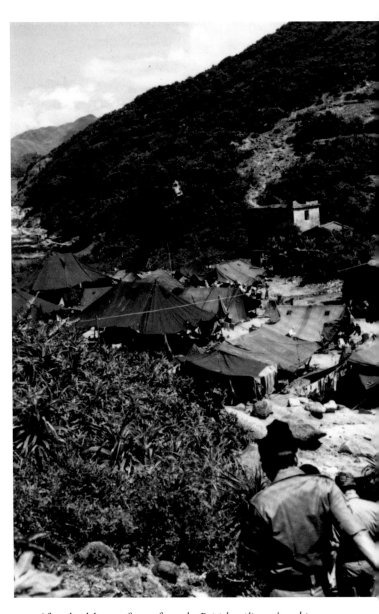

*After the delivery of tents from the British military based in Hong Kong, the lower areas, in the centre of the island, became a popular place to live. This part of the island was referred to by those working on Tai Ah Chau at the time as Tent City.*

*The island was evacuated several times during its first years of occupation, once because of a cholera outbreak and several times due to adverse weather. During one of the evacuations, while all Vietnamese were located in other accommodation, Tent City was demolished and replaced by four Nissen huts (below). These huts proved unpopular with the Vietnamese. Inside was very hot and the open living arrangements offered very limited privacy. Most of those housed in the huts eventually wandered off back into the hills, and built alternative accommodation there (left).*

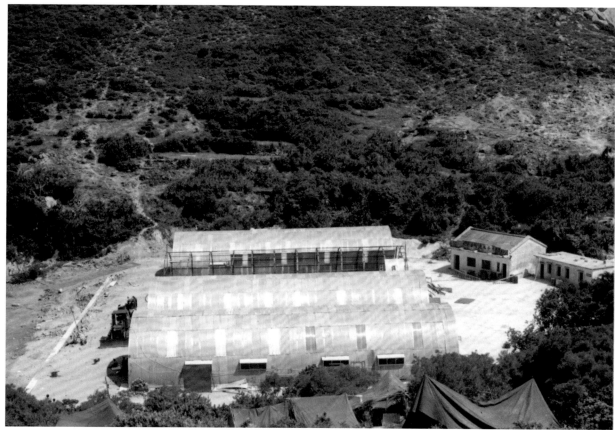

## The ferries

"I want you to go over to Stonecutters Island first, and see what help you can offer there," came the order from Marine Police Headquarters. "What's going on on Stonecutters?" I asked.

"Just get yourself there, you will find out," came the helpful reply.

Stonecutters Island is situated on the western side of Victoria Harbour, just to the southeast of Tsing Yi Island. Then, it was an island; these days it's part of the Kowloon peninsula, connected by the West Kowloon reclamation. Following the transfer of sovereignty in June 1997, the People's Liberation Army established their Hong Kong naval base on the island. Prior to that, Stonecutters had been occupied by a number of British military units, stretching back to before World War II. The Royal Naval Radio Intercept and Direction-finding Station was built there in the 1930s, as were facilities for the Special Operations Executive, a secret British organisation during the war used for espionage, sabotage and reconnaissance. In more recent years, the splendid old colonial buildings that were dotted around Stonecutters had been used by the British military as a rest and recuperation resort for personnel stationed in Hong Kong.

After arriving in Hong Kong in 1976 I'd visited Stonecutters on numerous occasions. There was a live firing range on the island and I and other Marine Police officers were permitted to go there from time to time to practise weapon handling and to be tested on our proficiency in using our standard-issue firearms. The military facilities on the island were predominantly managed by British Army Sikhs. Resplendent in their blue pagris, these soldiers of the Army Depot Police made a splendid sight. There was always a Sikh sergeant on the pier to welcome us when we went along for range practice. He would always snap off the smartest salute.

But not on this day in 1989. We made good time in our RHIBs around the south side of Hong Kong Island towards Stonecutters, passing Green Island at the western harbour entrance as we went. The old ammunition dump on Green Island had recently been converted into the Hong Kong Government's official Vietnamese boatpeople reception centre. All new arrivals were now taken there for their initial screening interviews. It would be in this centre that they would find out if they would be granted refugee status or be sent back. I'd been inside this centre and found it to be a dark, depressing place. There was a network of old tunnels that formed part of the former ammunition bunker. I couldn't help but imagine the anxiety that must have existed in that facility. I imagined the government and UNHCR officials as Roman emperors at the Colosseum, summoning from high the gladiator to come forward to receive his fate. Thumb up, or thumb down.

Five minutes later we approached Stonecutters Island from the southeast. From half a mile out, it reminded me of a scene from a Conrad novel. Grand white stone colonial buildings, bleached by the sun, half-hidden amongst the tamarind, *ficus benjamina* and banyan trees. But the scene on the northeast side was very different indeed, and it was not difficult to locate the area earmarked as the new boatpeople camp. The site was a small piece of reclaimed land adjacent to the military firing range. Four old black and

white double-decker Hong Kong and Yaumatei ferries were moored alongside a heavy flat black pontoon, which was tied to the concrete seawall. The four ferries were moored in two pairs of two – one against the pontoon and one outboard of the pontoon ferry. These ferries, which were about the same size as the standard Star Ferry, had been built in the 1950s and had seen better days. I couldn't recall ever seeing them operating across the harbour, and I suspected they had been out of service for a number of years. Dirty and pockmarked with rust patches, they now sat empty and waiting to perform their final task before being scrapped.

There were a number of uniformed men standing on the pontoon next to the ferries, looking around and pointing at things.

*Below: Four HYF ferries provided the sleeping facilities for some 2,000 boatpeople at Stonecutters. The ferries were moored alongside a Marine Department pontoon that, in turn, was moored alongside an open piece of land. This ferry-pontoon-land arrangement was the Stonecutters Camp. Here, a food delivery has just taken place and officials are arranging for the supplies to be distributed. Food deliveries at this time were mostly canned and dried goods such as beans, biscuits and tinned meat, plus, of course, rice.*

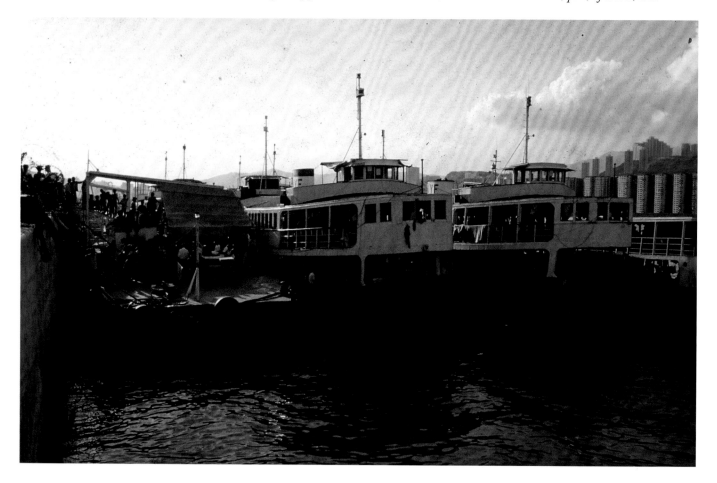

The open land, which was about the size of a football pitch, was bordered by a fence made of six-foot-high curled barbed wire. The only other thing inside the fence, other than the group of men, was a bright yellow 20-foot shipping container. Positioned in the far corner of the compound, it looked strangely out of place. This land, the shipping container and the four-ferry arrangement was, I assumed, the newly designated Stonecutters Island Temporary Detention Centre.

*Below: The Stonecutters Camp staff office, plus the 'annex'. The day before the camp opened, there was no electricity supply, no fresh water and no telephone connecting the camp to the outside world. But all was in order by the following morning. Camp staff worked from this canary-yellow shipping container for the entire time Stonecutters was in operation. The 'annex' to the office was the tented blanket affair to the rear of the container, which offered shade for people sitting on a collection of folding wooden chairs. No one could figure out why the container had recently been painted bright yellow. One suggestion was: 'It makes it easier to find.'*

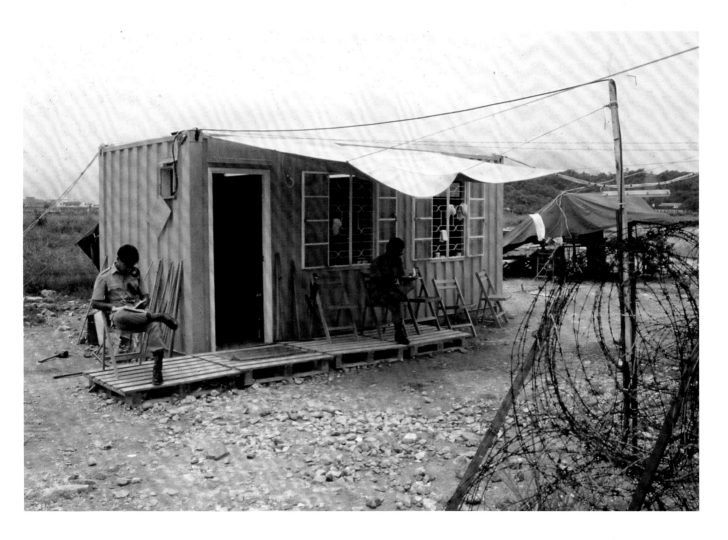

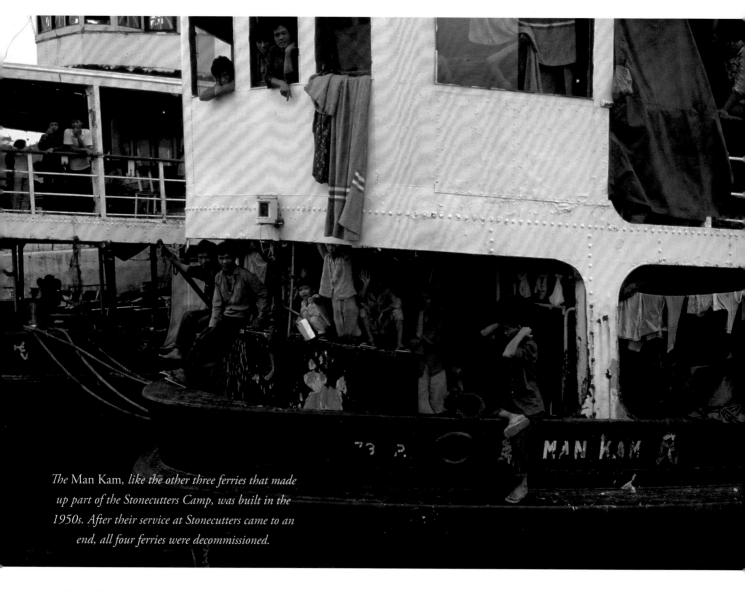

*The* Man Kam, *like the other three ferries that made up part of the Stonecutters Camp, was built in the 1950s. After their service at Stonecutters came to an end, all four ferries were decommissioned.*

We pulled up alongside one of the ferries and I scrambled up on to the lower level of the first one, the *Man Wah*. The ferry was void of life. There was a pungent smell of engine oil. The wooden passenger seats had been removed and inside it looked quite spacious. On either side of the ferry was a large gangway, painted black. The ropes by which these gangways could be raised or lowered were tied up in a cluster of clumsy knots. At the middle of the deck was the ferry's central superstructure, its heavy black metal door wedged open. I peered down inside and looked at the ferry's engines in the gloom. The engine room floor was awash with what looked like a mixture of dirty water and spilt oil.

"These engines are not going to be needed for some time," I thought to myself. I continued to climb through the second ferry until I reached the pontoon, where a young police inspector was waiting for me.

"Good morning, sir," the fresh-faced lad said. He didn't salute as he was not wearing a cap. It didn't matter to me, as there were far more important things to do here. "What's going on?" I asked him.

"I have been sent here to open the camp," he replied, pointing at the open ground behind him. He was British, medium height, blond hair. I put him at about 25 years old. "What's your name?" I asked. "Clark, Inspector Ian Clark, sir. I was the launch commander of Police Launch 71 in East Division until this morning. Now I am, err, the camp commandant, here, I think." Clark wiped the sweat from his forehead with a handkerchief.

"You are from East Division?" I asked. "Not many Vietnamese vessels arriving via there?"

"No, none. Actually I've never seen one. In fact, I've never seen a Vietnamese refugee before either."

"Right," I replied. "Well, that's a good start. I suspect you are going to rectify that gap in your Marine Police experience quite soon. What's the set-up here?" I asked, pointing back at the ferries.

"These four HYF ferries were moored here yesterday. They are going to remain here, alongside this pontoon, to act as the accommodation for the Vietnamese who will be housed here. I'm told that Government is planning to put 500 people on each ferry, so a total of 2,000 in the camp at any one time."

I looked back at the ferries and tried to imagine how 500 people would live together on one vessel. "And this?' I asked, pointing to the open land, fence and container.

"This is the camp," said Clark, waving a hand at the open ground. "It's fenced on three sides. The Vietnamese will be free to walk around the camp as they wish, stretch their legs. And that shipping container in the corner is our office."

The shipping container was just that, a large metal box painted, for some reason, in bright canary yellow. Inside was a wooden table, two chairs, one single battery-operated light and a group of uniformed Marine Police officers. "These are my men," said Clark, "two sergeants and eight PCs. They will divide into two teams so I will have a sergeant and four PCs with me at any one time."

"Any women officers?"

"No, I'm afraid not, they are spread too thinly amongst the other camps, I'm told. But the aid agencies are sending some female volunteers, so we will need to join forces, I guess."

"Your officers are not armed?" I asked.

"No, no weapons in the camp. But I have this." Clark held up a portable radio.

"Your link with the outside world?"

"Yes. Actually it does work," he said, looking rather pleased with the radio.

I looked around the container. "Electricity? Water? Food? Toilets?" I asked. Clark shook his head. "No, nothing."

"When are they going to bring the Vietnamese here? When is Day One?" I asked.

"I'm told they will be delivered here from Green Island the day after tomorrow, after they have been screened, so everyone here will be a new arrival," said Clark. "In respect

of the water, electricity and food," he continued, "I have asked Marine Headquarters about this and they are chasing it up. I hope to get things sorted out before the Vietnamese arrive."

I walked back outside and looked around. "You are a bit exposed out here," I said to Clark. "Have you been given any written orders? Any directives?"

He shook his head again. "No, nothing, no guidebook. I guess there isn't one?"

An hour later I was at Marine Police Headquarters in Tsim Sha Tsui to see the Marine duty controller about what support was planned. "We have arranged for the Electrical and Mechanical Services Department and the Water Services Department to be there first thing in the morning to install power and water," said the duty controller. "Also, another shipping container and more office furniture will be airlifted in by the Royal Auxiliary Air Force. The military, those already based on the island, will be lending a hand too, and I am just arranging a feeding system for 2,000 Vietnamese, plus our guys as well of course. I'm afraid it's going to be

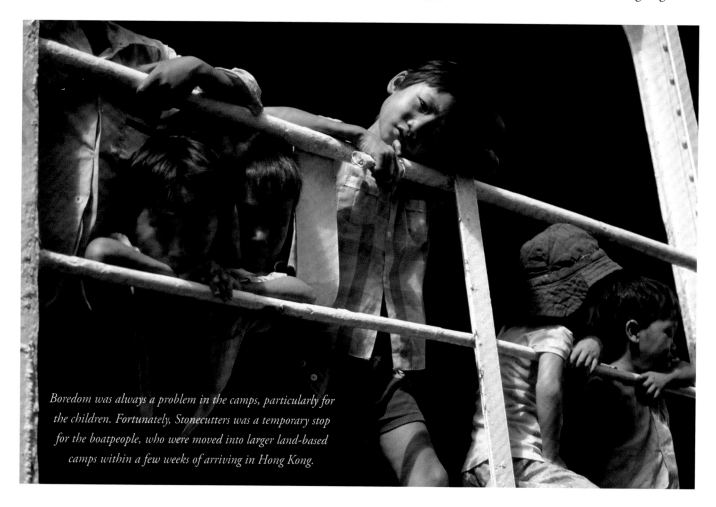

*Boredom was always a problem in the camps, particularly for the children. Fortunately, Stonecutters was a temporary stop for the boatpeople, who were moved into larger land-based camps within a few weeks of arriving in Hong Kong.*

lunch boxes for now. The Royal Corps of Transport will be bringing in the Vietnamese from the Green Island Reception Centre in a landing craft the day after tomorrow, so I have a lot to do. Now, is there anything else?"

And so the Stonecutters Island Temporary Detention Centre opened its doors, or rather lowered its gangways, to some 2,000 Vietnamese boatpeople. A few weeks later I returned to see how Inspector Clark was coping.

"The camp is somewhat rudimentary for sure, but I have to say it was quite remarkable the way things were set up here in just one 24-hour period. As you can see, we have pretty much a working camp." Clark pointed in the direction of

the four Hong Kong and Yaumatei ferries that were moored in the same spot as before. The only difference was that there were now 2,000 people living on board.

We walked over to take a closer look. Clark continued to bring me up to date. "Mostly, we leave the Vietnamese to their own devices. From day one I quickly realised how resilient and adaptable a people they are and how they organise their living spaces as best they can."

From the seaward side of the camp, we could look across the harbour at Hong Kong Island, just two kilometres away. From where we stood I could clearly see the skyline of Central and Western Districts. Also, to our left, I could see

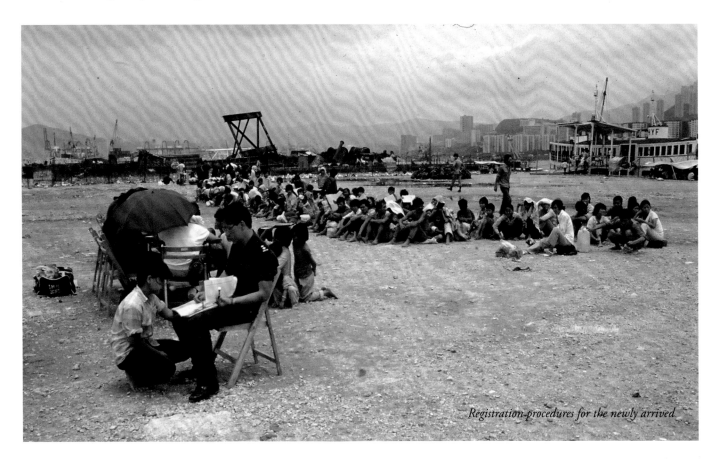

*Registration procedures for the newly arrived*

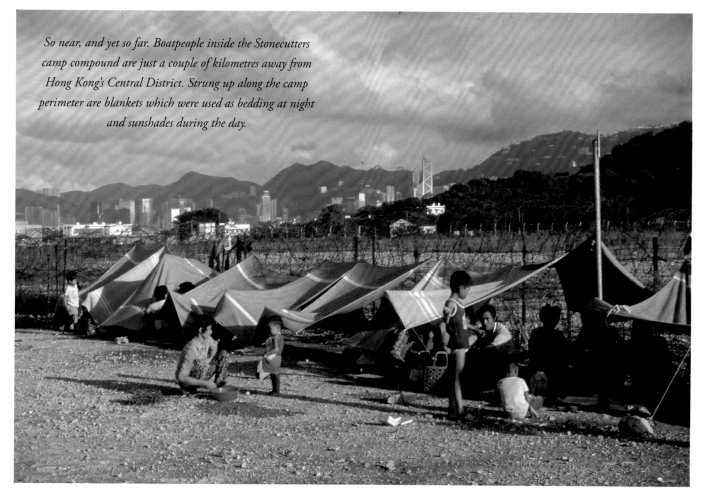

*So near, and yet so far. Boatpeople inside the Stonecutters camp compound are just a couple of kilometres away from Hong Kong's Central District. Strung up along the camp perimeter are blankets which were used as bedding at night and sunshades during the day.*

the Star Ferries criss-crossing the harbour between Central and Tsim Sha Tsui. I tried to imagine what it was like for the Vietnamese who had sailed this far across the open sea, only to be incarcerated in a camp where they could watch in plain sight the daily life of one of the world's greatest cities, right there in front of them, while their own futures hung in the balance.

Along the inner boundaries of the camp, the Vietnamese had fashioned awnings using their Hong Kong Government (HKG)-issued blankets. This tent-like arrangement ran the

entire length of one side of the camp, offering protection from the direct sunlight. Most appeared to prefer sitting outside in this shade, rather than staying on the ferries, where the heat and humidity of the day, and a lack of proper hygiene, made things very uncomfortable.

"Things work best if we keep everyone on board the ferries at night, but during the day they are free to walk around." Clark checked his clipboard. "There are just over 600 children included in the 2,000 we have here, which means the majority are family groups. But there are some

single men, and we need to watch these guys very carefully as there is a 'survival of the fittest' attitude developing among some elements of the male contingent, who seem intent on exerting control over the others for whatever benefits or loyalties they can coerce."

"We are having the same problem on Tai Ah Chau," I said.

"The Vietnamese have already started to 'personalise' the ferries," continued Clark. "They have stripped off fittings and anything else that could be used to enhance their personal circumstances or comfort levels."

"Have you had any trouble?" I asked.

"There's no segregation on the ferries, we can't separate the people from the north of Vietnam from those from the south. We leave that up to the Vietnamese themselves, hoping they will keep their distance if they have an issue. As our intelligence network developed, we identified some gang activities. There have been a few disputes, a couple of assaults and fights break out from time to time. So, we began crime prevention patrols, identifying the main culprits. Since we started doing this, the problem has declined."

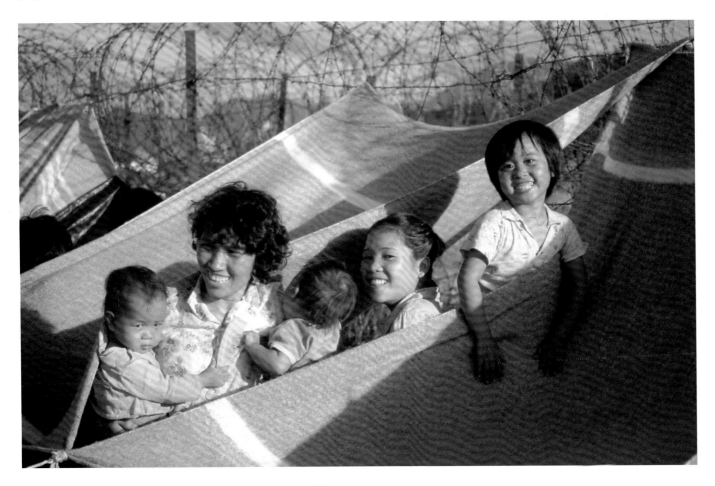

"On Tai Ah Chau we found that some of the men were skilled in making weapons," I said.

Clark nodded. "Once a week, everyone is moved from the ferries and into the compound while a thorough search of the ferries is carried out. We always find a variety of homemade weapons, which we remove and dispose of."

"There's no cooking facilities here in the camp?" I asked.

"No, it's still rice boxes, which are delivered three times a day."

I was beginning to like Inspector Clark. Although young and relatively inexperienced, he had pulled this camp into shape from scratch and now he was responsible for the day-to-day wellbeing of some 2,000 people. The plan was that those 2,000 would go to the Kai Tak camp as another 2,000 new arrivals came in. Clark would have regular visits from government officials, the UNHCR and aid agencies.

*All passenger seats were removed from the ferries to make way for space for sleeping. The red-lettered 'Life Raft' sign points, ironically, to a yellow plastic bowl.*

Back in Clark's container-office I noticed a model boat on his desk. "This is a Macau ferry?" I asked.

"One of the children, a little boy, made it over a number of days. With nothing much to do here, he sat on the sea wall and watched the Far East jetfoils passing back and forth between Hong Kong and Macau. As you know, they pass quite close to the island. Then, using discarded lunch boxes, he somehow managed to fashion this remarkably accurate replica of a jetfoil, right down to the red and white markings. I can't figure out how he did this. The model is made of dozens of cleanly cut pieces of polystyrene. And the red colouring, where has that come from?"

*Metal crowd control barriers, together with the camp's barbed wire perimeter fence, form a corridor where the boatpeople queue with their HKG-issue bowls for one of the daily distributions of fresh water. A large percentage of the adult male boatpeople arriving in Hong Kong in 1989 were recently demobilised from the Vietnamese military. Two of the men in this photograph are still wearing their army-issue shirts.*

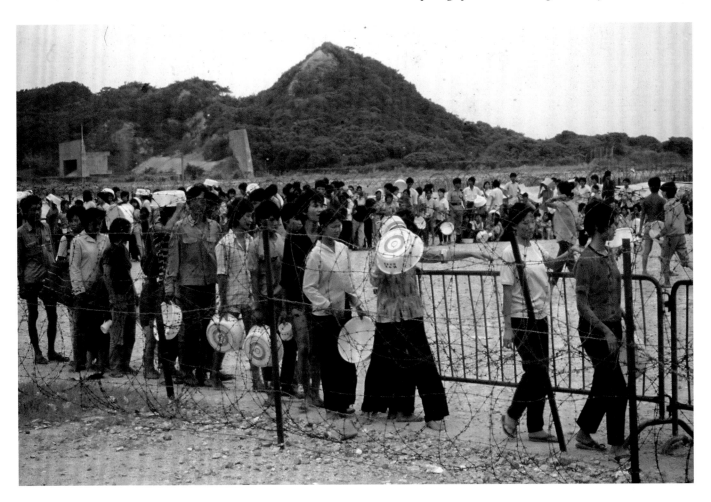

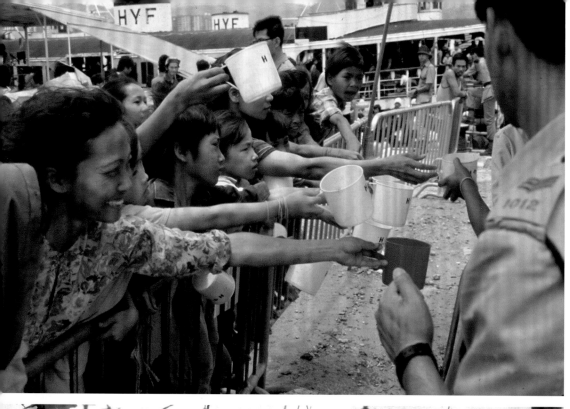

*Rice issue. Sometimes a smile gets you noticed.*

*Children wait with their HKG-issue plastic mugs for the rice distribution.*

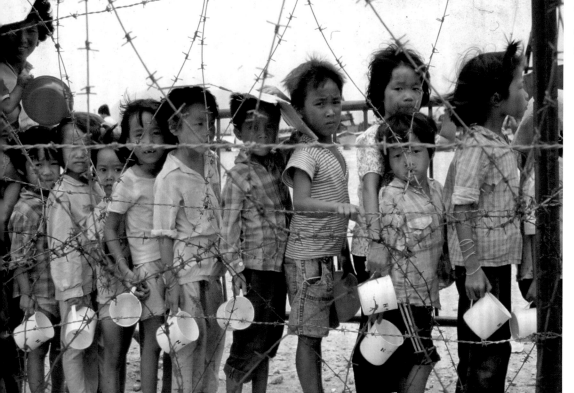

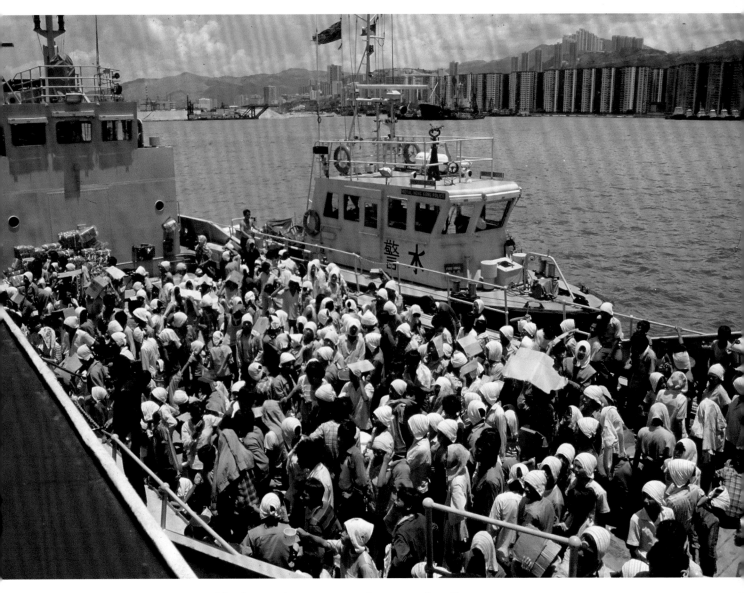

Most boatpeople spent no more than two weeks on Stonecutters, a
temporary facility until room in one of the more established camps could
be found. Arrivals and departures took place on a daily basis. Here a
military landing craft proves an invaluable resource. The Vietnamese on
board use whatever they can find to protect themselves from the heat of
the day as they wait to be told what will happen next.

As we spoke, a team of Civil Aid Department officers arrived and began arranging the Vietnamese women with small children in lines across the open ground. "Ah, this is the de-lousing that has to be done for all new arrivals," explained Clark.

We watched as red-and-yellow Hong Kong Government-issue plastic buckets and bowls, all full of water, were handed out to the Vietnamese women. An officer then walked along the line pouring a white powder into the bowls, turning the water into a milky white liquid. Systematically, the women then began to wash their children with the liquid.

"After many weeks at sea, and with no sanitation or change of clothes, most arrive here in poor condition," said Clark. "Every group is going to have to do this, I'm afraid."

**A teenage girl's story**

During my research for this book, I was introduced to Thanh Vu. In 1988, when she was 16 years old, Thanh Vu

was told by her parents that they were going on a trip and that she should pack a small bag. The family were living in north Vietnam at the time and she imagined that they were going to visit relatives.

The family travelled at night, arriving at the port of Hai Duong Thong in the early hours. There, to Thanh Vu's surprise, she was put on board a wooden boat with a group of strangers. In the confusion at the dock, she was separated from her parents, who were eventually left behind. She has hardly any recollection of the sea passage. This is her story of her arrival and first few weeks in Hong Kong.

After our boat was intercepted by the Hong Kong Marine Police, and after doing the refugee procedures, they took us to a very large floating vessel, placed in the middle of Hong Kong Harbour. On this vessel all our equipment was thrown away, and the officer told us to gather in groups. They sprayed us with a white powder, then we went under a large shower spray to remove the white powder, like we sprayed our dog back home.

Welcome to Hong Kong! It was a shock that I will never forget.

Afterwards they gave us all dry biscuits and milk and we were put on the floating ferries for a few days. At night, looking at the splendid and magnificent Hong Kong skyline under the lights, everyone was in awe, and they began to dream about their future plans, what they would do when they were allowed into this wonderful city. That night I fell asleep floating in the middle of Hong Kong Bay.

A few days later we were all transported to the Kai Tak camp in prison trucks with netting over the top, and our convoy drove through streets lined with skyscrapers, and shops from small to prosperous. The free world. The first modern city I had seen in my life. Kowloon City. The convoy stopped at the arched building of some disused airport area. We moved into the arches, and former aircraft hangars. The outside area was covered with mesh and barbed wire and had a police patrol.

In those hangars there were many boatpeople who had arrived before us. This was called a transfer camp. There was nothing to live in, we had to eat and sleep on the floor covered with straw mats, and the lights were on all day and night.

I went 14 days without clean clothes to change into. I just showered in all my clothes, then stood in front of the fan to dry. We had no toothbrushes, just three meals, in a red plastic bowl and a yellow drinking mug with a HK logo. My first meal in Hong Kong was a bowl of rice with canned fish and one apple and a cup of tea.

Then some Hong Kong charities visited. They filmed us and handed out old clothes and toothbrushes to us. I tried to hide from the camera as much as I could. But I did want the old clothes and sandals, as the whole time since leaving home I had only worn one set of clothes.

Early each morning there was a headcount. We had three meals a day and were allowed to go out twice to walk around in a yard. I imagined the magnificent

city I had seen that first night.

In this arched house living with all these people, I wanted to make myself very small, like a very lonely snail on the sand, not knowing when the storm comes. I had missed my period for two months. The doctor at the camp said it was a psychological reaction, like when someone has been through overwhelming panic or shock. I wasn't the only female boatperson to suffer from this. I no longer cried.

A few weeks later, we moved to Sham Shui Po Camp. I was transferred to Zone A. The biggest house, three floors with lots of beds. Coming here was the start of a life of hell on earth. Thieves became chiefs. The criminal gangs took over. We had to be as subdued and silent as possible to survive. You could be beaten for a look they didn't like. The criminal gangs divided their power in the building where everyone lived together. I didn't know what to do. I watched as a conflict exploded between Hai Phong boatpeople and boatpeople from Quang Ninh. That night I saw people sharpening knives made from the bedguards. Sharp crosses used as swords to fight.

That night I hid in my bed, hearing only screams and more screams and bloodied people running amok, until the police arrived carrying shields and electric sticks. The aching siren blared and the red light was on. After about an hour there was silence.

The power division war was reported in the Hong Kong press like a medieval fight, with iron bars, sharpened wooden sticks and plastic knives cut from prison bowls. Many were dead and wounded. The whole camp lay awake that night, the whispering continuing to last until they took the morning attendance.

More than 30 years on, I still do not understand why these people didn't know how to cherish their lives. They had overcome so many difficulties, dangers and ocean waves to reach this land. After that night of upheaval, the camp became quite peaceful. At night I lay awake and listened to the hustle and bustle of life out there, where the Hong Kong people's path of freedom was just a wall separating them from me, the sound of children calling for their mother, the laugh of a couple of lovers, the sound of a car driving along a street at night, of a free life that I could not have.

Thanh Vu was granted refugee status and was accepted by the British government. She was able to reunite with her parents. She still lives in London.

# Chapter Seven

# Endgame

For a good 13 years and more of my career in the Marine Police, I was either fully or partly involved in dealing with the tens of thousands of Vietnamese people arriving in Hong Kong. Over those years I had listened to so many stories from these people about their lives in Vietnam before the war; what happened to them during the war as the Viet Cong approached Saigon and the Americans left; and what happened to them afterwards – in particular what made them leave their families and friends, and give up everything they had worked for in order to risk their lives to cross the South China Sea. This played on my mind for some years, so I was keen to see the place where all these people had come from.

Entry into Vietnam was restricted for foreigners for much of the 1980s, but in 1991 a business friend of mine in Hong Kong told me that he had secured a visa to visit Ho Chi Minh on business. Although I was a serving police officer in Hong Kong, I decided to accept my friend's invitation to join him as his "business partner" and applied for a visa on the strength that I needed to accompany him for work. My friend supplied papers and we were both issued with visas for the Ho Chi Minh City (HCMC) area only. It was made clear in the documentation that travel outside of the city was forbidden.

During the three days I spent in HCMC I walked everywhere. While my friend conducted his business I was free to wander around the city. I was surprised by how many residents spoke Cantonese and they were surprised to find a foreigner who could converse in their own language. Almost all of the people I met were ethnic Chinese.

The shops had very little to offer. It was mostly Russian produce (Russians supported the Viet Cong). I recall looking in the window of one shop. All they had were pyramids of cans of Russian caviar stacked up from floor to ceiling, probably purchased on the military black market. I couldn't figure how these shops did any business. None of the locals could afford one can of caviar. And they didn't want it anyway.

I recall many ex-military stalls and shops where one could buy arms and ammunition, all sorts of military paraphernalia. Most of it was American with some ex-South Vietnamese military junk.

I visited the war crimes museum. I was the only visitor. I was treated with suspicion and asked if I was American.

Americans were banned from entry. I produced my British passport and paid to go in. I was followed around by the staff. Inside it was dark and run-down. The main exhibits were two enormous, framed photos. One of Nixon, one of Johnson. Under both in large letters was the word "MURDERER". The other exhibits were mostly of dead Vietnamese people, the victims of the murderers.

I found a travel agent in HCMC (they were not very busy!) and surprisingly on offer was a trip to see the Mekong River. Many of the Vietnamese I had intercepted in Hong Kong had begun their sea journey from the Mekong area, southeast of HCMC, with many of them boarding the vessels at the port of Vung Tau, about 75 miles outside of HCMC. My friend, who had concluded his business, agreed to come along and so we booked a trip to see the Mekong Delta and hopefully visit Vung Tau. The three people-smuggling ships that came to Hong Kong from Vietnam had all loaded their human cargo in Vung Tau, so I was keen to see where their journey had begun. In fact, many of those who fled Vietnam in the late 1970s did so from the Vung Tau area. Vung Tau is the closest port to HCMC and being on the eastern seaboard it was ideal for beginning journeys to the northeast, towards Hong Kong. Also, the government officials in the Vung Tau area were the ones organising these people-smuggling rackets.

The road trip out of HCMC for the two of us was in a white van. With us was one driver and one "tour guide". This tour guide was a government official, sent to keep an eye on us. Although he was a tour guide he never spoke a word the entire day, other than "No", if we asked to go too close or take a route off the agreed road.

Outside of HCMC the evidence of war was everywhere, even then, some 16 years after the end of the conflict. Burned-out tanks could be seen in the jungle areas from the road as we drove by, our tour guide refusing to stop for us to take a better look. But at one point we had to stop for a bathroom break, and we found a crashed helicopter hidden amongst the trees near to where we stopped. I quickly climbed up into the helicopter and had a photo taken before our guide returned from the bathroom.

*A crashed Bell UH-1 Iroquois helicopter (more commonly known as the 'Huey'). It must have been in these trees since 1975. Rusty and broken, there were no visible markings.*

When we arrived on the outskirts of Vung Tau we stopped, and our guide spoke with a group of uniformed people who were manning what looked like the main entrance to the port area itself. From where we were, we could see ships alongside the dock. We were refused entry and had to leave, but driving away we stopped by the seashore and could look back at the place where the *Huey Fong*, the *Skyluck*, the *Sen On* and thousands of wooden vessels must have loaded their human cargos some 16 or 17 years before.

## Leaving Tai Ah Chau in their Sunday best

The following four photos were taken by a friend, Hugh Osborne, who by this time, at 42, was senior staff attached to the Police Tactical Unit. Hugh was twice on Tai Ah Chau at the end of its time as the 14th camp in 1996. His final trip was as a police observer, while a search was conducted for weapons or any other illegal items across the island. He described to me how it felt quite strange now just to see the vacant buildings where thousands of people had been.

A few days before, HYF ferries were used to take all the remaining boatpeople off the island.

Hugh joined me in November 2020 for a walk around. He described how overgrown the island has become since he was last here 24 years ago, but also the sense of poignancy he felt recalling how parents dressed their children in their "Sunday best" as they left the island.

*In 1991, during one of the many evacuations of the Tai Ah Chau, the entire central segment of the island was flattened and concreted over. On the new 250sqm slab, a purpose-built camp that could accommodate 10,000 people was constructed.*

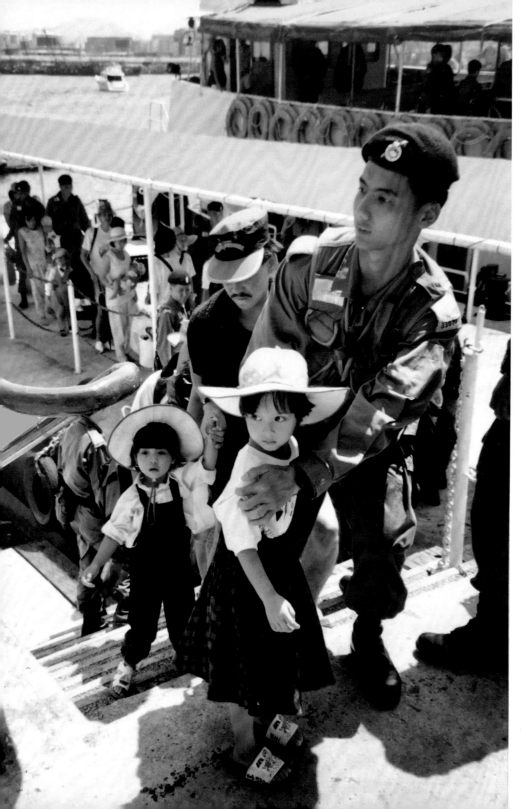

"It took at least two days to move them off – and we used Hong Kong and Yaumatei ferries to take them off and it was almost like a holiday atmosphere for the children as they left. The mothers had dressed their little girls and boys in their best Sunday clothes. They were all very excited to be moving off the island. There was no trouble whatsoever. We didn't have to force anybody off the island."

They went up to Sai Kung to the High Island detention centre and they stayed there until they were processed.

*A Police Tactical Unit officer assists a family off one of the Hong Kong and Yaumatei ferries that were used to evacuate Tai Ah Chau.*

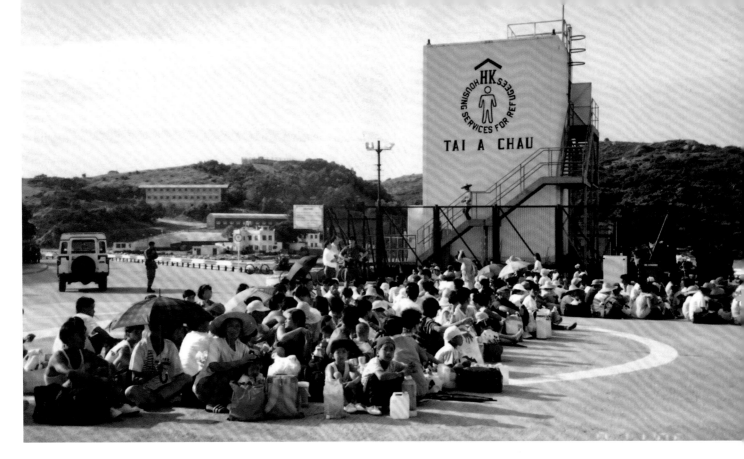

*Above: Throughout the 1990s, as the number of arrivals in Hong Kong dried up, and the numbers of Vietnamese still housed in the camps decreased, the camps were systematically closed. Tai Ah Chau's turn came in September 1996, when just over 3,000 of the last boatpeople remaining there were transferred off the island and moved into other camps. Tai Ah Chau Vietnamese Detention Centre was closed forever, and the entire camp demolished. Here, some of the last boatpeople to be moved wait on the pier for sea transportation off the island.*

*Right: The deserted camp interior. In the foreground, a line of small cooking stoves that were used by the Vietnamese, as there were no cooking facilities in the accommodation blocks.*

## Twenty years a refugee – Mary's story

During the time that I've been putting this book together, I've had quite a bit of correspondence with Mary Nguyen, a retired Vietnamese kindergarten teacher and a grandmother. Mary and her family for me represent how people could be permanently on the move, living transient lives due to political circumstances beyond their control. She was taken initially to Tai Ah Chau.

I was born in Saigon in 1957. My family, which originates from Nanning province, had fled China for Vietnam in the late 1940s after the communists came to power. We settled initially in north Vietnam, but in 1954, when the country became divided by the war, we moved south and settled in Saigon.

I met my husband, To Nguyen, in Saigon. He's four years older than me. In the early 1970s he abandoned his education to join the army to fight the communists and became a lieutenant in the South Vietnamese Army.

In 1975, at the end of the war, my husband was arrested and imprisoned for more than a year. He was very badly treated and after his release we continued to be harassed by the government. In the early 1980s, after the end of the Vietnamese-Cambodian War, we decided to move across the border into Cambodia. We planned to try and cross the country and enter Thailand, but we were refused entry many times. We were afraid to go back to Vietnam as we thought we would be sent to prison so we stayed in Cambodia

until they sent us back. After returning to Saigon we started a family, a son in 1981 and a daughter seven years later. It was shortly afterwards that we decided to try and go to Hong Kong and hopefully be accepted by another country for resettlement.

In early 1990, we travelled 2,000km by bus from Saigon to the Vietnamese-China border town of Mong Cai and, a few days later, across the border by road to the Chinese town of Dong Hung, where my husband's uncle lived. Realising now that we had insufficient money to pay for a sea passage to Hong Kong, my husband returned to Saigon to try and raise the funds to buy a boat by persuading others to join us and splitting the costs. This took time and required two such trips before he managed to persuade eight others to join us. One of these was a fisherman who could drive the boat. We had to pay for the small wooden boat in gold, costing us the equivalent of 40,000 Yuan. So, our group was ten adults and our two children, who by then were aged nine and two. We left Dong Hung in May 1990. Our boat hugged the coast as much as possible, but from time to time we had to go far out to sea to avoid the Chinese military patrol boats. At times the sea was rough. None of us could swim and I was terrified for the children. We sailed north of Hainan Island, arriving in Hong Kong seven days later.

Once caught by the Marine Police in Hong Kong we were sent to Tai Ah Chau. We were very happy to see the Hong Kong Marine Police because we knew

we were safe. The first thing that happened to us when we arrived on the island was the de-lice. We were all sprayed with a white antiseptic powder from head to foot and given an anthelmintic drink and special powder to wash our hair. Most of the accommodation on Tai Ah Chau was in tents. But after screening by the Immigration Department, we were rejected for refugee status and transferred to the closed camp at Chi Ma Wan, where we lived with other families in a large dormitory.

I began teaching the children of kindergarten age and I was paid HK$110 per month for the work. Even though Chi Ma Wan was a closed camp I was allowed to take the children to visit places in Hong Kong such as Ocean Park. A Hong Kong Government person accompanied us. After being in Hong Kong for one year I gave birth to my third child, a daughter.

We lived in Chi Ma Wan camp until 1996 when we were eventually sent back to Vietnam, repatriated.

We were very sad and worried what would happen to us after we returned because of my husband's military background.

We were flown back to Vietnam from Hong Kong on a special flight where returning Vietnamese and Hong Kong Police were the only passengers. The plane landed in Hanoi and we were then put on a special bus back to Saigon. Once we had returned we were interrogated and were forced to take an oath of allegiance to the government. For several years after returning to Vietnam my husband was the subject of army and police attention. He was harassed and followed. But over time this has ceased. We're back in Saigon. Vietnam is better today than it was when we left in 1990, but if I had the choice today I would live overseas, in Britain or the United States.

Back in Saigon I began a kindergarten school, but I have stopped teaching now as I am too old.

# Afterword

Looking back at those years, at the photographs that I and my former colleagues took along the southern boundary – images of those first small wooden craft that arrived in Hong Kong, and those of the Marine Police vessels that intercepted them – I sometimes wonder how we coped. Back then, our vessels were slow and nowhere near as capable as the state-of-the-art Marine Police fleet of today. It's been good to reconnect with some of my former fellow officers up to 40 years on.

In writing this book I have been in touch with some of the Vietnamese people who came to Hong Kong in the 1970s and 1980s in search of a new life. And I've also thought about the many who didn't make it across the South China Sea. What particularly resonated with me on a more positive level was when some former refugees who now reside in Montreal – and who were children on the people-smuggling freighter, the *Sen On*, the ship that ploughed into the beach on Lantau in 1979 – told me that the pictures in this book are the only photographic record of their youth. That I'm providing information about a journey that they were too young to remember.

Many former boatpeople, in the US, Canada, Australia, the UK, and even those who were eventually repatriated to Vietnam, have written to say that they appreciate that their time, traumatic as it was, has been recorded and remembered in this way, providing a record of that era – when they came with their boats along the southern boundary.

# Acknowledgements

I would like to thank the former Hong Kong Marine Police officers who have scrambled around attics and prised open old tea chests to reintroduce the light of day to the photographs they took of the people, the boats and their work all those years ago. I am very grateful to my Vietnamese friends and new acquaintances for giving me their trust, recounting their journeys and experiences as they escaped Vietnam and arrived along the southern boundary, some to find new homes in other countries and others to be sent back. I appreciate that sharing those personal recollections has not been easy. I thank the former Hong Kong immigration and other government officials and historians who have willingly put up with my questions. Many thanks to all of you for helping to make this book possible:

Alistair Asprey, Bill Bailey, "John Baker", Crispian Barlow, Ian Clark, Rod Colson, Peter Conolly, Cang Dang, Phan Dang, Phung Dang, Yen Dang, Dr Stephen Davies, Nigel French, Frank Lai, Paul Lai, Steve Le, Clinton Leeks, Ross Mitchell, Wally Murison, Mary Nguyen, Mark Ogden, Hugh Osborne, Gary Stokes, Stephen Tooke, John Turner, Bau Vu, Thanh Vu, Iain Ward, Alasdair Watson and Caroline Wu.

Thank you to Hong Kong community artist Evelyna Liang Kan, who said "You should make a photo book!" And to Harry Ho Yin of Chinese University for displaying some of my photographs at an earlier exhibition on the experience of the Vietnamese boatpeople in Hong Kong.

For their ongoing support, I'd like to thank the Royal Asiatic Society, Hong Kong and the Facebook groups: 'HK Camps', 'Freighter Sen-On 1979 Refugees' and 'Stories of Vietnamese Boat People'.

A special thank you to my publisher, Pete Spurrier, of Blacksmith Books. And to my family, May Anne, Catherine and Towa, who have always been my inspiration and been my stalwart support throughout.

I would like to acknowledge the following publications used in research for this book:

- Hong Kong Year Books, 1979 to 1990
- *Mariners*, Iain Ward
- *South China Morning Post*
- *The Invisible Citizens of Hong Kong – Art and Stories of Vietnamese Boatpeople*, Sophia Suk-mun LAW
- *From Both Sides of the Fence, Vietnamese Boat People in Hong Kong, 1975-2000*, Carina Hoang

# Abbreviations and Glossary of Terms

**ARVN**: Army of the Republic of Vietnam, the ground forces of the South Vietnamese military.

**Balustrade**: a handrail together with its supports around the open deck of a ship.

**Bridge** or Wheelhouse (Marine Police): a bridge is a room or platform of a ship from which the ship can be commanded. A wheelhouse is the enclosure that houses the ship's wheel. On Hong Kong Marine Police launches both locations are combined.

**CAS**: Civil Aid Services (Hong Kong Government)

**CID**: Criminal Investigation Department (Police)

**Coracle**: a small rounded lightweight boat made of interwoven bamboo and waterproofed by using resin and coconut oil

**CPA**: Comprehensive Plan of Action – the 1989 international agreement focusing on the repatriation back to Vietnam from Hong Kong those deemed not to be refugees.

**DO**: District Officer (Hong Kong Government)

**Dory**: a small, shallow-draft boat ranging from about 16 to 23 feet long.

**Duty Controller**: the senior Marine Police officer in charge of the Marine Police Command and Control Centre

**EOD**: Explosive Ordnance Disposal Unit (Police)

**EOT**: Engine Order Telegraph – a communications device used on a ship for the officer of the watch on the bridge to order engineers in the engine room to power the vessel at a certain desired speed.

**EPD**: Environmental Protection Department (Hong Kong Government)

**ETA**: Estimated Time of Arrival

**Freeboard**: the height of a ship's side between the waterline and the deck.

**Galley**: the kitchen in a ship.

**Gazette/gazetting**: to announce or publish the appointment of someone or something in an official post or gazette.

**GD**: Government Dockyard, the government shipyard where all government vessels are repaired.

**Grappling net**: a heavy-duty net made in cross-sections of rope and fitted with hooks for grasping and holding the net in place. Often thrown or lowered over the side of a ship to assist boarding.

**HMS**: Her Majesty's Ship

**Hong Kong Squadron**: the permanent Royal Navy force for the protection of Hong Kong, comprising primarily of five Ton-class coastal minesweepers supported by logistical supply vessels.

**HYF**: Hong Kong and Yaumatei Ferry Company

**New Development Zones** (Vietnam): zones created in Vietnam after the United States lifted its trade embargo on the country.

**Nissen hut**: a prefabricated steel structure for military use, especially as barracks made from a half-cylindrical skin of corrugated iron.

**OOW**: Officer of the Watch – a deck officer assigned with the duties of watch keeping and navigation on a ship's bridge. While keeping a watch on the bridge he is the representative of the ship's master and has total responsibility for safe and smooth navigation of the ship.

**PC**: Police Constable

**PL**: Police Launch (followed by number)

**Polaroid**: Polaroid Corporation (US), recognised as the founder of the instant photography camera – the camera that included the operations of a darkroom and the photo production inside the camera itself.

**POLMIL**: abbreviation of 'Police Military' – the name given to the higher command room for joint Royal Hong Kong Police and British military operations.

**Port of First Asylum**: the status of "safe haven" provided by the Hong Kong Government to Vietnamese boatpeople, that included a grace period in which to make resettlement applications to third countries.

**PTU**: Police Tactical Unit

**RHIB**: a Rigid Hull Inflatable Boat is a lightweight but high-performance vessel constructed with a rigid-hull bottom joined to side-forming tubes that are inflated to a high pressure so as to give the sides resilient rigidity.

**RHKAAF**: Royal Hong Kong Auxiliary Air Force

**RHKP**: Royal Hong Kong Police

**UNHCR**: United Nations High Commissioner for Refugees

**Viet Cong**: officially known as the National Liberation Front of South Vietnam, this was an armed communist political revolutionary organization in South Vietnam.

**WQA**: Western Quarantine Anchorage – an area of Hong Kong's western harbour sectioned off to house the initial medical and immigration processing facilities for newly arrived Vietnamese boatpeople.

**Zodiac** (brand name): a lightweight, inflatable boat powered by a small outboard engine.

## ALSO AVAILABLE FROM BLACKSMITH BOOKS

From retailers around the world or from *www.blacksmithbooks.com*

**By the same author**

*A Small Band of Men* is a colourful memoir by Les Bird of his 20 years in the Royal Hong Kong Police Marine district, from the mid-1970s until just before 1997. It's a period of rapid change in one of Britain's remaining colonies and Bird witnesses the last years of the hard-working, hard-drinking colonial police officers. He begins his career as the inspector of West Lantau in sleepy Tai O, sorting out village issues with his patrol dog Ratbag. He was one of a handful of senior officers instrumental in dealing with highly sensitive issues including a flood of refugees fleeing Vietnam and the increase in the smuggling of guns, drugs, people and luxury goods either to or from China.

Filled with gripping stories, *A Small Band of Men* follows Bird and his cohorts including his mentor, "Diamond" Don Bishop, an eccentric officer whose volatile temper and larger-than-life personality was a major influence in Bird's career. These tales provide a fascinating insight into the intersection of cultures that is Hong Kong.